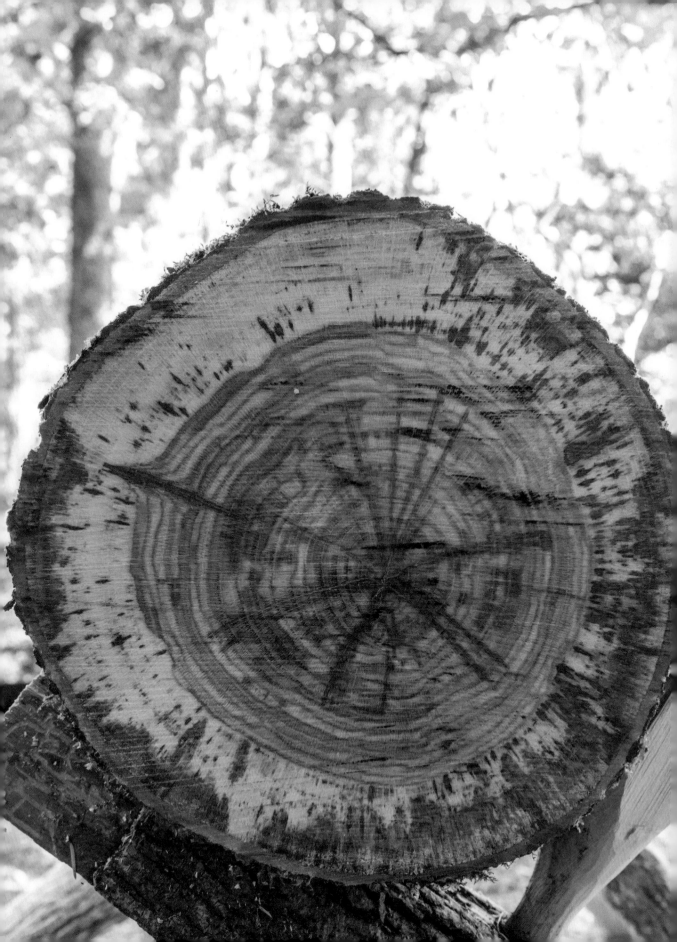

THE FOREST
WOODWORKER

Dedicated to our fathers.

Willem Suijker, who worked as a bookkeeper but who, during his life,
liked to light a fire and every now and then sighed that he would rather
have been a lumberjack.

Har van der Meer, who was happy as a horticulturist but who sometimes wished
he had been a carpenter. Har is also our oldest student.

First published in Great Britain in 2019
Search Press Limited
Wellwood, North Farm Road
Tunbridge Wells
Kent TN2 3DR

Originally published in the Netherlands in 2017
as *Vers Hout*

World rights reserved by Forte Uitgevers
© 2017 Forte Uitgevers BV, Baarn
www.fortecreatief.nl

Editor: Mariëlle van der Goen, Hilversum
Photography: Gerhard Witteveen Fotografie,
Apeldoorn and Sjors van der Meer, Eefde
Cover and layout design: bij Barbara, Amsterdam

English Translation by Roselle de Jong, Vitataal.

ISBN: 978-1-78221-736-7

SUPPLIERS
If you have difficulty in obtaining any of the
materials and equipment mentioned in this book,
please visit the Search Press website for details of
suppliers: www.searchpress.com

For more information about VersHout:
www.vers-hout.nl

METRIC / IMPERIAL CONVERSIONS
The projects in this book have been made using
metric measurements, and the imperial
equivalents provided have been calculated
following standard conversion practices. The
imperial measurements are often rounded to
the nearest $1/16$in except in the rare circumstance
where precision is crucial, for example when
making tenons; here we have just used metric.

SJORS VAN DER MEER & JOB SUIJKER

THE FOREST WOODWORKER

A step-by-step guide to working with green wood

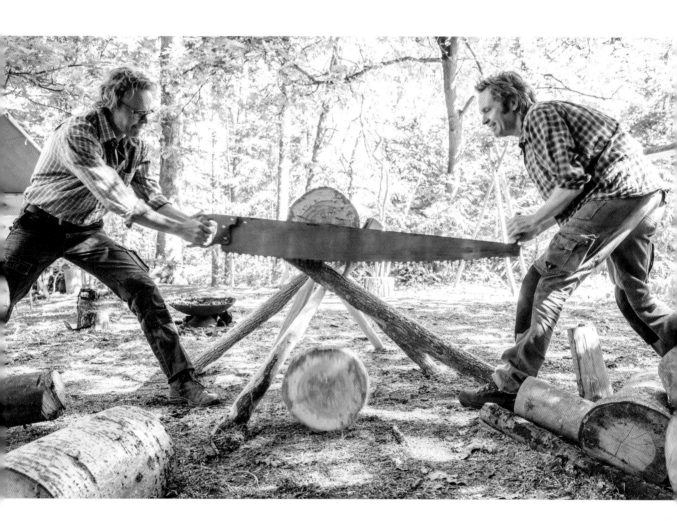

SEARCH PRESS

CONTENTS

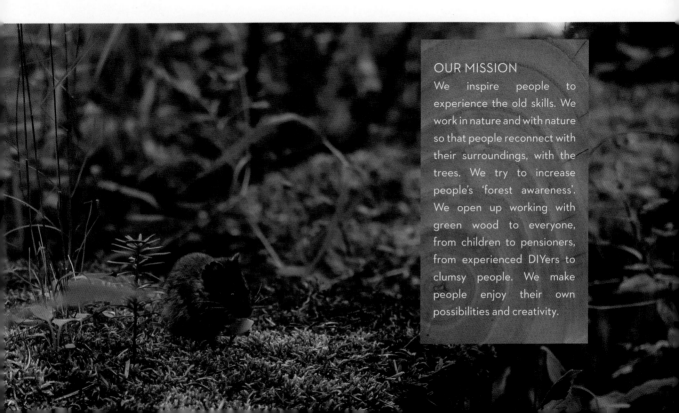

OUR MISSION
We inspire people to experience the old skills. We work in nature and with nature so that people reconnect with their surroundings, with the trees. We try to increase people's 'forest awareness'. We open up working with green wood to everyone, from children to pensioners, from experienced DIYers to clumsy people. We make people enjoy their own possibilities and creativity.

FOREWORD BY MIKE ABBOTT

For most of the 20th century, remarkably few books were written on the subject of green woodwork(ing) but as the 21st century progressed, green woodwork gained in popularity and new books appeared not only in the UK and the USA but also in Scandinavia, Japan and Germany. It made sense for somebody to write such a book to satisfy the interest that was blossoming in the Netherlands. In 2017 Sjors and Job duly wrote such a book and the following year I was asked by Search Press if I would be prepared to 'sense check' an English translation of their book.

I was immediately struck by the high quality of the numerous, atmospheric colour photographs. On reading the text, I loved the unbridled freshness and enthusiasm the authors obviously feel for their subject. This took me right back to my early days discovering the magical secrets that had been hidden out of sight by mainstream 20th century woodworking.

The authors have been practising their green woodworking skills for over a decade, and have made it their mission to 'reconnect people with nature'. Part of their mission has been to produce this book. As you turn each page you are reminded just 'how BEAUTIFUL it is out there'. This is what their book did for me with their simple, heart-felt sentences, such as 'Crafts are beautiful. The forest is beautiful. Crafting in the forest is beautiful times two'.

Sjors and Job have soaked up influences from Britain, the USA and Scandinavia and blended these with their own experiences in the Dutch forests. The result is an up-to-date, evangelical, almost spiritual companion that goes way beyond conveying a collection of technical information. 'Wood is like bread. If it gets old, it becomes hard and dry,' conveys more about green wood than a whole chapter describing cell structure, with its xylem and phloem.

While working on the translation from Dutch to English, there were long deliberations over words like 'cleaving', 'riving', 'splitting' and 'chopping'. There were issues over dimensions and their conversion from metric to feet and inches. There was nothing to be gained from ironing out every slight nuance, just as long as it could be understood by the reader (see the note on conversions on page 2). You will still be able to hear their Dutch accent as you read their words, and this serves to add charm to a book that will become a valuable and unique addition to the growing collection of literature on the subject.

FOREWORD BY OTTO KOEDIJK

Years ago, two boys from next door – about eight or nine years old – wandered into my workshop. They said hello and watched me curiously while I was wood turning. After a while I asked: 'What do you like best, owning things or doing things?' They were clear about that: doing things. Then I asked: 'But do you know someone who would rather own things than do things?' They thought about that for a while and concluded that there was one boy in their class who would rather own things.

Why would anyone spend a whole day carving a spoon that would cost next to nothing in a shop? My answer is simple: it enriches you! For humans, a big part of the brain is used for the fine motor skills. When you use your hands, you get to know yourself a bit better. When you carve a spoon, you learn about spatial orientation, hand-eye coordination and balance. Your right and left hand work together in unison. You get to know yourself and the world a bit better. And that is richness.

When you make your own spoon or knife, you can experience, in small part, what a human being in the Iron Age must have felt when he made a spoon or knife. Making your own spoon puts you in contact with the material and with your own environment. The wood in your hands might come from a maple tree from a public park. It is wonderfully versatile and special, and it will become something you can use every day. This way, you get to know yourself and your place in this world. If a shop-bought spoon breaks, you have to buy a new one. Once you have made your own spoon, you will know exactly how to do that again. Nowadays, people are starting to appreciate the intelligence of our hands once again More and more students apply for furniture-making colleges in the Netherlands. More people see the possibilities of wood. Working with fresh wood, known as green wood – which used to be very common – is getting more and more popular. Job and Sjors are enthusiastic ambassadors of this movement.

One of those boys next door has now enrolled at a furniture-making college. And I would heartily recommend that his old class mates – well, almost all of them – should attend a workshop with Job and Sjors.

INTRODUCTION

Something happens to people who are introduced to the craft of working with green wood. That 'something' is not easy to describe. It has to do with working with the pure material – wood – that, directly from the tree, with simple hand tools, gets transformed into something special and useful. Anyone can do that! The surprise that people feel about what their hands are capable of is part of 'what happens' when they start working with those hands. Beautiful, sharp tools; soft, green wood; a couple of hands that are eager to learn; open eyes – these are the ingredients for a small landslide in your mind. It is incredible how

'Wood is not hasty.'

Timo Salman

happy and surprised people are when they make a stool from a piece of fresh (or green) wood during one of our workshops. We tell them something about the craft and the wood and introduce them to basic tools like the drawknife, the hand axe and the wood-carving knife. They sit down on the shaving horse (a special kind of working bench) to make the legs, and it is hard to get them to come off. They take home an actual stool. An object you can buy anywhere for next to nothing. But not this stool! It is a piece that took them all day to make. Often, it is not even 'pretty' or perfect but it is definitely unique and completely homemade, and that is what it is about.

Working with green wood is done in the woods. Under the trees that have delivered the material for the projects. Of course, you can cut a spoon at home by the fire or make a chair in your back yard or on the balcony but it is best, literally and figuratively, to stay close to the trees. It is so earthly and at the same time almost spiritual: felling a tree and immediately making something great from its wood. Without modern techniques or electrical appliances. Outside, in nature, with others, working with wood and working with your hands.

For the last couple of years, the interest in old skills has been growing. There is a certain desire for the past, for simplicity and honesty. More and more people realize that this cheap hip coffee table with branches for legs is not necessarily sturdy or skilfully made, not to mention

← *Job Suijker* *Sjors van der Meer* →

durable – even though the table is trying to communicate all of this. Buy me! For next to nothing! Add something natural to your home! Often these tables are made in China, adding to the growing pile of garbage that we all produce.

We can change this and, as far as we are concerned, we have to change this. By working manually, we connect differently to what is in our hands and in our homes. We are restoring our relationship with these items!

The day will start differently when you eat your breakfast with a homemade spoon, from a homemade bowl while sitting on a chair you made from a log of green wood. In the best scenario you yourself have felled the tree where these items all came from. It is possible and actually very easy. But we have become awfully far removed from it.

In this book we will take you into the woods! We will introduce you to a number of trees and to the fantastic types of wood that these amazing organisms give us. For tens of thousands of years man has worked with wood. It seems that deciduous trees and the modern man have conquered the world more or less at the same time, so we have literally lived together, like brothers, since living memory. Trees and humans... Somewhere, deep inside, we remember this. This old tie may be the explanation for the magic that happens when humans and wood are reunited again. We invite people to (re)discover this old connection. This book will show you how to do that and what you need to experience the craft. Roy Underhill, a craftsman from the United States, did a TED talk that you can watch online. He tells us how he was invited to a TV programme about the present, past and future. Roy was asked to represent the past. A young man who worked with computers and internet represented the future. Roy did not agree with this. He wanted to join but only as a representative for the future. The modern computer industry, based on oil, gas, plastic and fibreglass, is the past. Craft! Handiwork! Pure materials! That is the future.

We get inspired by this kind of rebellious vision. As far as we are concerned, we need more stories that show us how we can do things differently – sustainably, on a small scale, with more fun! That way we reignite the craft and start to appreciate nature and our beautiful trees. And no, we do not have to chop them all down for the wood. There is an enormous supply that we can harvest in moderation, to save them from the chipboard and biomass industry, which is where the average tree in the Netherlands ends up. This is how we work on a new relationship between man and landscape.

Working with green wood is a tradition that goes back hundreds of years. This book is filled with techniques and tips that used to be commonly known. Every farmer and peasant knew what to do with their tools. Trees on a farm were used to supply the wood for tools, fences, sticks, bean stalks, and lots more. Timber-framed structures are also a great tradition. With this book we try to revive this. Because there are other ways.

We hope you enjoy reading this book but we also hope you like making the projects (and enjoy that unique little stool, even if it isn't perfect).

Sjors van der Meer & Job Suijker
Eefde, Zutphen

1. GREEN WOOD, AN INTRODUCTION

- GREEN WOOD, ABOUT MAKING A CHAIR AND CARVING A SPOON
- OLD TOOLS • TREES AND WOODS • SHAVING HORSE
- AXE, KNIFE, SPOON KNIFE… SPOONS!

GREEN WOOD, ABOUT MAKING A CHAIR AND CARVING A SPOON

Logs! Not pre-sawn boards or beams, but fresh round trunks. That is the green woodworker's base material. Preferably the wood is still 'captured' in the tree, which will get cut down to access it. Not thoughtlessly or taken for granted, but with respect for the tree and the woods where it grows. Then you start working with the newly harvested logs. That is the craft of the green woodworker.

This craftsmanship encompasses many very different traditional greenwood uses. A thin branch is enough to make a small spoon. (Carving a spoon from green wood is becoming a trend in the UK; and in the Netherlands more and larger spoon-carving workshops are being organized.) A spoon made of green wood is an example of a beautiful, almost minimalistic 'branch' of the craft.

As well as the spoon carvers, there are the chairmakers. Making a chair from a couple of 1m (39in) logs is a true work of art. All parts are 'cleft' from the green wood and cut to size on the spot. In the UK this is a tradition that goes back for centuries and it is still going strong. Up until way into the 19th century, the 'bodgers' supplied the cities with chairs. Back then it was hard work for little money, but nowadays a chair can be the crowning glory of one's hobby. Funny how things turn out.

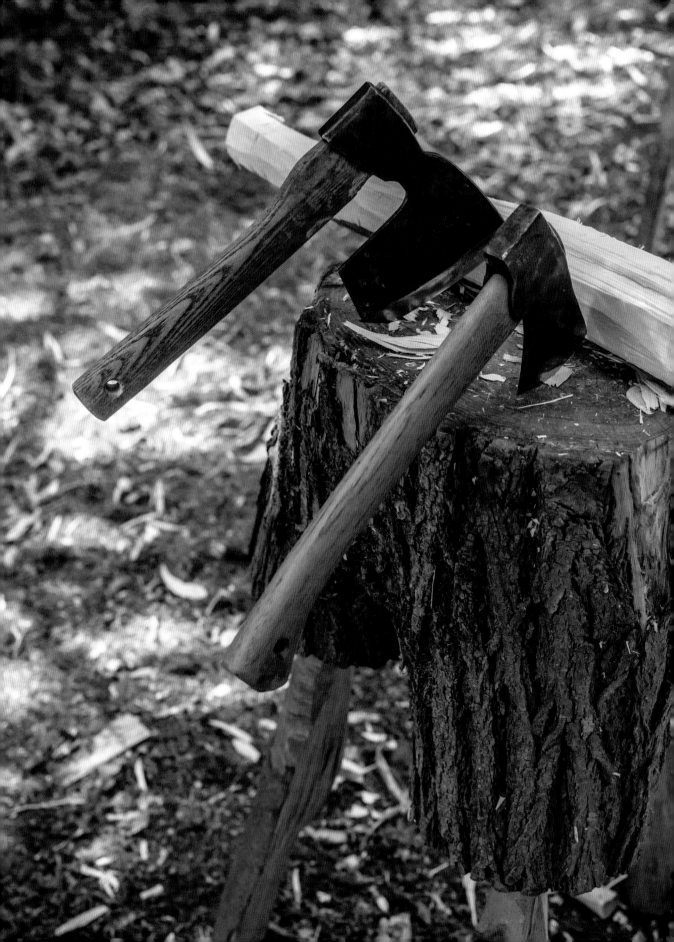

OLD TOOLS

As well as chairs and spoons, there are other traditional pieces to make from green wood. For centuries, green wood has been turned on feet-driven lathes to make bowls, chair legs and other 'round' items.

In the Netherlands, making wooden shoes is a great example of traditional greenwood craftsmanship and it deserves more attention! There are only a handful of people that can make clogs the traditional way. (Most wooden shoes nowadays are made by machines.) This book and our workshops are aimed mainly at making chairs, stools and other useful utensils, like the shaving horse. And we like to make spoons! All these beauties are made with hand tools only. There are no machines involved.

The axe, drawknife, bar-auger and froe are indispensable for a craftsman. Working with beautiful, sharp tools is a joy. The axe, for instance, is a great tool that can be used for more jobs than just chopping logs. For millennia, man has been carving wood with axes. A modern, handmade axe is a joy to work with. With the right technique and a sharp axe, you can cut the rough shape of a spoon or a couple of legs for a stool in a matter of minutes.

And then there is the knife! It is hard to imagine an older and simpler tool: a sharp piece of steel with a wooden handle. A good knife can work magic.

OUR HANDS' INTELLIGENCE

Do you ever make things yourself? I actually did not do it that often, until I discovered how important it is for your development.

Making things with your hands makes you smarter. That may sound strange, but it is true! It is a matter of balance. Especially nowadays it is important to develop your heart and hands, as well as your brain, and that can be a very pleasurable experience when you actually make something. It gives you satisfaction and confidence. Once you have found your craft, you can keep learning more for the rest of your life and perfect your skills. Your hands will learn the 'trade'... and before you know it, you have mastered it. We call it developing the hands' intelligence. It is something that makes you happy. Relaxed, care-free, focused. Completely in the here and now. Being where you are.

It is worrying how nowadays screens hinder this 'state of just being'. Both adults and children spend hours on them every day. It is like they are there but not actually there. Like self-appointed apostles we travel the country to convert people, to seduce them to do something and rediscover what their hands were originally meant for.

Of all the old, efficient tools that we use, the bar-auger has the most beautiful name. These drills were traditionally used for timber framing. In this book, we use them to drill holes for furniture legs. These drills are amazing! With just your hands you can drill holes up to 50mm (2in) in diameter. Apart from the axe and drill, we work with many other great tools with equally great names: adze, spokeshave, froe and brace, to name but a few. We will elaborate on them further on in this book.

These old tools were once almost only seen in museums but the greenwood movement is bringing them back to life. Old axes are restored, drawknives are given a new lease of life. There may be old tools in your (or your grandfathers') attic. Dust them off, restore them, and use them how they were meant to be used. Let them touch wood again.

TREES AND WOODS

Wood is a wonderful raw material. A tree is something concrete, growing from the earth. A truly raw material. Grown with solar power and water. A process that has been going on for thousands of years: the growing of trees. A wonderful fact and quite handy, when you work with wood on a daily basis.

The forest is the stage for greenwood crafts – at least, when it comes to making furniture and tools from green wood.

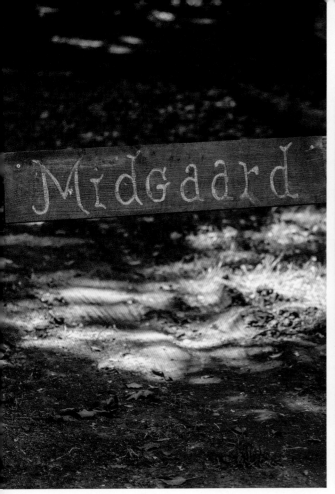

The 'dry-wood' furniture maker often has no idea where his wood comes from, just like the DIYer who buys his wood from a timber yard. The lumberjack often does not know where the wood of his trees ends up. The greenwood craftsman or craftswoman experiences the whole process. From tree (trunk) to the products that are made with it. Working in the woods, surrounded by the raw material, gives the craft its special character. Crafts are beautiful. The forest is beautiful. Crafting in the forest is beautiful times two.

It brings you closer to the trees, to the forest. It is, in a way, very intimate that you swing an axe into a living organism that you just separated from its roots. As soon as the tree falls, it is not a tree any more. It has become wood. From oxygen supply to raw material. It is quite a transformation.

It is rather special to experience this transformation together with other people. We honour trees and forests by turning the precious wood into beautiful, durable and sustainable pieces. In the Netherlands, the already limited number of forests are not in a great state. Oak and ash have suffered from fungi, insects and soil acidification. Too little attention is given to this issue. We have lost the connection with the trees with which we share this country. More care and attention is needed. Good management supplies good material for useful applications. Ecology and crafts are supposed to go hand in hand.

MIDGAARD AND FOREST AWARENESS

In the Netherlands there is an actual movement of people who choose to take a different route. There are many initiatives based upon living together, in harmony with our surroundings. Organic food is growing in popularity. The political group 'Party for the Animals' got five seats in the Dutch House of Representatives, and the supermarket chain Albert Heijn sells mini allotments.

Amid this growing world of sustainability, there is a little gem called Midgaard. It is an unofficial country estate in the east of the Netherlands (near Zutphen) where a number of green idealists have joined forces in order to reconnect people with nature. One of the foundation's ambitions is to get the term 'forest awareness' (*bosbenul*, in Dutch) into the dictionary. The problem is that there is no clear definition of the term yet.

What is clear is this: the greenwood movement is a manifestation of this forest awareness. The craft brings everything together: working in nature, with a small group of people. With VersHout, Midgaard offers a social crafts platform where people are invited to connect with each other, with their hands and in the end also with themselves. Who am I? What do I do all day? What can I do? How do I connect with the forest that surrounds me? These questions regularly pop up in our courses.

It is no surprise that slowly but surely companies too find their way to VersHout. In the end, they struggle with the same questions. One day of working together in the woods, under the supervision of a good coach, gives much more clarity about mission and vision than hours of strategy discussions (which are more effective if done while carving a piece of wood). Forest awareness tries to combine all of this. It unites people, nature and crafts to bring about insights, changes and improvement. Something changes when tools touch the green wood!

'Being a complete human being also means making your own utensils, and that contributes to self-confidence and that much needed connection with the Earth.'

SHAVING HORSE

Working with green wood is done on a shaving horse – the most important tool in greenwood craft. At markets and events, it always draws a lot of attention. Sometimes people ask if we came up with the shaving horse ourselves. Well...

Many a caveman will have cut green wood with a sharp stone. Probably they knew tricks to secure the wood firmly. In between a couple of stones? Or wedged in a half-split log? Perhaps they just sat on the wood while cutting it. Sitting, hmm... Sitting, wedging and working on the wood. Someone somewhere must have come up with an idea that led to the modern shaving horse. You sit on top, secure the wood firmly and then your hands are free to work on the wood. Great! How would the inventor of the first shaving horse feel about the fact that his simple invention still gets admired thousands of years later?

The simple brilliance of this old gripping device cannot be exaggerated. And what cannot be emphasized enough is the enormous joy it gives to work on it. Zen woodwork. The shaving horse's brilliance lies in the simplicity of its use. You do not have to be able to do anything really. You do not have to do anything consciously. It all goes automatically.

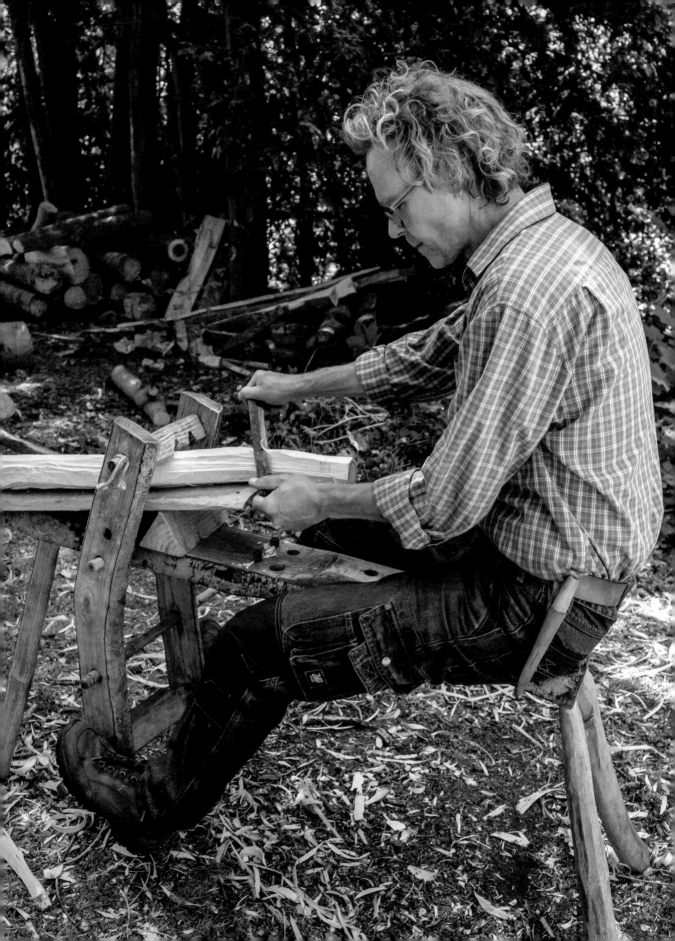

Your position when you sit on the shaving horse is ideal to cut the wood in the direction of the grain, which is very easy using a sharp drawknife. Without thinking, your feet push harder when you pull harder on the drawknife. Your body knows the way. Pull that knife!

We are talking about the 'basics' but there are also shaving-horse jobs for the more experienced. Although the basics are easy, it can be quite hard to actually make what you have in mind. Often you shave off too much wood or you get stuck in a nasty knot. Then it is all a bit less zen. Practise. Simply by using the shaving horse, you get a feel for it. Apart from the quick and rough jobs, you will find that you can also do fine and detailed work on it. To just take off that half a millimetre extra so that the tenon will fit.

A shaving horse is easy to make. It is great when people make their own. A shaving horse in every household would be amazing! Further on in this book we explain how to make one yourself (see page 82).

AXE, KNIFE, SPOON KNIFE… SPOONS!

A lot of work for chairs and other furniture is done on our shaving horse. All parts of a chair are cut to the right shape with a drawknife while you sit on this beautiful gripping tool. But if you want to make a chair from a tree, you will need a whole lot more tools. Drills, tenon cutters, drill moulds, measuring tools, a froe, a spokeshave, setting jigs, wedges, etc.

Then there is spoon carving. The tools that you need show the special simplicity of this craft: an axe, the straight wood-carving knife, and a spoon knife (hook knife). That is all you need. And this is exactly what makes carving spoons so accessible. You can do it almost anywhere and always. You could bring the tools with you on holiday.

As in the UK, spoon carving is getting more and more popular in the Netherlands: there is more interest, and more and more people are becoming enthusiastic spoon carvers. Who knows, in a couple of years' time, we might all be carving together on our commute to work, teaching each other the latest knife grips. It would be an improvement on the current atmosphere on the train!

THE RISE OF THE WOOD-CARVING KNIFE

In the early years of VersHout, we hardly ever used knives. We spent many a happy hour on the shaving horse and we made chairs, shaving horses and lots of great stools. In October 2014 we met Jan Harm ter Brugge, from Hout van Bomen. Jan Harm is a skilful spoon carver. Very skilful. We decided to organize a small wood festival, where several greenwood crafts could come together. And thanks to this, the knife found its way into our greenwood toolbox.

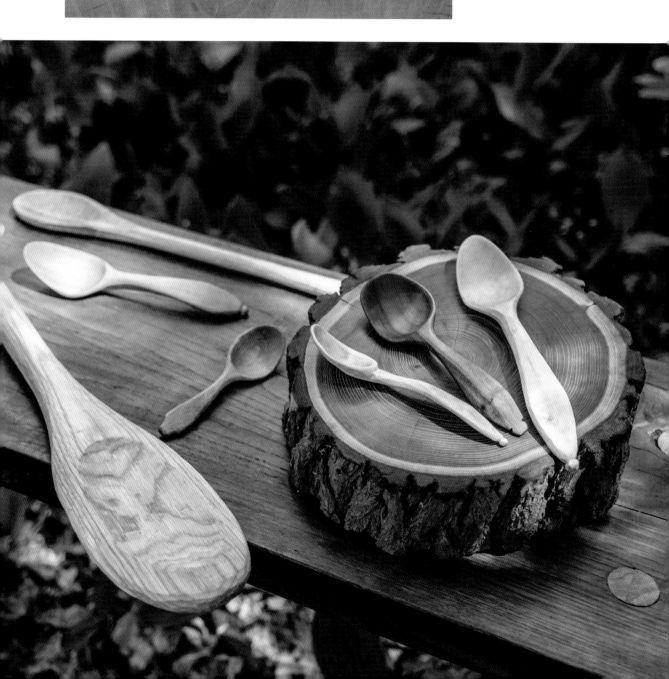

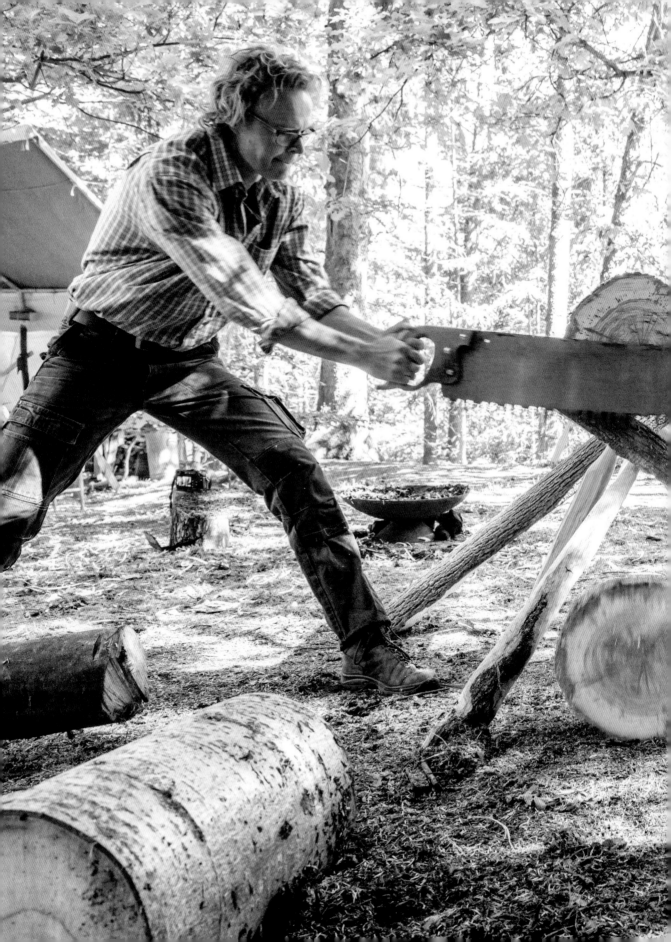

2. GREEN WOOD, BACKGROUND INFORMATION

- HANDMADE • THE MAGIC OF CLEAVING • MAKE IT FRESH, ASSEMBLE IT DRY
- THE MOST IMPORTANT WOOD JOINT: MORTISE AND TENON JOINT
- WHEN IS WOOD (STILL) GREEN? • A TREE INSIDE OUT
- FELLING A TREE • WHERE TO GET GREEN WOOD
- HOW TO KEEP GREEN WOOD GREEN

Working with green wood is a traditional craft: from harvesting a tree to oiling your chair or spoon, there is no machine or electrical plug in sight. In this chapter we talk about the craft's fundamentals and about that one special material: wood.

Green wood as a craft, or green woodworking, is a combination of several crafts that all use freshly harvested logs as a raw material. In the UK, this craft has been growing in popularity since the 1990s. Knowledge and experience have been passed down from older generations. In the UK, there is more interest in maintaining knowledge and experience; it is more appreciated. Green woodworking is still done on a professional basis. Mike Abbott, Ray Tabor and Ben Law are some of the leading men in this field.

In England, the following crafts are included in the green woodworking movement: making chairs, tools (handles), clogs, fences, charcoal, baskets and timber-frame structures. Apart from this UK tradition, we also follow the Scandinavian spoon-carving tradition. In the 1970s, the Swede Wille Sundqvist revived spoon carving and the techniques involved. In the last couple of years, spoon carving has been growing in popularity, especially in the UK.

HANDMADE

We use green wood in and from the forest. It is harvested at the scene or in the region, with a sharp axe and saw. Then, with simple techniques, it gets turned into a great chair, for example – without any glue, nails or screws but by using patience, endurance and beautiful tools.

Some jobs that are done by hand can compete with the speed of machines. Drilling holes with a 40mm (1^1/$_2$in) diameter can be tricky with an electric drill. The speed is too high and the force too big to drill a hole with exactly the right depth and angle. With an old-fashioned bar-auger you can drill holes and have complete control over angle and depth. Cleaving wood is also done by hand. With the right wood and the right technique, it can be done superfast. No saw can compete with that.

Apart from handiwork being 'fast', the way you connect with the material is different. You can actually feel the wood through the knife or drawknife so that you experience its qualities firsthand. No matter how great and handy Makita or Bosch are, they do not give the same feeling.

'Going forward to the early days – living backwards into the future.'

The Book of Merlyn, T.H. White

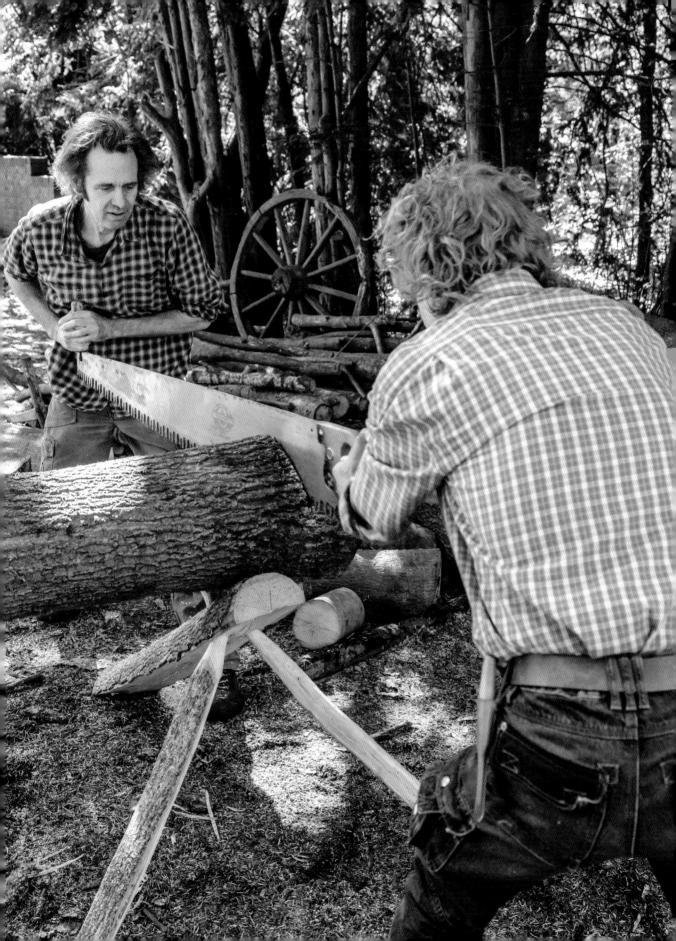

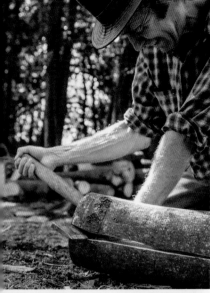

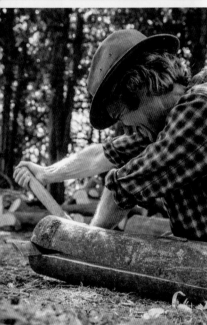

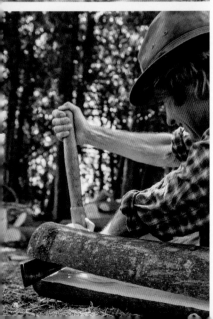

THE MAGIC OF CLEAVING

The art of cleaving wood is unique for the greenwood craft. With green wood this is an easy task – with dry wood it is much harder. Green wood generally cleaves easily lengthways, which means you do not need a saw.

Cleaving wood is a very clever technique for making the parts you need for your project (bench, stool, chair, rake, pitchfork, longbow, spoon). With a bit of practice, it can be a very precise and quick job. Besides, cleft wood gives a much stronger end product! By cleaving the wood you follow the grain and the wood fibres stay whole, while a saw goes straight through them.

Traditionally, no (round) branches are used in our segment of the craft – only cleft parts of big branches or logs. With an axe or drawknife, the heart gets removed from the cleft parts. This way, the wood is prevented from cracking or tearing. If you leave the 'heart' in the wood, it will dry and shrink unevenly and the wood will crack. With the heart removed, the wood will distort a little bit but the chance that it will crack or tear is minimal.

'Split a log and there I am.'

Gospel of Thomas (apocrypha)

A special tool is used for cleaving: the froe. With a firm blow you hit it into the endgrain of your log (straight through the heart), after which it is remarkably easy to divide the log into two equal parts. Further on in this book we will describe in detail how to use the froe (see page 55).

MAKE IT FRESH, ASSEMBLE IT DRY

People often ask us whether a piece of furniture made from green wood will last. After all, the wood still has to dry and will warp. A legitimate question, therefore. The answer lies in the fact that we make the furniture parts from green wood, but we do not assemble them yet. We put the parts together once they are all completely dry. If you fit a handle made from green wood in an axehead, it will give you a lot of trouble. This matter will be explained in the project descriptions. Having said that, we regularly construct simple furniture, like small tables or stools, from fresh or green wood. The result is quick and with some aftercare the product will last a long time.

FROM BAR-AUGER TO SPOKESHAVE

There are a couple of secrets to the greenwood crafts. First, there are the tools' unusual names. We already mentioned the shaving horse; other interesting names include the froe, the bar-auger, the holdfast, the spokeshave, the turner's pole lathe, and the tenon cutter. While learning to carve spoons we teach people how to make a 'swok', a highly mysterious project... And then there are all the secrets that are hidden in the green wood, which get revealed as soon as the freshly harvested log meets the froe.

THE MOST IMPORTANT WOOD JOINT: MORTISE AND TENON JOINT

A classic furniture maker uses straight, dry timber. He or she turns it into beautiful furniture with special wood joints like the Japanese dovetail joint, the finger joint, either hidden or not, wedged or with a mitre joint.

We only use one 'simple' wood joint: the mortise and tenon joint. A hole is drilled in the receiving piece of wood and a pin of the same diameter is made on the other piece of the joint. It is an easy joint that is used in almost every piece in this book. This is what makes green woodworking fun, both for beginners and for more experienced woodworkers. But while constructing even a relatively straightforward chair, you still have to make about 25 tight mortise and tenon joints. And make them even half a millimetre too big or too small, and your piece is ruined.

WHEN IS WOOD (STILL) GREEN?

Wood is green when it has just been felled and the tree sap is still there. Living trees contain a lot of moisture. How long a type of wood stays green varies. Oak, for instance, only dries 1cm (3/$_8$in) a year, while willow dries a lot quicker. It also depends on how thick the wood is and where it is stored. A whole oak trunk can take years to dry, depending on the diameter and whether the trunk is stored in or out of the sun. Ash is often dry after only one season.

When we talk about dry wood, we refer to wood you will find in DIY stores and at timber merchants: trees that were felled elsewhere and have dried (artificially). This wood gets cut into standard-sized timber and has a moisture content of about 15 per cent. This percentage will fluctuate as a consequence of the ever-changing moisture content of the environment. Wood keeps warping.

A TREE INSIDE OUT

It is easiest to work with wood if you understand it. In this chapter we describe the characteristics and peculiarities that you will experience while working with green wood. Characteristics depend on the type of tree and, even then, every tree is different, even if they do have a lot in common.

THE TREE

What makes wood so unique? To find out, we have to take a good look at a tree. A tree is a strong construction. Just look at that big tree outside your window. So many heavy branches with leaves attached to one single trunk. The trunk has to carry the weight of the branches and leaves, and keep it all balanced. It has to be strong enough to withstand a heavy storm. When we look at the tree, it seems to be connected to the earth at a relatively narrow point.

TREES ARE MIRACLES
A tree is more than its component parts. Everything is integrated: transport systems for water, minerals and sugars. A complete factory of leaves for converting sunlight into sugars, with which the tree can supply its own energy requirements. Besides, the tree produces offspring – it multiplies and renews. Under the ground, it collects minerals and water, and it collaborates with fungi and other trees. Is there any other raw material that can match this?

Invisible to us, there is an extended root system that anchors the tree and makes sure that the tree keeps upright under almost all circumstances. The extreme length:diameter ratio of a tree is remarkable. Trees and branches bend with storms and only snap when the wind gets too strong. These static and dynamic forces affect the inside of the tree.

THE STRENGTH OF WOOD

How does a tree absorb vertical and horizontal forces? And how does this show in the wood structure? Lengthways, a tree consists of fibre clusters that are 'glued' together like a bunch of straws. A single straw bends easily and therefore is not strong lengthways; a bundle of straws however is incredibly strong. These fibres have been bundled in a sheaf. This bundle makes a strong base for the tree and thus for the wood. So across the fibres, the wood is very strong and able to withstand heavy storms. Wood can carry a lot of weight without breaking. Lengthways more so than widthways. One could, for instance, put enormous pressure on a stool or chair without breaking its legs. Lengthways, wood can absorb a lot of pushing and pulling but it is remarkably easy to split these fibres apart. In greenwood craft, we use this 'weakness' when cleaving wood.

BRANCHES AND KNOTS

Apart from a trunk, a tree also has branches. They are, in a way, new trees that grow from the trunk at an angle. Branches normally start from the centre of the tree. They more or less obstruct the straight pattern of fibres in the trunk. This obstruction in the trunk is called a knot. Knots can provide a nice fibre pattern. When branches have been sawn off or died at an earlier stage, the tree can heal over the remains of the branch. With time, this wound will be barely visible, which means there will be a hidden knot.

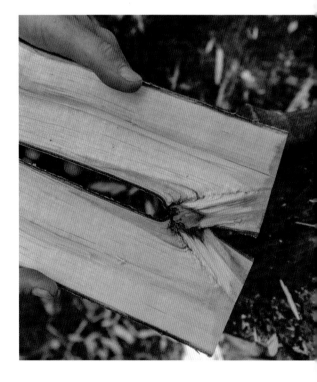

Knots in wood can be good and bad. In a hammerhead or a chopping block knots are very welcome and considerably prolong its life. They keep the wood together. A knot in a piece of wood that you want to shave or cut can be a challenge. A knot is a lot harder than the surrounding wood.

RESILIENCE/ELASTICITY

A tree and its branches need to be resilient in order to stand forces like wind. Without resilience, the tree would fall over or break. Almost all green wood is more or less elastic, depending on its diameter. Some types of wood, like ash or yew, are relatively elastic, even after drying. Therefore, ash is very well suited for tool handles and chairs and yew for making longbows.

TORSION/TWIST

A tree has another secret way to withstand strong winds: the ability to absorb force by twisting around its axis. This creates a distortion or twist in the wood. You can see this as a twist in the tree bark, but more often it becomes apparent only after the wood is cleft. The tree fibres are slightly twisted and, after cleaving, the wood is warped. The opposing ends of a log of 1m (39in) can be at as much as a 90-degree angle. This makes making a straight or smooth surface tricky, but causes no problems if you want to make a feature of them, such as by making a twisted chair leg. Every type of tree can contain a different amount of twist. Alder can have extreme twists; ash and oak much less so.

HARDNESS/SOFTNESS/DENSITY

Types of wood can be very different in hardness and density so you have to treat them differently. Oak can become rock-hard when dry, while lime (linden) wood will always stay soft. With green wood, however, the difference in hardness is less extreme. Even oak is easy to work with when green. Trusses are traditionally made with green oak.

Each type of wood has a different density and weight.

WOOD DENSITY* GRAMS PER CM³			
boxwood	1	birch	0.72
oak	0.8	ash and cherry	0.7
beech	0.8	alder	0.64
yew	0.8	hazel	0.62
maple	0.8	sweet chestnut	0.62
holly	0.76	lime (linden)	0.52
apple	0.75	willow	0.4

*From *The Encyclopedia of Green Woodworking*, Ray Tabor.

During drying, wood loses a lot of weight. Willow, for instance, keeps the same volume but gets really light, whereas oak stays heavy, even after drying. Because of these differences in wood, every type of wood has its own use.

The terms hardwood and softwood are sometimes confusing. These terms show the difference between deciduous trees and conifers. It is very well possible that a softwood (yew or douglas fir) is much harder than a hardwood (like willow). Wood is generally easier to work on the cleft side then it is on the end grain. Cleft wood follows the grain and fibre along the length of the timber. The cut goes almost parallel to the annual rings. Working with endgrain wood is harder. You have to cut through several annual rings and across the fibres. If you really want to saw along the grain you need a special saw: the ripsaw.

ANNUAL RINGS

A tree grows and makes new annual rings every year. In some trees this is clearer than in others. Every year a new ring forms around last year's ring. This way, the width of the tree increases. It does not grow in autumn and winter, in spring it has a growth spurt, and in summer it grows at a slower pace.

The very start of a tree, the yearling tree, stays in the centre of the trunk and is a relatively weak part. There is often a colour difference between spring and summer wood, which causes the characteristic annual rings. Oak, black locust and yew are trees with clear annual rings; a birch's annual rings are harder to distinguish.

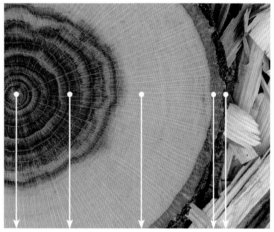

heart heartwood sapwood bast outer bark

The annual rings and the subsequent colour differences contribute to the unique character of wood. The pattern that appears depends on how the wood is cut or cleft. The heart of a tree is not always in the middle. Depending on surrounding trees, shade and sun, a tree can move its core. The hearts of heavy branches are usually not in the middle: the branch has to carry extra weight because it does not grow vertically but more horizontally. It compensates by producing extra wood under the branch, especially where it is connected to the trunk. Sweet chestnut trees sometimes have ring shakes: freshly cut sweet chestnuts can show splits in between the rings, as a consequence of tension in the tree trunk. This wood cannot be used for making shingles (see page 110).

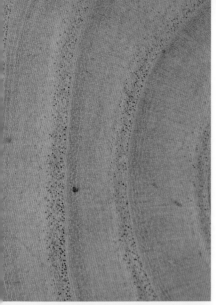

RING-POROUS, DIFFUSE-POROUS AND MEDULLARY RAYS

In spring, some trees create extra-big vessels to transport water and sugars. In summer, these vessels shrink again. This will create a ring of relatively large pores; we call this wood ring-porous. One example of this is oak, where the vessels can be seen with the naked eye. The wood is not suited for cutlery as the pores can get polluted with food.

Trees that divide their pores equally over spring and summer wood are called diffuse-porous. This happens with beech, maple and birch.

Medullary rays are thin, flat structures that grow from the centre outwards. Their function is food storage. In oak, these rays are clearly visible. Cleaving wood along these radial lines is very easy. In dry-wood furniture making, oak that has been cut exactly along these lines is very popular. It has a nice pattern, called figure or mirrors.

SPALTING FROM FUNGI

As soon as a tree is felled, the defence mechanism against fungi and insects stops working. Depending on the type of wood, where it is kept and the time of year, fungi and insects will grab their chance and will nestle especially in the sapwood. With some types of wood, this adds a nice pattern, for example with birch and beech. This effect is called spalting. You have to know when to stop this process because birch wood especially will start to decay fast.

SAPWOOD AND HEARTWOOD

Every year, a tree creates a new, sometimes visible, annual ring. Some trees show a clear difference between the wood from the last couple of years and wood that is older. Oak is a good example of this. Sapwood is relatively young and has a lighter colour. The older, darker wood is heartwood. In the heartwood, a tree stores oils, tannins and other substances, which give it a darker colour. These differences in colour create nice patterns.

After felling a tree, the younger, less solid wood decays quicker than the heartwood. It is also more prone to damage by insects (cossid millers). If you intend to use the wood for construction or outside, it is advisable to remove the sapwood. It is very well suited for making furniture though.

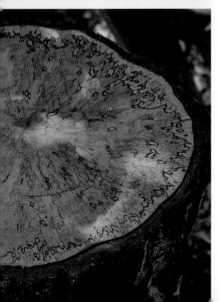

DRYING

When green wood loses its moisture, it will shrink. But wood does not shrink equally in all directions. This becomes apparent when you dry a disc of wood. After a while, cracks will appear from the centre and become wider on the outside. The wood along the outside of the wood shrinks more than the wood in the heart. Lengthways, in the direction of the fibres, wood shrinks less. For sawing and drying discs (thick slices of crosscut wood that have been cut across the stem) shrinking is a great challenge.

We often make stools from green wood with a seat made with such a disc. There are certain limitations, challenges and tricks to take into account while working with green wood. Further on in this book we tell you more about this.

NOTIFYING TREES

When we need wood for a workshop, we choose a tree. We notify the tree: we tell the tree, a living organism, that we want to fell it. This notification is an old woodcutter's tradition, comparable to farmers who used to notify their cattle before the slaughter. By notifying the cattle in advance, the animals appeared to be calmer on the day they had to go. Perhaps that way they could get used to the idea and make peace with it. For us it is a nice ritual that brings us closer to the tree and encourages us to take responsibility for turning the tree into something beautiful.

FELLING A TREE

Working with green wood means felling, chopping or sawing trees. The type of tree determines what you need or what tree is available. Felling a tree is a skill. And it is not without danger. Falling dead branches, a splitting tree trunk or an unexpected direction of falling may even be life threatening. There are books and courses available if you want to learn more about felling trees.

Felling trees is also an impressive job. With a sharp axe and/or a sharp saw you can fell a tree in no time. A big tree that is being felled is exciting. Slowly but surely it starts moving, until it falls on the ground with a big thud. It is surprisingly easy to fell such a tree, often weighing tons and measuring many more metres than yourself. After the relatively quick felling of the tree comes the big job: sawing off branches and dividing the tree into manageable pieces.

If you are in the woods and have the owner's (and the wood's) permission to harvest, it is wise to be critical about which tree to fell. Chopping. Or sawing. Chopping and sawing? You could write a whole book about felling trees. We would like to give you a few guidelines but please be advised that **this is not a manual for cutting down trees!**

SAFETY FIRST

Take care of yourself and your surroundings. If you have no experience whatsoever, then make sure you are in the company of someone experienced.

Look around you. Cut off branches that are in the way. Clear the area where you will work and make sure there is a safe way out.

WHICH WAY WILL A TREE FALL?

Take a good look at the tree. You do this by touching the trunk with your nose and then looking straight up. Walk around the tree this way. Only like this will you get a good impression of the tree's preferred direction and its branch structure. Take what you have learned into account when you start chopping.

Also look around the tree. Can it fall freely in any direction or are there other trees or buildings in the way? You need to prevent the tree falling onto a shed or against another tree, where it could get stuck. The last scenario can be dangerous because you will then have to chop the tree in a different, difficult way.

You can divert from the direction that the tree will fall to automatically, but only up to about 45 degrees both ways. This also depends on how strong the 'leaning' of the tree is.

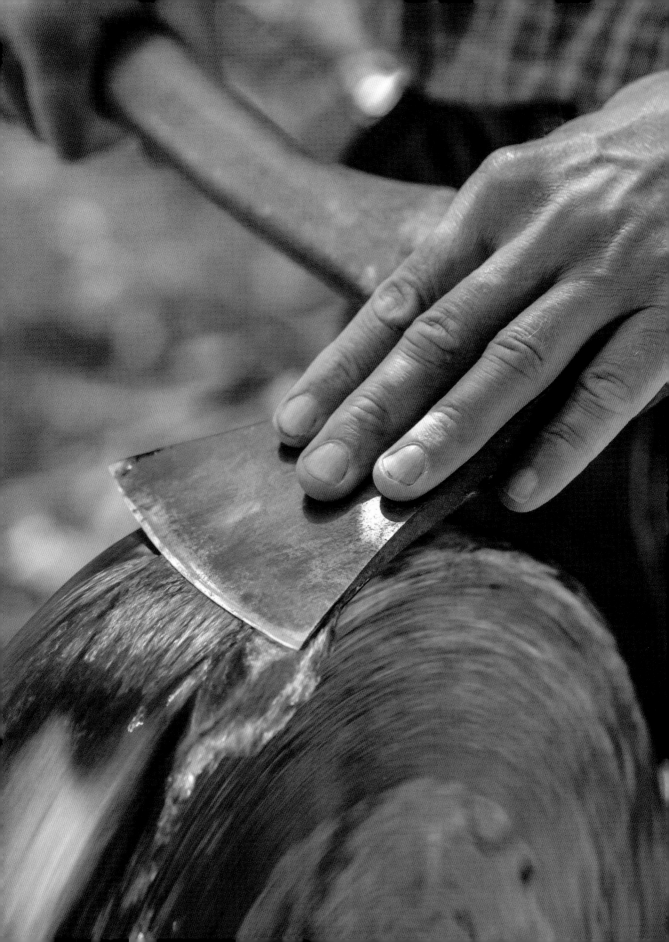

NOTCH CUT, FELLING CUT AND HINGE

Make a notch cut and a felling cut. The notch cut also determines the tree's falling direction, so you make this on the side where you want to tree to fall to. The cut is made by first horizontally sawing in the tree trunk up to about a third and then chopping away a nice wedge with a sharp axe. This wedge ensures there is no wood in the way when the tree falls. Then, on the other side of tree, you saw the horizontal felling cut, a couple of centimetres (an inch or so) above the notch cut. This way, you make a kind of hinge. When the tree falls, it turns over the hinge and you do not run the risk of it falling off the trunk backwards. By sawing the hinge broader or narrower you can still influence the direction of the fall while sawing.

You can keep sawing until the tree falls but you can also stop earlier and use wedges in the felling cut to influence the direction. Find a safe spot when the tree falls (see below). Never stand right behind the tree because sometimes big splinters can come loose and are launched out of the back. Personally we have never seen it happen but if it does, it may be fatal.

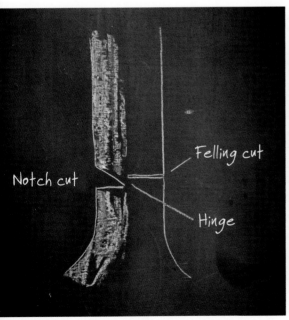

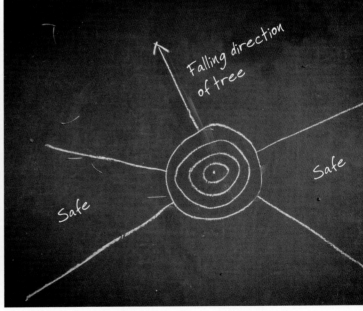

WHERE TO GET GREEN WOOD

You do not need a lot of green wood – a couple of logs or a branch is often enough. But you cannot buy green wood the way you buy timber at a DIY store or a timber yard. So where do you buy it?

That depends on where you live, and whether you live in the city or in the country. Surprisingly, there is a lot of wood available in cities: from gardens and public parks. A single telephone call to a tree surgeon or gardener can give you a supply, often for free or at a low price. You could also keep an eye on cutting permits in the local newspaper. The wood often just gets taken to the dump. If you live in the countryside or even in the woods, wood is more readily available. If the wood is on someone's property, you will have to ask their permission. Maybe you need to pay for it, but that is usually not more than what you would pay for cut, split hardwood logs. This means that it is much cheaper than buying wood at a DIY store.

You can also get in contact with nature conservationists. Sometimes there are people that maintain pollard willows or groups that manage coppices. The best scenario would be if you have your own piece of forest, where you can harvest wood in a sustainable way, but that is not for everyone.

HOW TO KEEP GREEN WOOD GREEN

Keeping green wood green can only be done up to a certain point, depending on the type of wood and diameter. Wood will lose its moisture mainly through the cut ends. So leave your green wood in as long sections as possible. Store the wood in the shade, and never in your home or a heated room. It helps to cut the wood in autumn and/or winter, when it is colder. Then the wood loses its moisture less quickly.

You can postpone the drying out by making the ends water tight. You can do this by using (diluted) wood glue, paint or sunflower oil. If the pieces of wood are small, for spoons for instance, you can keep them in a closed plastic bag (even in the freezer). If only the ends of your wood have dried (and have cracked), you can easily just cut off those pieces.

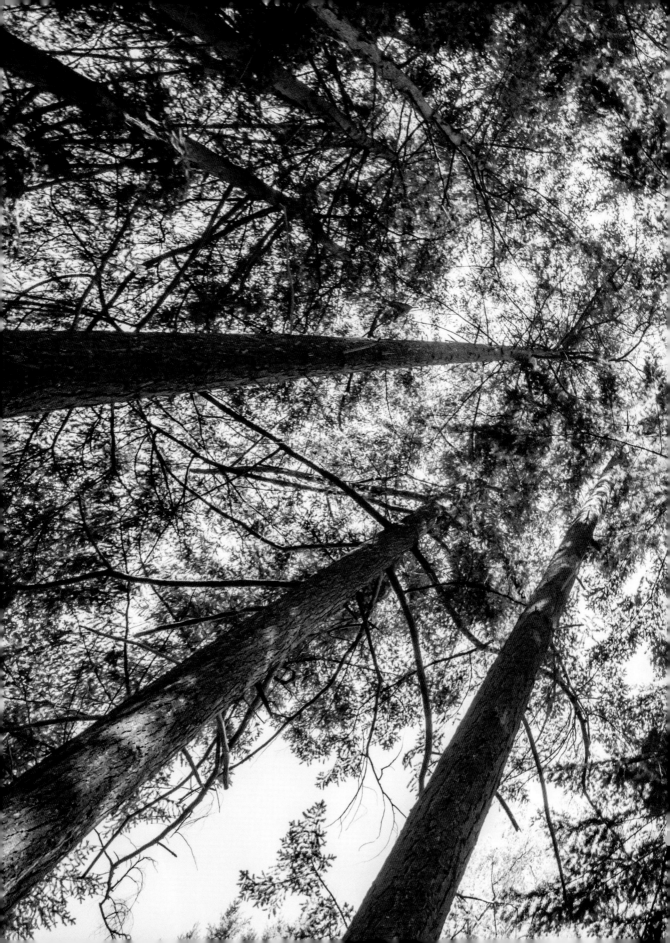

3.TREES, WOOD AND THEIR USE

• BIRCH • BEECH • OAK • NORTHERN RED OAK • ASH • MAPLE FAMILY
• BLACK LOCUST • HAZEL • SWEET CHESTNUT • WILLOW • YEW
• OTHER TREES • COPPICE: WOOD PROVIDING TREES

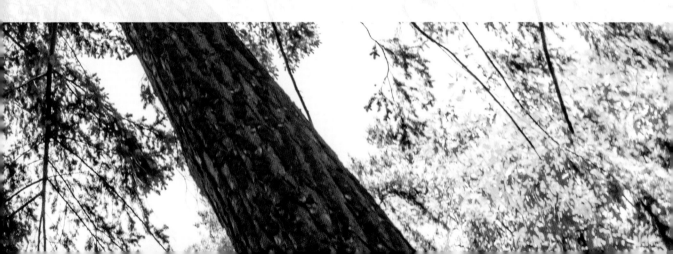

Certain types of wood have specific uses, following tradition or experience. In this chapter you will find characteristics for each type of tree and wood. Herbert L. Edlin's book *Know Your Broadleaves* provides a lot of information on many tree species. If you need a more precise identification, you can use determination guides.

BIRCH
Betula pendula, Betula pubescens

Features: birch (downy and silver) is one of the most beautiful indigenous trees. A striking appearance, with a smooth white bark that looks like a zebra in wintertime. When the birch grows older, the bark cracks and becomes rough and black (silver birch). The downy birch does not get very big but the silver birch can become quite tall. The birch has small, twig-like branches. The seeds are recognizable: small and light, with 'wings', they are spread in great numbers. The birch is a sort of pioneer: it is one of the first trees that will appear in areas where the soil has been disturbed, for instance after digging works.

Wood characteristics: birch is a fast-growing type of wood that hardens when dried. The wood is quite white, without a clear difference between sapwood and heartwood. The outer bark is watertight. If you leave a log of birch outside, the wood will quickly get mouldy and rotten. But before that happens, the wood can get a beautiful pattern because of the fungi, i.e. spalting. The structure of green birch wood is fibrous. You will notice this while drilling and carving.

Green wood use: birch can be used in many different ways. The wood is excellent for making small furniture, cooking utensils and spoons. The bark is used for pots, shoes, roof tiles and canoes. The outer bark is also excellent for starting fires, as it contains an oily substance.

BEECH

Fagus silvatica

Features: a beech tree can grow to monumental heights. A beech forest, with high trunks and mighty, closed crowns, is almost like a cathedral. Beeches will not allow other trees to grow near them. It is the last species in the ecological succession of trees. The leaves are rather small and oval, with a toothed edge. The branches reach far and are almost at a 90-degree angle from the trunk. The outer bark of a beech is and stays smooth, and there are no grooves lengthways. The fruit is the well-known beechnut, which used to be popular pig fodder.

Wood characteristics: beech wood is hard, heavy and has a dense and fine structure. The wood has recognizable small lines. There is no difference between sapwood and heartwood. Beech wood is not suitable for making garden furniture. The wood can be cleft and bent easily.

Green wood use: beech wood can be used for furniture but also for things like tool handles, wedges and hammerheads, and for kitchen utensils like spatulas, spoons and bowls. It is great firewood and makes good charcoal.

TREES ON THE MENU?

Seeds, flowers, fruit, leaves and sap can be edible. Why don't you try a rowan tree's young leaves? After a bit of chewing you get a lovely, somewhat bitter almondy taste. Young beech and lime (linden) tree leaves also taste delicious. Beechnuts, sweet chestnuts, hazelnuts and walnuts are great. Apples, pears and lots of other fruits are tree produce. And think about acacia honey, lime (linden) honey and maple syrup. And where would we be without olive oil? The great, slightly sweet (spring) sap from birches tastes refreshing and is used to make beer and wine. Or would you rather fancy a nice cup of lime (linden) tea or a glass of elderflower cordial? And there are so many more culinary uses...

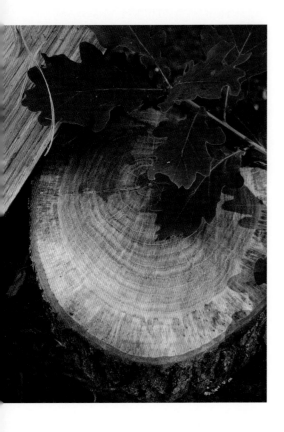

OAK

Quercus robur, Quercus petraea

Features: oak is an indigenous tree, recognizable because of its warping branches. The crown is big and lets the light through. With age, the oak gets an outer bark with deep grooves. The leaves are lobed, and the fruit is the well-known acorn. Oak trees grow slowly and can get very old. In the Netherlands and in the UK, traditionally there are two species: the common oak and the sessile oak. The acorns from the common oak (*Quercus robur*) grow on stalks; the acorns from the sessile oak (*Quercus petraea*) have no stalks and grow in small bunches. The leaves of this species, however, have clear stalks. Most of the oaks growing in the Netherlands are common oaks. The oak is known for the great number of organisms that live in and around the tree.

Wood characteristics: the difference between heartwood and sapwood is very clear in oak wood. The sapwood is lighter in colour, relatively fragile and prone to insect damage. Oak contains quite a lot of sapwood. The wood is ring-porous, and the pores can even be seen with the naked eye. The wood is brown, hard, strong and heavy. The annual rings are clearly visible. Until there were iron axes, oaks could not be felled, which is where the Latin *robur* (sturdy) comes from. Oak is a durable type of wood that can be used outside untreated. The wood contains a lot of tannic acid, which reacts with iron. Oak will turn blue when it touches metal. In the olden days, the tannic acid was extracted to use for tanning leather. Oak also contains medullary rays, which are visible when the wood gets sawn radially (see page 32). In timber, the rays create nice patterns. These are also visible with green wood because we usually cleave it radially too.

Green wood use: fresh oak wood is excellent for woodworking since it cleaves well. The tree is traditionally used for meadow fences, shingles and furniture. On traditional farms, the trusses are usually made of oak. Chopping blocks can be made with oak, especially when they have knots. Dried oak is good for making wedges. Oak also makes excellent firewood. It is not suitable for kitchen utensils because of the large pores (which make it unhygienic) and the tannic acid.

NORTHERN RED OAK

Quercus rubra

Features: the northern red oak is an impressive tree that has an outer bark that looks like a beech. Its leaves, like the common oak, are lobed but much bigger and with sharp, long points. This oak's bark is rather smooth and can easily be confused with that of a beech. The northern red oak was imported for its rapid growth and beautiful autumnal colours. Ecologically, the northern red oak is much less important than the indigenous oak.

Wood characteristics: the wood is heavy. There is a clear difference between the white sapwood and the heartwood, which has a red tone. The wood is ring-porous and contains tannic acid. Northern red oak cleaves easily when it is green and is easy to work with. The wood is not suitable for use outside, unlike that of its European cousin.

Green wood use: excellent to use for furniture. Like the common oak, it is not suitable for kitchen utensils.

CAN A TREE FLY?

A small seed contains an entire tree. In autumn, a seed wings through the air and slowly falls towards the ground. There goes a young birch, landing on the earth, not far from its parent. Months later, when winter is gone and spring is on its way, the birch embryo germinates. It sends a tiny root straight into the soil, so that it has a strong base and the first connection with the ground has been made. It absorbs the first nutrients from the soil. After that, it sends a first shoot up to the sky, defying gravity. Soon it unfolds its first leaves, and what will be the heart of the tree is starting to take shape. The tree protects its inner parts with a thin skin: its still-delicate outer bark. Under this outer bark is the bast that transports the collected nutrients. Later that year, more leaves will follow and even small side branches will grow. Then autumn comes and, for the first time, the young birch drops its leaves. Growth stops temporarily. In spring it starts again and creates a new ring. Later in life, it will create seeds that can germinate. So can a tree fly? For a very short period of its life: yes.

About four years ago we heard about it for the first time: ash dieback. We received mixed messages: perhaps it wasn't so bad, and next it turned out to be even worse than it sounded. Now we know the future really doesn't look great for the ash.

In the winter of 2017, we collected some ash trunks with a local forester. He had harvested a lot of ash wood and almost everything was heavily affected. Tragic. Ash dieback is caused by an exotic fungus. Until recently, we assumed that a tree would not succumb to the fungus but now it appears that is very well possible. In the UK there are many ash trees, and a great percentage of them will disappear. We notice that a lot of people have no idea that the trees around them are dying. In the UK, however, more people seem to be aware of the crisis.

The ash wood we collected carried a poignant reminder of this on its edge. We decided that we should use it to make some extra-special pieces.

ASH

Fraxinus excelsior

Features: the ash is a strong tree with a straight stem and steep branches. The crown lets the light through; the leaves are feathered. In winter, the black velvet buds are quite striking. With young trees, the outer bark is smooth and green. Later on, grooves appear and the colour changes to grey.

Wood characteristics: ash wood is mostly white but at a later age (forty years and older) the heart can be darker, called olive ash. There is no visible difference between the heartwood and the sapwood. Ash is ring-porous. It is a strong, elastic type of wood that can absorb shocks. It is not suitable for outside use. Green ash cleaves and cuts easily if there are no knots.

Green wood use: ash is traditionally used for tool handles and wooden clubs because it is strong and shockproof. It is also excellent for furniture, especially chairs. It is a great wood for longbows.

 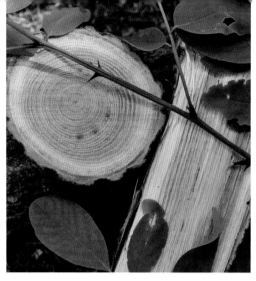

MAPLE FAMILY

Features: there are several different trees in the Maple family. In Europe, the most common maples are the sycamore (*Acer pseudoplatanus*), the Norway maple (*Acer platanoides*), and the field maple (*Acer campestre*). The common features in most maples are the 'helicopter' seeds and five-lobed leaves, which turn an attractive red or yellow colour in the autumn.

Wood characteristics: maple wood is nice and light in colour and has a silver shine. There is no sapwood. The wood looks like ash but has a finer structure. It is hard and suitable for making furniture and kitchen utensils (spatulas and spoons) because the wood will not absorb or give off odours. Not suitable for outside use.

Green wood use: suitable for utensils like spatulas and spoons, and also for furniture.

BLACK LOCUST
Robinia pseudoacacia

Features: black locust, sometimes called acacia, is striking because of its deeply grooved and twisted bark. The crown is open and light and the leaves are feathered. The tree originates from the east of the US where it has been growing since the 17th century. The tree is part of the *fabaceae* family and fixes nitrogen in its roots.

Wood characteristics: wood from the black locust is hard and grows relatively fast. The (small amount of) sapwood is yellow, while the heartwood is darker in colour. There are clear annual rings. The wood contains tannic acid, just like oak, and it has a bitter smell after it has been cut. It is easy to cleave and very strong. It is excellent wood to use outside.

Green wood use: suitable for furniture and excellent for tool handles, for building and for pasture posts.

HAZEL

Corylus avellana

Features: the hazel generally is a bush-like tree with many stems that can grow very fast. It often gets cut down low and then grows up to 1.5m (5ft) a year. The leaves are somewhat egg-shaped, the bark is rather smooth. The fruit it produces is the hazelnut.

Wood characteristics: hazel wood is soft, flexible and very tough. It is white and turns red after cleaving. Hazel trees are usually harvested by coppicing: that is, cutting stems back to the base to encourage the regrowth of new, straight rods (see also page 51).

Green wood use: hazel is ideal material for woven fences. Hazel rods have been used for ages in walls made of wattle and daub. Hazel wood is suitable for beanpoles and ideal for walking sticks. Because of its manageable size and the softness of the wood, it is great for children to work with. They can make small bows or wooden knives. It is also good for making charcoal.

SWEET CHESTNUT
Castanea sativa

Features: the long, thin leaves with serrated edges are distinct. The bark has spiral grooves. The edible fruit, sweet chestnuts, are wrapped in a prickly pod. The trees have been growing in the Netherlands, especially in the south, since Roman times. It was also introduced to the UK by the Romans. There is no connection with the horse chestnut.

Wood characteristics: sweet chestnut is a durable hardwood, ideal for outside use. There is not a lot of sapwood. Sweet chestnut is very well manageable as coppice and it cleaves easily.

Green wood use: in the UK and France, sweet chestnut is traditionally used for making fences and wooden shingles.

WILLOW
Salix alba

Features: the pollard willow can be found in a typically Dutch polder landscape. There are many willow varieties, white willow being one of them. This fast-growing tree has long, thin leaves; the bark on young trees is smooth and shows more grooves as it gets older. The wind spreads its fluffy seeds.

Wood characteristics: willow wood is soft and white. It is tough and flexible and is easy to cut. The wood is not strong and therefore not suitable for furniture. The flexible willow wicker, on the other hand, is excellent for weaving. Several willow types have been especially cultivated for this use: the basket willow and the golden willow. Willow wood is used a lot outside but is not very durable.

Green wood use: willow wood is great practice material if you want to learn to carve spoons. It can be used for legs for small furniture if they do not have to carry much weight. Willow wicker is used for weaving baskets and garden fences. It is also used for bean poles in the vegetable patch. Willow wood and poplar wood are very good for making clogs.

YEW
Taxus baccata

Features: the yew is a relatively low conifer with striking red berries. In the Netherlands it is often used as a low hedge. The yew is an indigenous tree, and there are still some original trees in the east of the country, around Winterswijk. The needles, wood and seeds are lethally poisonous although the pulp of the seeds is not poisonous. Yew trees can have incredibly long lifespans.

Wood characteristics: yew wood is unique. It is tough, strong, durable and elastic. The sapwood is light in colour while the heartwood is reddish. This makes for great colour combinations. If you carve yew wood, a shiny surface appears. Yews grow very slowly and are not planted on a large scale; therefore the wood is not often available.

Green wood use: yew wood is used to make the traditional English longbow. The beautiful wood can be used for turning and carving. It is used for the handles of small tools.

OTHER TREES

There are, of course, more great, useful types of green wood like cherry, alder, apple, pear and walnut. These are beautiful types of wood to use for carving spoons and other cutlery. They often have pretty colours. Apart from cherry, these types grow slowly and are therefore quite hard. We cannot possibly discuss all types of wood and that is why we have chosen to omit a number of trees, such as the conifer.

COMBING FOR WOOD

If your hands get itchy you can keep them busy with woodwork but it is not always easy to find wood. Here are a few tips.

- Ask and comb! In winter, a lot of gardening and pruning takes place and there will be many stems and branches available. Ask pruners if you can have some of their wood. Many local prunings have provided us with wood for spoons. We call it 'combing for wood'. Try to save some before it gets thrown into the shredder.
- Always read the local newspapers to stay informed on cutting permits.
- Get friendly with park keepers in your area and with gardeners from landscape management. Tell them about your greenwood crafts, show them your enthusiasm and ask if they want to help to save this great craft from extinction.
- Companies that do landscape management often have wood available. Contact them.
- We once tracked down the owner of a nice piece of ash forest and asked him if we could harvest some wood. No problem. Wood in abundance.
- Cry from the heart: we have to try to get to a point where it is considered normal to supply wood to the local craftsmen. The wood is actually there! All the local council has to do is to organize it properly.

COPPICE: WOOD PROVIDING TREES

Many of our trees were managed as coppice in earlier days. That means that these trees would be cut back to the base at regular intervals (around five to seven years for hazel to much longer cycles for sweet chestnut), so that many new stems would grow back again. The advantage of coppicing is that it supplies a lot of young wood that grows straight up as it grows close together. Because the roots and the food supply stay intact, the young coppice grows very fast. Oaks used to be coppiced every ten to fifteen years.

Many farmers used to have a small piece of forest where the trees supplied wood for general products that were needed on the farm: ash wood for tool handles, or oak for fires and for building. In horticultural areas the coppiced ash provided bean stalks. The wooded bank where the coppice grew provided even more: as well as providing food for humans and cattle, the sharp thorns of the hawthorn and sloe and other prickly bushes made sure the cattle could not escape. This made them early ecological zones. The invention of barbed wire has contributed to the loss of the wooded banks.

Willow, oak and ash were commercially used as coppice, and outside the Netherlands the sweet chestnut was as well. Willows for coppice were grown in osier beds. A lot of willow wood was used for building dikes and weaving baskets. Many species and types were especially grown for this purpose. Oak coppice was grown for its bark, called tanbark. It contained a lot of tannic acid, which was used to tan leather. This coppice culture came to an end when chemical acids took over.

If you want to work with green wood in a sustainable way, it is worth growing your own coppice. In this book, this topic will not be discussed in further detail, but you'll find plenty of information elsewhere.

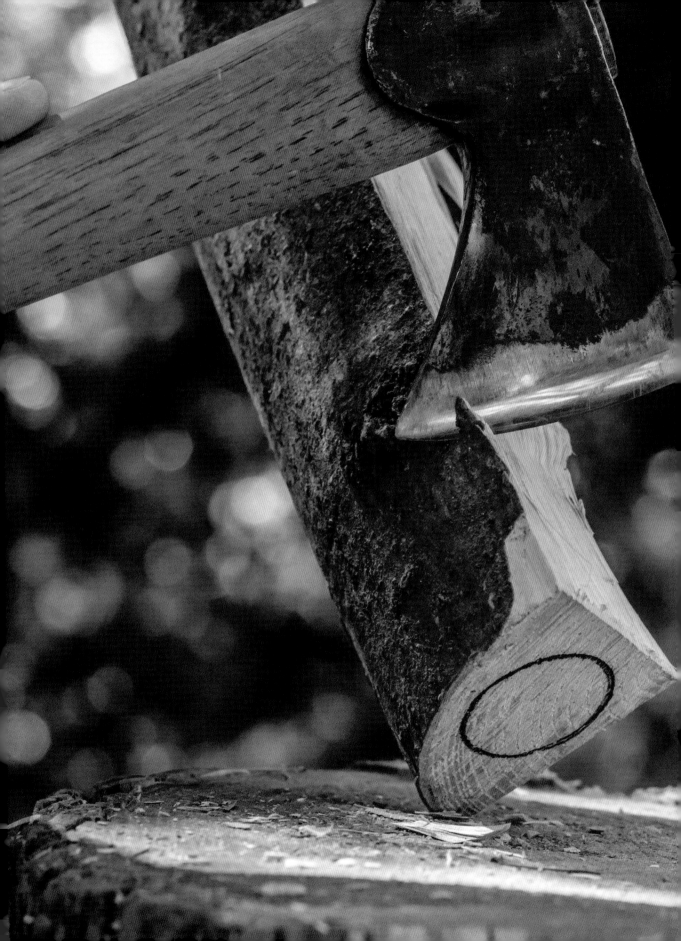

4.GREENWOOD TECHNIQUES

• CLEAVING • USING AN AXE • SAWING DISCS

• MORTISE AND TENON JOINTS FOR A CHAIR OR STOOL WITH RUNGS

• DIFFERENT TECHNIQUES • MAKING A TENON ON A LEG

• WEDGING A JOINT • DRYING LEGS, RUNGS AND TENONS

• MAKING YOUR PIECE LEVEL • WOOD-CARVING KNIFE GRIPS

• GRIPS FOR THE SPOON KNIFE

A number of greenwood techniques keep coming back. Sometimes these are exclusively for the greenwood craft, sometimes they are more general. In the projects further on in this book we will refer back to these techniques. Pay attention to these.

TECHNIQUE 1: CLEAVING

We 'split' logs to produce firewood. 'Cleaving' and 'riving' are both words that describe a greater degree of precision to influence the direction in which the wood splits. For many greenwood projects we will need to cleave wood. Legs for stools, tables and chairs are all cleft. Boards are cleft to provide shingles. Logs are cleft for the seat of a shaving horse. And long thin twigs, like those of the hazel tree, are cleft for making fences. How should you go about this?

THE RIGHT WOOD

When working with green wood, we start with a log. This is the most important step: getting and selecting the right kind of wood. Not all types of wood are suitable, and not all wood of the right type is suitable to work with. Look for flawless wood. Straight fibres, no knots, with a nice central heart. A diameter of 25–30cm (10–12in) is ideal.

Every type of wood cleaves differently. Sweet chestnut, black locust, oak, ash, beech, willow, birch, maple and alder will cleave very easily. The willingness of each individual piece of wood also depends on how green it is and whether or not there are any (hidden) knots. Knots (side branches) prevent a straight cleft and if these knots are big, they can even make cleaving impossible. Wood will cleave straight through smaller knots or it will cleave around it. Sometimes there will be hidden knots in wood. These are reminders of side branches that died off or were sawn off; new bark then covered the spot. From the outside the wood will look perfect but on the inside there will be surprises. This is what always makes cleaving wood a bit of an adventure.

THE SOUND OF A LOG CLEAVING
It always surprises us how easy it is to cleave a log. The ash stem in front of us measures 120 x 20cm (47$^1/_4$ x 8in) and looks perfect. No visible knots. We put the froe on one end and hit it firmly with a heavy club. It cracks the whole diameter, and a small crack appears on the side of the log. With some forceful hits, the crack along the side gets bigger and bigger. If we are quiet, we can hear the log giving in. A slow crack and then suddenly the log breaks open – and we have two halves. We are slightly surprised at how easy it was and we admire the inside of the white wood.

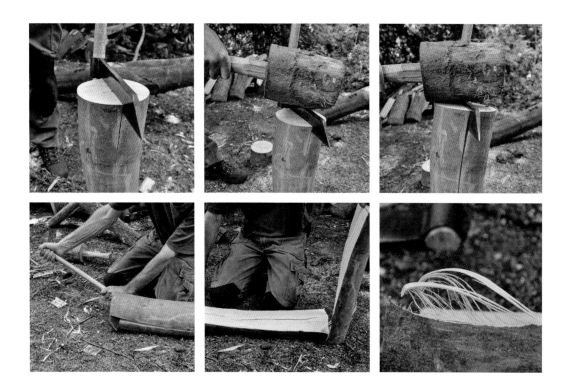

CLEAVING

Not many things are as fun as cleaving a nice fresh log. Start by looking at the crosscut side of the log. If this is very dirty or not straight, then saw off a thin slice. Look for the heart. If it isn't in the middle, turn the log so that you can draw a straight line with equal amounts of wood on both sides. Put your froe (or a cheap axe if you do not have a froe) exactly on this line. Hit it firmly with a big branch or club. You will see that the log cleaves a considerable length, although the cleft is probably not complete.

This is where the advantage of working with the froe shows: put the log down on the ground, froe and all, and use the handle of the froe as a lever to prise the log open. And there you go: your log is cleft! Now, for the first time, the wood is touched by the sunlight that built it. It is a magical moment that especially impresses children – and us too, of course. Now there are two halves. You can cleave these in fourths, eights and sixteenths and... see how far you can go!

If the cleaving is difficult or when you want to cleave a big long log, you could, in addition to the froe, also use an axe, wedges and a big wooden beetle or maul.

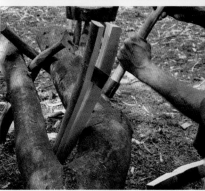

CLEAVING BRAKE

This is a tool that can help you do the more delicate cleaving jobs. You can build this tool with a couple of beams or solid branches or use a natural fork. You need a cleaving brake to direct your cleaving action. It is often impossible to cleave a whole log exactly through the middle. The cleft tends to go off-centre, making one of the halves useless. You can redirect the cleft by putting pressure on the bigger side of both halves, using the froe. This way, you force the wood in the right direction. It might take some practising but eventually the cleaving brake can save you a lot of wood.

RADIAL AND TANGENTIAL

We usually cleave the wood perpendicular to the annual rings – this is called radial cleaving. This is the first thing you do when you cleave. After you have cleft a log into four or eight, it is often wise to cleave along with the annual rings, i.e. tangential cleaving. This way, you will get a usable piece of wood from the part that would be too thin after cleaving or that would get removed with an axe or drawknife.

With tangential cleaving you have to decide where to put the froe. You have to use the golden ratio. We could write a whole chapter about this phenomenon but others have done this more elaborately and better. What it comes down to is this: measure the distance from the tip to the inside of the bark (see pictures). Multiply this by 0.62. The product is the distance – measured from the tip – where you have to put your froe. After a bit of practise you do not have to measure any more as it gets easier to determine the right cleaving point just by looking.

With these guidelines you can school yourself in the art of cleaving. Cleaving is the basis of this kind of woodwork. With the right wood you 'cleave your project together' (then just refine your piece on the shaving horse).

CHOPPING WOOD

If you have a wood burner at home, you know what it is like to chop wood. With a big swing your axe lands on a log, which then hopefully cleaves. Within the greenwood craft, the cleft is created in a much more controlled manner. You place the froe, wedge or axe exactly where you want the log to cleave and then hit it firmly with a wooden hammer, a club or wooden beetle or maul.

TECHNIQUE 2: USING AN AXE

The idea is simple! We will discuss the use of small hand axes. Like with all chores: let the tool do the job! This is especially true for working with an axe. Too often we see people using an axe in an unworthy way.

The effective use of the axe may just be too straightforward: lift the axe and drop it. That is all there is to it. You have to hold it, of course, so do not literally drop it. But you drop the hand that holds the axe in a relaxed manner. And your forearm is also very relaxed. Lift the axe, drop it. Straight down – not at an angle! You keep your wood at an angle while sending the axe straight down. Easy, right? (The reality is not always that easy!)

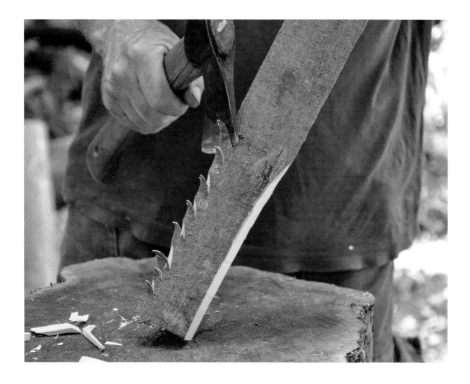

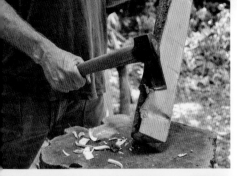
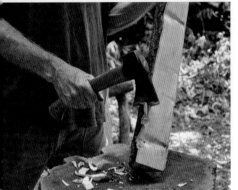
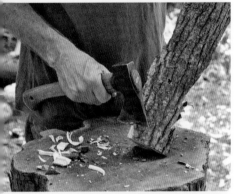
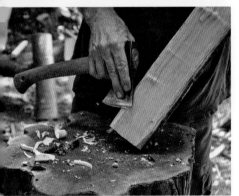
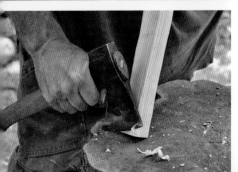

POSTURE

Stand firmly behind the chopping block. Place the leg at the side of the axe a bit further back. Put your wood on the chopping block, at the far end. This way the axe will hit the block and not your leg, should you miss a blow.

Do not chop too close to your other hand. If you need to chop a piece of wood lengthways, turn the wood halfway through the job and chop the other half. Use a chopping block that reaches up to your hip. Work from the bottom up and make a series of axe strokes in the wood, which you keep at a 45-degree angle to the chopping block. This way, you break the fibres of the wood.

Next, stand the wood slightly more upright and remove the broken fibres with one firm blow.

HOLDING THE AXE

Long grip: this grip gives a lot of power but little control. We rarely use it.

Midway grip: gives great control while still being forceful. The axes that we use are especially made for this grip. If you hold the axe midway, there is a nice balance.

Short grip: for more precise chopping. A lot of control but not much force. Use this for the finer chopping jobs, e.g. when you carve a spoon.

Carving grip: it is easy to use an axe for carving. Put one or two fingers on the blade of the axe and use the axe like a knife. You can do this with the chopping block as a support – or without the support, freehand. Nice if you want to make a piece using only an axe.

Guillotine grip: put the tip of your axe on the chopping block and use this as a pivot. Use the rest of the axe as a lever to push your cut through the wood.

← From top to bottom: long grip, midway grip, short grip, carving grip, and guillotine grip.

THUMB AND ELBOW

Try to move your thumb to the back of the handle while working with an axe. You can direct your blows much better this way. It is good to steer 'from the elbow' while chopping (especially if you want to do a precise job). Keep your elbow relaxed against your side while chopping. This way, you create extra stability. If you want to chop off only a small part of the wood, you can hit the chopping block next to the wood and then slowly, chop by chop, 'walk' closer the wood, until you hit it. Exactly where you wanted to hit it!

TILTING

You can also use the axe as a cleaving tool. Use this technique when you want to evenly lower a part of your piece (see description for making a spoon, page 140). With the classic 'chop and remove' as described earlier, you create a pointy or tapered piece of wood. Great for making a leg but not for a straight spoon handle.

Land your axe in the wood and leave it there. Then tilt it sideways by pushing the axe out using your wrist and forearm. This way, the wood cleaves straight down or even a bit outwards and you get the shape you want. Very useful.

TECHNIQUE 3: SAWING DISCS

This is an activity that gets great results with little effort. With a Japanese saw you saw thick discs straight across the trunk. This saw's super-smooth cut shows the 'soul' of the tree: a beautifully finished piece of wood that you could use as a stool seat or a small table top. Or you just put it on the wall. It is perfect already. If you do not have a Japanese saw, you can also use a greenwood saw. For a smooth surface, you will have to sand it down after drying. A bow saw will not give you a smooth disc as the blade is too thin and narrow. For more on saws, see chapter 9, page 155.

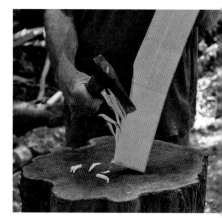

↑ *Tilting the axe sideways to cleave the log at the desired spot.*

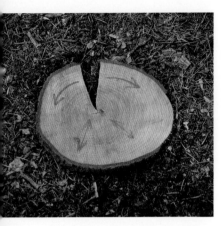

↑ *A crack caused by shrinkage while drying.*

A disc tends to crack when drying because the outer rings shrink more than the heart of the disc. You can prevent this from happening by taking the following into account:

- **The type of tree:** oak cracks easily, birch often does not crack, black locust does not crack so much.
- **Speed of drying:** do not put the freshly sawn disc close to the heater or in the sun! Drying the wood gradually in a cool spot is best. First a week in the basement, then under a cool lean-to, then in the boot room, etc. Thus the wood will slowly get used to your home. The more patient you are, the better the result.
- **The disc itself:** a disc without any knots or irregularities has got a much bigger chance of cracking than a disc with some knots. Knots cause irregular shrinkage, which keeps the wood together. Besides, they also look more interesting.
- **Using spalted birch:** birch that has been drying for a while is ideal for sawing discs and other uses. The wood is sensitive to a certain type of fungus. When this fungus is present in the drying wood it creates a special, attractive pattern in the wood – spalt. A nice extra is the fact that the wood will hardly warp afterwards. The sawn discs will not crack and they look beautiful.
- **Angling your cuts:** if you saw the disc at an angle it will be more oval in shape. It starts looking more like a 'board' and the wood will warp and crack less.

TECHNIQUE 4: MORTISE AND TENON JOINTS FOR A CHAIR OR STOOL WITH RUNGS

Japanese dovetails, finger joints, mitre joints – you will not find these in greenwood crafts. To connect two pieces of wood, we use round pins, 'tenons', that fit in round holes, 'mortices'. This sounds simple, and it is. But if you want your piece to last a hundred years, then you have to take into account a couple of important rules. Follow these rules and you will make super-strong mortise and tenon joints. Tenons have to fit the holes that receive them, preferably without glue.

GREEN BECOMES OLD

Wood is like bread. If it gets old, it becomes hard and dry. Because wood loses moisture while drying, its shape changes. It shrinks. And you have to take that into consideration.

The essence of working with green wood is that we make the parts of our pieces while the wood is fresh, but we do not assemble the piece until the wood has dried.

If we were to build a chair straight from the shaving horse, using green wood, it would not end well. The chair would fall apart because all the parts will have shrunk. Despite this, we do organize five-day courses where people start with a log of green oak or ash and end up with a chair. This is possible because we dry the wood artificially. When the rungs of a chair have been shaped, we put them by the fire, in the oven or in a special airing cupboard. Drying only takes a couple of days and sometimes just hours. Small parts can be dried quickly in an oven at 70°C (158°F).

MAKING TENONS ON THE SHAVING HORSE...

The wood has been cleft and the excess wood has been taken off with an axe. So now you can finish the tenon on the shaving horse. You have already decided what the diameter of the tenon should be; factor in a shrinkage of 10 to 15 per cent. This means that you use a template to draw the outline and finish the tenon neatly 1mm outside the line (for precision, we have removed the imperial conversions here). You can also use a template that is just a bit bigger than the diameter that you want to end up with: a template of 32mm is perfect if you want a tenon of 30mm. After drying, you finish the tenon until it is completely smooth (if needed). Then continue with technique 5.

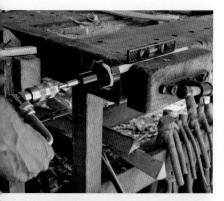

↑ ↑ *A tenon cutter.*
↑ *The result: a nice tenon.*

... OR USING A TENON CUTTER

Some great tools have been developed for this job. These are essentially enormous pencil sharpeners in different shapes and sizes that will make a nice tenon in no time. There are some that you use by hand and others that you can attach to your brace drill or even your electric drill. Within a couple of seconds, you can make the perfect tenon. The disadvantage is that it does not teach you anything – it is just time-saving. During the workshops we organize, we do not use any electrical appliances, but a tenon cutter in a brace works great in the woods and is very useful for some pieces (for an average chair you have to make at least twenty mortise and tenon joints).

... OR A KNIFE

Why not? If you master the knife techniques, it is easy to cut tenons with a knife. This is especially good for making smaller tenons. It is useful to prepare the work on the shaving horse, using the drawknife.

DIFFERENT TECHNIQUES

You have made and dried tenons, drilled holes, and now you have to assemble the parts. There are a couple of possibilities:

OVAL TENONS IN ROUND MORTICES

By wedging a tenon you force the tenon to become oval in shape: you make the tenon bigger or wider so that it sits tight in the round mortice. We usually work with parts of a log. We cleave these in parts and cut the tenons at the ends that will shrink irregularly in different directions. The wood shrinks much more parallel to the annual rings than perpendicular to the annual rings. As a consequence, a round tenon made of green wood dries up to an oval shape. Which is very useful! By forcing your oval tenon into a round hole, you get a very strong joint without having to use glue or wedges. This method is mainly used for chairs and stools with rungs.

IMPORTANT: the technique of oval tenons in round mortices works well. With hard, strong types of wood like ash or oak you can use very small diameters (for precision, we have removed the imperial conversions here): 15mm (dried) tenons in 14mm mortices. If you work with softer types of wood (birch), you will have to adapt the size of the tenons and mortices. With birch wood, you need tenons of e.g. 17mm (dried; tenon made with a 19mm tenon cutter) and 16mm holes. (We do not work a lot with softer wood types. We invite you to share your experiences with us!)

↑ *Left: a green, round tenon. Right: a dried, shrunken and tidied up tenon.*

EXAMPLE

For precision, we have removed the imperial conversions here. With the tenon cutter you make tenons of, say, 16mm. After drying, these measure around 14mm widthways and 15mm in height – they have become oval. Next, you drill 14mm holes. Hammer the tenons into the holes and you will see and feel that the joint is very strong. It is strong enough for a grown man to hang on (see right).

One condition for lasting joints is that the tenons are completely dry when you use them. The chair or stool legs (where the mortices will be) should be just a little moist. This way, the joint can only get stronger because the tenons will only 'swell' and the legs can only shrink (under normal circumstances in your home).

Make sure you put the tenons in the mortices at the right angle. The height of the tenon's oval always has to face the same direction as the leg in which the tenon will fit. Should you attach the tenon in a different direction, the leg may split. The same will happen if the leg is still too moist or if the tenon is still too big. In the latter case, you can easily adjust the tenon with a knife.

SQUARE TENONS IN ROUND MORTICES

First, you make square tenons using a drawknife on the shaving horse. A precise job. Then you cut the tenon into an octagon by cutting off the four corners. This way you get a not-so-smooth tenon but because the corners 'bite' into the mortice, you still get a very strong joint. It might take a bit longer but you do not have to buy an expensive tenon cutter and it is nice to craft them yourself.

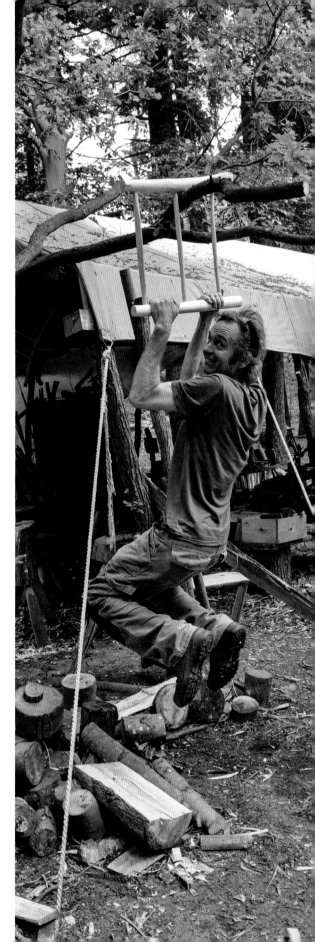

TECHNIQUE 5: MAKING A TENON ON A LEG

Stools, small tables, shaving horses... they all have legs. For a well-fitting joint between the surface that is carried by the legs and the legs themselves, it is necessary to make good round tenons on the legs. A nice job on the shaving horse.

CLEAVING YOUR LEG

Take your wood. Check for knots; if there are any, keep them on the bottom of the leg (they are hard to work with on the shaving horse).

↑ A drill template for a 38mm (1¹/₂in) drill (bar-auger).

WHICH DIAMETER?

Decide on the diameter of the leg's tenons. Keep in mind the 10 to 15 per cent shrinkage after drying.

For a tenon diameter of 30mm – quite common for a stool or small table – you use a 32mm template (see measuring tools on page 167). You can also outline using the drill or bar-auger. To do this, you turn your drill in the crosscut end of the wood for exactly one turn so that the desired diameter is outlined. Just stay on the outside of this line, by a couple of millimetres, when making the tenon. After drying, it is important that you do not end up with a tenon that is too small.

WORKING WITH AN AXE

First, get rid of any excess material by roughly chopping with an axe. Remember to make a nice tapering towards your final diameter: if you work towards your outline over too short a distance, you will end up with a tenon that is too short. That is a problem that is hard to correct on the shaving horse.

ON THE SHAVING HORSE

On the shaving horse, make the tenon nice and round and at the right length. For a nice and round tenon you have to keep turning the wood around. The length is determined by what you make. If it is a 'hidden tenon' (stool or small table) a length of about 4cm (1^1/$_2$in) will do (depending on how thick the receiving wood is).

DRYING AND FINISHING

Shape the leg and let it dry. When the tenon is completely dry, put it on the shaving horse again and finish it – if necessary – to exactly the right size. If, due to irregular shrinkage, the tenon has become oval, you can use this shape to firmly fix the tenon without the need for glue or wedges.

GREEN TENON AND MORTICE JOINT
When people book a one-day course with us, we assemble the stools (that is usually the project) that very day. Green, that is (see project 1: stool, page 102).

The sawn seat (for instance, a thick disc of birch) will probably not shrink as much as the legs, so after a while the legs will start to come loose. With technique 6 you can fix this problem and make a strong joint.

↑ *On the left, a tenon that is too thick; in the middle, a good one; on the right, one that is too tapered.*

↑ *Tenon almost of the right size.*

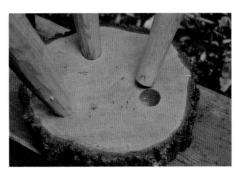
↑ *A good mortice and tenon joint on a stool.*

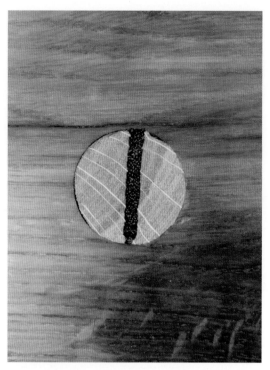

↑ *A wedged joint.*

TECHNIQUE 6: WEDGING A JOINT

To make a mortice and tenon joint on a stool, table or axe head even stronger, you can wedge the joint.

SAWING A WEDGE FROM DRY WOOD

Saw the wedge from a piece of dry oak wood. The shape has to be exactly right: if it is too sharp it will not work, if it is too dull it will do too much and will get pushed out by the force of the incision. Aim for an angle of about 10 degrees.

Saw the wedge in the direction of the grain so that you keep the fibres whole. This prevents your wedge from breaking when you hit it. We recommend applying a bit of glue to the wedge so that it stays put. (Differences in shrinkage between the tenon and the wedge can push the wedge out.) Put the wedge perpendicular to the grain of the receiving wood to prevent the wood from splitting.

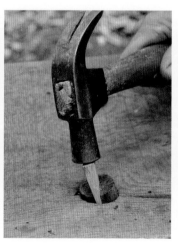

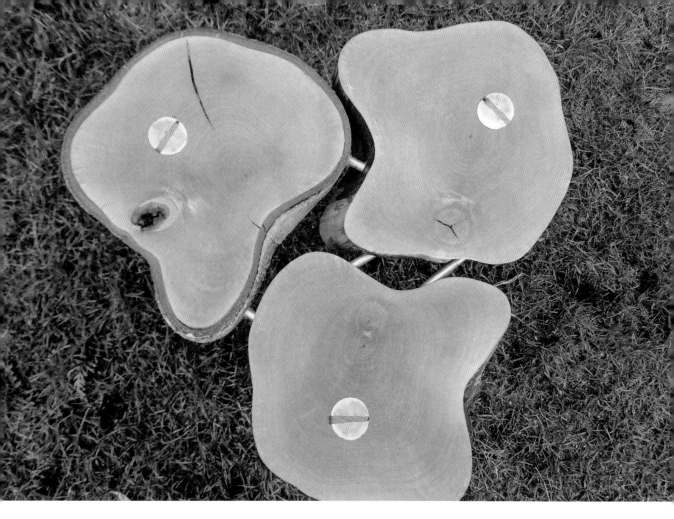

WEDGING A JOINT

To do this, make a sawcut in the tenon, about as deep as the tenon's width. This is where the wedge will be. With a through mortice and tenon joint, you simply hit the wedge into the incision after having stuck the tenon in the mortice. Hammer it until it is firmly stuck and then saw off the excess wood (the parts of the tenon and wedge that stick out). Do this by putting the saw flat on the wood, against the tenon that sticks out. Put your free hand on your work and slowly slide the saw under your fingers while putting light pressure on it. The joint is now nicely finished.

BLIND WEDGING

A hidden tenon (that does not go through the part with the mortice) can also be wedged. This is called blind wedging. The procedure is the same, but instead you hit the bottom of the part connected to the tenon. Before you do this, you loosely put the wedge in the incision. The wedge needs to be as long as the depth of the incision.

TECHNIQUE 7: DRYING LEGS, RUNGS AND TENONS

If you want to make furniture with green wood, you first make the parts, then dry them and only then assemble the piece (sometimes you can assemble a simple stool or small table with green wood).

With a chair and stool with rungs, the rule is that the tenon must be completely dry and the legs must still be a little moist. This means that you dry the rungs with the tenons in an oven, for example. With a temperature of about 65-70°C (149-158°F) this takes only a couple of hours. In winter, you can dry the rungs on the radiator or over the wood burner. We have also dried rungs in the sun, on top of a black plastic sheet that got really warm.

Because of the greenwood shrinkage, the tenons are made bigger than they should be. When making legs for a stool (tripod) or small table, take into account a shrinkage of 10 to 15 per cent. For 30mm tenons, we use an outline template of 32mm. Often the tenon is still too big after drying and has to be finished on the shaving horse.

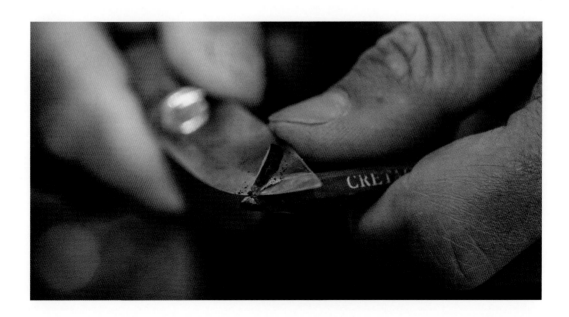

TECHNIQUE 8: MAKING YOUR PIECE LEVEL

When making your stool, chair or table, the legs will often be at an angle or do not all touch the floor. If your piece tilts or wobbles, you will need to saw the legs to make it level. To prevent you from sawing off too much so that the legs get smaller and smaller, we have a little trick. Follow these steps and your piece will be perfectly level.

- Put your piece on a flat surface: a table, the floor or workbench.
- Put thin pieces of wood under one or more legs until the top of your piece is level and the piece does not wobble any more. Check with a spirit level. You can also measure the distance between the top of your piece and several points on the flat surface. This tells you where the legs have to come up or down.
- Use tape to stick a pencil to a block of wood that is high enough to bring the pencil to a level where it can touch all the legs.
- Now draw a line around each leg while moving the block of wood across the flat surface. This line will run parallel to the surface and the top of your piece and this is where you will saw the legs.
- Saw off the ends of the legs, along the lines. The lines (or sawn ends) on the other legs will help you aim.

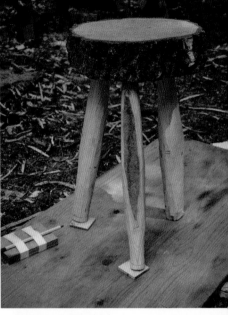

↑ ↑ *Make the top of your piece level with small bits of wood.*

↑ *Draw saw lines with a pencil stuck to a piece of wood.*

TECHNIQUE 9: WOOD-CARVING KNIFE GRIPS

WOOD-CARVING GRIPS: JUDO WITH KNIFE AND WOOD

If you want to turn a piece of green wood into a spoon, it is wise to practise a couple of basic grips. Please read the following instructions on how to use a wood-carving knife safely and efficiently.

SAFETY

Safety first! Beware of the razor-sharp tool in your hand. Pay attention to what you are doing. At any given moment, you should know where the knife would end up should it slip: that should always be in the wood or in the air. If you ever feel you are not working safely, stop what you are doing and look at the description of the grip you are using.

POSTURE IS EVERYTHING

The grips mainly put a strain on your shoulders, arms and elbows. Cutting movements from the wrist are not effective. With some of the grips we mention here, it is a great challenge to do nothing with your knife and hand, but use the rest of your body 'behind your hand' or 'supporting your hand'.

Do not try to cut off too much at once. Your knife will get stuck and you have to use excessive force.

Only cut small surfaces. If you want to work on a 2cm (³/₄in) wide strip, do not place your knife on the whole width on the wood. Instead, place your knife at a slight angle from the surface so that you cut broad corners instead of the entire surface. This way, the job will be easier.

↓ *Parts of the wood-carving knife.*

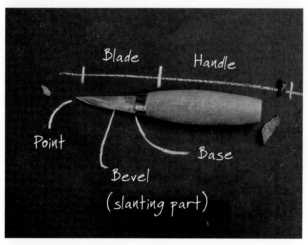

Use the length of the knife – slice instead of push. Imagine what would happen if you put the blade of a knife flat in your hand. You could even use some force without anything happening. But as soon as you move the knife just a millimetre to the front or back... you will cut yourself. The same goes for wood. Use your tools to your maximum advantage.

To start, choose soft, green wood. Birch or willow are ideal. The grips that we will show you will feel uncomfortable to start with. That is normal! By using them a lot, they will become familiar. You will discover that certain grips suit you better than others. Besides, we all have different hands. You will develop preferences and that is perfectly normal. But please do try all the grips! Later, when you have some experience, you will develop your own variations. Let us know!

FOREHAND GRIP

Hold your knife firmly. Cut away from you. Hold a firm fist. Keep the knife and the wood next to you, not in between your legs. Put the knife on the wood, with your arm stretched. Aim the point of the knife upwards a bit so that the knife 'slides off' the wood, as it were.

Keep your hand in a steady position (lock it) while pushing your arm down from the shoulder. Let the knife slide smoothly through the wood. Start cutting the wood on the base of the blade and end the cut with the point (so that you use the whole blade).

With this grip, the force comes from the shoulder when you move it up and down. You can keep your arm slightly bent, but also try the grip with an arm that is completely stiff, as if it were in plaster. This grip is very suitable when you need to remove a lot of wood, without the need for too much precision or control.

Variation: place the wood on a (low) chopping block in front of you. The block's support gives more force and control. A stable and fixed point often makes working more comfortable and safe.

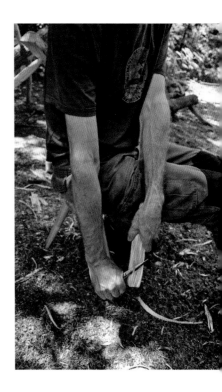

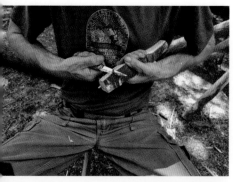

↑ Chest-lever grip.

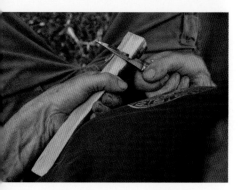

↑ Chest-lever grip.

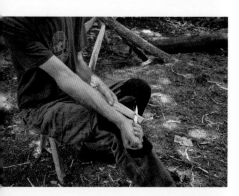

↑ Slicing grasp.

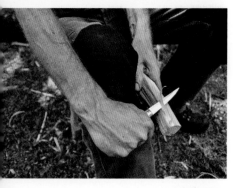

↑ Shin grip.

CHEST-LEVER GRIP

Hold the knife a little to the front, with the cutting edge away from you. Always start this grip by looking straight into the cutting edge, as it were. The wood is in your other hand and you cross it in front of you, high in the middle of your chest, with the knife on top. Your fists are resting on your chest, with your thumbs pointing away from you. By pushing your shoulders back and pushing your chest to the front, you can cut forcefully and with control. Note: the movement comes from the shoulders and chest and not from a movement of the hands. During this movement, both your hands stay in contact with your chest. If it does not work, change the position of the knife in your hand until you find that the angle is right. Just like the forehand grip, this is a forceful grip that you can use to quickly remove a lot of wood. There is more control but the cutting length is slightly shorter.

SLICING GRASP

Hold the knife with the cutting edge away from you. The tip of the blade points towards you (down). Put your forearm on your thigh, over the whole length, on the side where you hold the knife. Hold your hand and forearm with the wood on your thigh. The wood hand should be behind the knife. The point of the knife should point slightly towards you. Start the cut at the base of the blade. Push the knife forward, controlled and forcefully. While doing so, your knife makes an arch towards the outside, so that you use the entire length of the blade. Firmly pull the wood in the other hand. The force comes from your whole arm behind the knife. This grasp is forceful and cuts long lengths.

SHIN GRIP

Hold the knife firmly with the blade away from you. Put your knife hand with the area under the thumb in the hollow under the knee on the same side. Your knee will stop the movement. The movement does not come from the hand holding the knife, but from the hand holding the wood. Pull the wood forcefully along the knife. This is an efficient and quick way to remove material. Remember to use the whole knife, so pull the wood along the whole length of the blade. You might have to turn the knife slightly in your hand to get the right angle. See your knee and the hand behind it as a vice that secures the knife firmly and steady. You can also use other 'force grips'. There is not an awful lot of control but they are an efficient way to remove a lot of material.

PULL STROKE

Cutting towards you might seem scary but it can easily be done in a safe manner. Without this grip it can be hard to carve a good spoon. Take the wood between your thumb and index finger and hold it at the very end. Put the wood firmly against your chest. Hold the knife low in your hand, with the blade facing you. Put your thumb on the side of the blade, close to the handle. Keep your other hand away from the cutting direction. Hold your forearm firmly against your body and keep your elbow and wrist straight and stiff. Make sure that at any point you can stop the movement by controlling your forearm. Start cutting at the base of the blade and end with the point. With the thumb on your knife you can control the cutting angle: you can cut off thin, small curls or go a bit deeper, with a bigger cutting angle and more force. A great grip to refine and finish your piece.

Variation, reinforced pull stroke: If you hold the wood with thumb and index fingers, you have three fingers free. You can use these to help the hand holding the knife. Place your fingers behind the fingers of the hand holding the knife. This give you considerably more force and control. You do lose some cutting length.

THUMB PUSH OR THUMB PIVOT

By using the thumb of the hand holding the wood you can make fine and efficient cuts. There are roughly two variations: with the first one you push the knife forward with your thumb, and with the second you let the knife 'turn over your thumb', where your thumb works as a kind of lever or turning point. Hold the knife high in your hand, with the thumb on the back of the handle. Place your other thumb on the back of the knife. Cut the wood by using the force of your thumb and the control of the knife. You can push the knife forward with your thumb but you can also let the knife 'move over the thumb'. This way, you use a bigger part of the knife. You can change the position of your thumb. Some people put their thumbs on top of each other instead of on the knife. That is all good – just try and experiment. It is important that the knife does not slip; that is a real risk with this grip and it would mean you lose control. You can prevent this from happening by keeping your thumb in contact with the back of the knife. You have to imagine it is firmly stuck to it. This grip is very good to finish the ends of your piece, when you have to work against the grain. With a thumb push grip, you can also finish the convex back of a spoon.

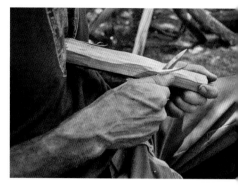

↑ *Pull stroke.*

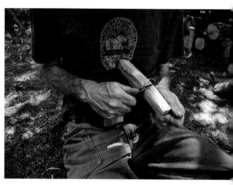

↑ *Pull stroke.*

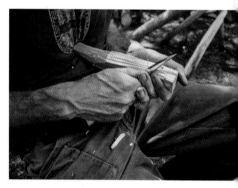

↑ *Reinforced pull stroke.*

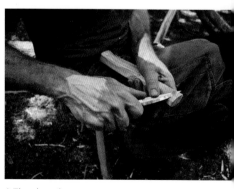

↑ *Thumb push.*

DRAW GRIP

This grip reminds us of peeling potatoes. You take your knife with the blade towards you at the very front of your hand, i.e. more with your fingers than with the palm of your hand. Place the thumb of your hand with the knife behind your piece and put the knife on the wood at the base of the blade. Keep your hand as wide and open as possible (without letting go of the knife). You cut by closing your fingers while letting the knife slide through the wood, until it reaches the point of the knife. For safety reasons, keep your elbow firmly against your body. Do not keep your thumb in the cutting direction of your knife. With lots of practice you can stop the cut wherever you want it, without slipping, by keeping your forearm firmly against your body and by controlling your fist. This grip is very good to finish off the ends of your piece.

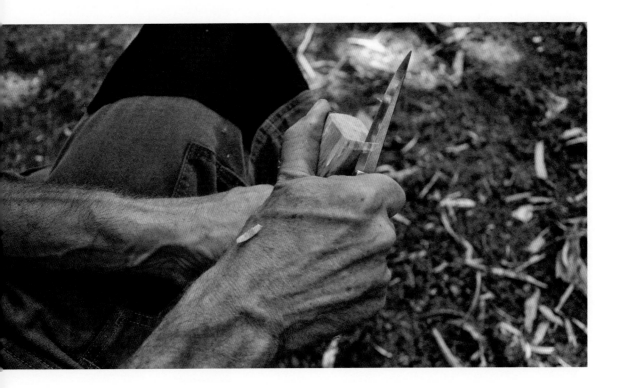

TECHNIQUE 10: GRIPS FOR THE SPOON KNIFE

The spoon knife, or spoon-carving knife, is used to carve the bowl of the spoon. Cutting with a curved carving knife is a bit harder than with a straight knife, so be careful! The knife will be very close to your hand. Follow the instructions carefully and there should not be a problem.

Do not use too much force and STOP if you are not sure if a movement is safe (everyone has got a built-in alarm mechanism, all you have to do is activate it). Let the knife do the work, so do not tug or push hard. Do not make deep cuts: this way, your knife will not get stuck in the wood and you do not have to use too much force, running the risk of a slipping knife. (If your knife gets stuck, get it out and put it in again, just in front of the slit you have just made. After cutting some of the wood off, you can go back to the cut you made when the knife got stuck.) In principle, you cut across the fibres or diagonally. This way, you will not pull out any fibres.

Start with the centre of the spoon's bowl and then work your way out. You need to work in a controlled and forceful way when cutting the bowl. The grips make sure there is a good 'end' to each cut. Start slowly by taking away very small pieces. Once you get more confidence, you can work quicker and firmer.

Spoon knives exist in different shapes and qualities (see tools, page 165). There are versions for right-handed and left-handed people and knives that are sharp on both sides. With single-sided spoon knives, you can use the fingers of your other hand for extra force and precision. Take a good look at the pictures on the next pages!

BASE GRIP

Firmly grip the wood at the handle, with the palm of your hand upwards. Put the thumb of your knife-hand against the wood. Take the front end of your knife loosely in your hand. Close your hand while pushing with your thumb and pulling with your fingers (like when you are peeling a potato). The hand holding the wood rests on your thigh. While carving, you turn the wood away from you slightly. This makes the cutting motion stronger. Put your elbow against your side for more control.

REINFORCED BASE GRIP

Hold the spoon knife a bit lower, so that there is more length to work with. Work the same way as described for the base grip, above, but use the free fingers of the hand holding the wood. Put these fingers on the blunt side (the back) of the knife. This helps you to cut with more force and control.

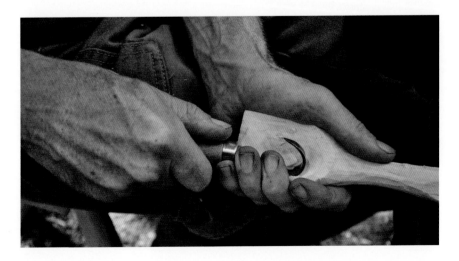

PUSH GRIP AND PULL GRIP

With these grips you can use a lot of power but there is little control. Use them for rough jobs or with bigger spoons. Hold your knife like a dagger, with the blade downwards. There are two ways to cut:

1. Push grip: hold your piece at the end, outside of your knife's reach. Rest the wood on your thigh. Your knife hand's elbow rests on your thigh or against your side. The sharp part of your knife is pointing away from you. Now push your wrist away from you while at the same time turning the wood along to the outside. Make sure there is nothing in the way of where the knife leaves the wood. The knife can slip easily with this grip.

2. Pull grip: similar to the push grip but you hold the knife with the sharp side facing you and with the handle sitting more in the front part of your hand. You cut by closing your fingers while turning the wood, this time towards you instead of away from you.

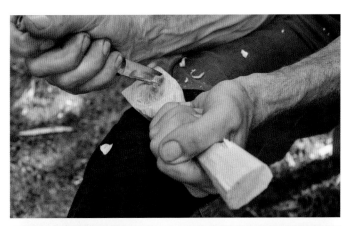

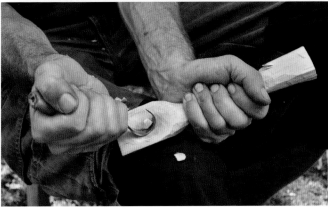

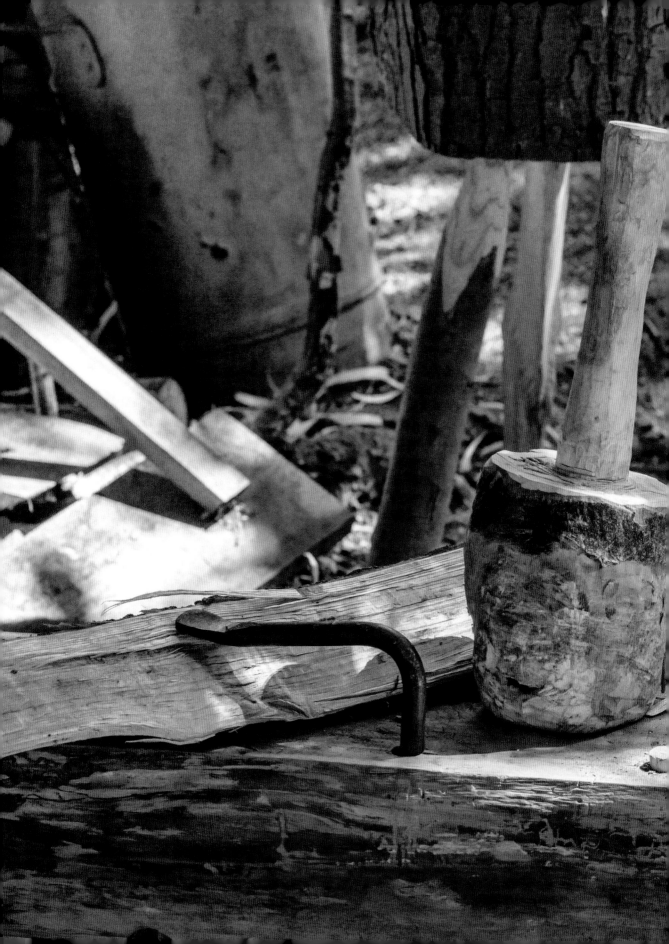

5. PROJECTS MADE WITH GREEN WOOD: TOOLS

Chairs, spoons, stools and shaving horses. Swords, longbows and magic wands. Hammers, clubs and axe handles. You can make all of these from green wood. It is useful and gives you energy and satisfaction (we cannot tell you often enough). And it is fun. These practical chapters are about making objects from green wood and they give you all the information you need to get started. It will be trial and error! Consider these errors as victories because they bring you closer to where you want to be. Our motto is: 'Your first piece will not be perfect, but your thousandth will be!' Nevertheless, good luck with your first.

HANDLING WOOD AND MEASUREMENTS

For all the projects in this book we indicate which type of wood is most suitable. In general, there will be several types of wood suitable for each project, each giving a totally different result; each has its own characteristics.

In general, oak (indigenous and northern red), black locust, beech, ash, maple, yew and sweet chestnut are considered (very) strong. Birch is reasonably strong, while willow is soft and less strong. Untreated indigenous oak, black locust and sweet chestnut can be used outside. Willow, birch and hazel are lighter types of wood; the other kinds are relatively heavy. If you need flexible and chip-proof wood, ash, black locust and yew are good options. Maple, birch and fruit trees are excellent for spoons or other kitchen utensils.

What it comes down to in the end is that you use whatever is available. It is good to look into the characteristics of wood. If you want to make a chair out of birch wood, this is not necessarily impossible but you will have to make tenon and mortice joints with bigger diameters. You could make one joint first and test its strength – by hanging – before finishing the chair.

MOMO
'Momo accompanies us on every workshop. It is a (children's) story for adults, written by Michael Ende.

It is about a girl/old woman, Momo, who ends up in a friendly town. The town, however, is besieged by grey gentlemen who subtly try to push the people towards a more efficient life. The men promise that the town will eventually get back the time they saved. The townspeople start to hurry, are less friendly and have no time for stories any more. Beppo, a street cleaner who befriends Momo, leads a happy and content life. He does his job, keeping the streets clean – by taking a step, a wipe and a breath, a step, a wipe and a breath. He does not think about the end result but at the end of the day he will have cleaned many streets. That is what we try to tell our students: enjoy it, that is what counts.'

With respect to the measurements and sizes in this book: use whatever you have. If you have a 25mm (1in) drill, then just adapt our measurements. If you are making a tripod, the mortice and tenon joints will be thinner and less strong, but they will often be strong enough, especially if you work with wood like ash. Of course, there are limits to this freedom. Somewhere along the line you will get to the critical point where the joints are not strong enough any more. Try to avoid this by using common sense and your experience.

BASIC TOOLS

To be able to make our projects, you need some basic tools.

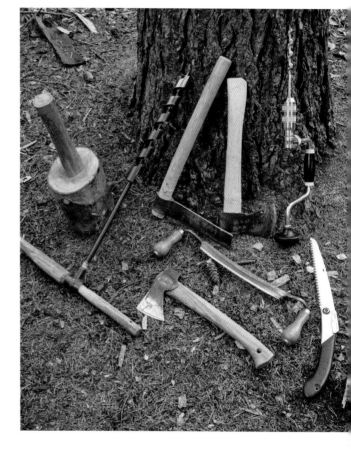

A handy axe (around 600g/21oz) for finer chopping; a **slightly bigger axe** for cleaving; a **brace or drill** (or bar-auger) of 2.5 or 3cm (1 or 1³/₁₆in); or even 4 or 5cm (1¹/₂ or 2in) in diameter; a (greenwood) **saw**; something to chop on; a **wooden hammer**; a **drawknife**; and something to secure wood (such as a **shaving horse**, a **vice**, or a weighted down **workmate**). For spoon carving, you need a good **wood-carving knife** and a **spoon knife**, and a **small axe**. Buying a **froe**, a 3cm (1³/₁₆in) **bar-auger** and (making) a **wooden hammer** will give you a head start. With this set you will be able to make most of our projects.

You can buy these tools new in hardware shops, or order them online. But if you are patient and lucky, you might find all the tools at a flea market. A froe will be harder to find, however, and bar-augers are often broken.

If you seriously want to start working with green wood, you have to prioritize making the shaving horse (page 82). With a shaving horse, you can secure the wood you are working on and it makes working with green wood so much easier. And besides, it is a nice starting project. In chapter 9 you will find more information on the tools (see page 146).

If you are converting millimetres to inches (metric to imperial) it is easiest to use a **two-system folding ruler or tape measure** (see also page 167 for more on measuring).

MAKING TOOLS

In greenwood crafts, you can make a number of tools yourself. As far as we are concerned, that is one of the charms of the trade. It is why we included this chapter on making tools. Making tools starts with making a shaving horse: the best work bench in greenwood crafts. But sawhorses, handles, hammers, work benches and chopping blocks will also make your work a whole lot easier.

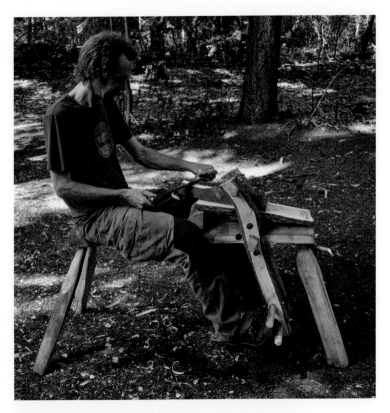

↑ *Shaving horse and drawknife in action.*

PROJECT 1: SHAVING HORSE

The shaving horse is central to the greenwood craft. It is a workbench that you sit on. It is a very simple and ingenious securing tool; you use your feet to fix your wood. A little frame that hinges in the seat works as a lever and will firmly hold the wood in place. Both your hands are thus free to work on the wood. The shaving horse is mainly used to work on wood lengthways. It is suitable for making legs and parts for chairs and stools, tool handles and longbows. You can sit comfortably: just a little pressure from the feet is enough to hold your wood steady; your bodyweight stabilizes the shaving horse. The shaving horse is often combined with a drawknife. It is a real joy to make nice wood shavings on the shaving horse, using the drawknife.

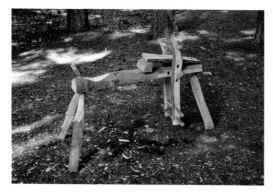

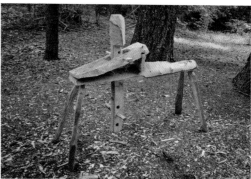

↑ *Shaving horse, English model.* ↑ *Shaving horse, continental model.*

SHAVING HORSE, COOPERS' MARE

As with many tools there are (or were) many different names for the shaving horse: coopers' mare and draw bank, depending on the trade and/or area. Coopers and tanners also used to have shaving horses.

It is not clear where the shaving horse came from, but we do know that it was used in the Middle Ages and possibly even earlier. There are different versions. The two best-known models are the English model, where the hinge is in the seat and a small frame clamps the wood, and the continental model, without a hinge but with a vertical beam that moves through the seat; the hinging and clamping happens on a higher platform.

The shaving horse in this book is the English version, with the clamping frame. This shaving horse is a version of Mike Abbott's shaving horse, from his book *Living Wood*.

MATERIALS

- **Wood:** oak, black locust, sweet chestnut, birch; willow or poplar is also suitable and will make the shaving horse much lighter. With softer/weaker types of wood the diameters of the tenon and mortice joints will have to be adjusted.
- **For the seat, legs and tenons:** tree trunk without knots of 1.25m (49in) long and a diameter of at least 20cm (8in).
- **For the arms:** a knot-free (preferably bent) branch or stem of 70cm (27^1/$_2$in) long and a diameter of 10cm (4in).
- **For the board:** a (cleft) board 20cm (8in) wide and 55cm (21^5/$_8$in) long.
- 1m (39in) rope, 1cm (3/$_8$in) thick.

HOW TO MAKE A SHAVING HORSE WITHOUT A SHAVING HORSE

Making a shaving horse without a shaving horse can be tricky. You will have to improvize to work on the wood. A workbench may be a solution. You can secure the wood with a clamp or a holdfast (you can make one out of wood!). With a sharp axe and a good wood-carving knife you can give the wood any shape you want. Most important is patience and perseverance. You will be generously rewarded.

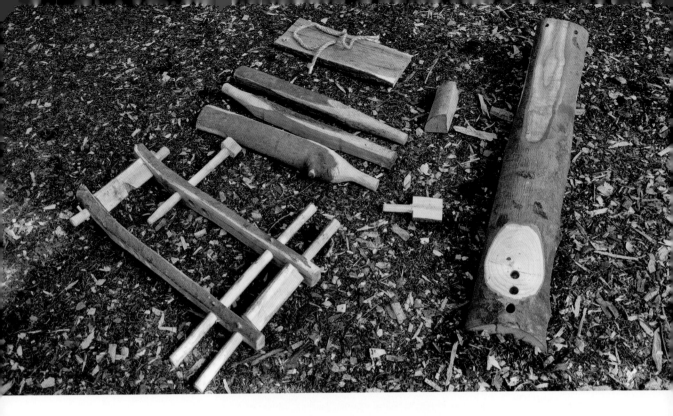

PARTS OF THE SHAVING HORSE

A shaving horse consists of several parts. The seat is usually made of a cleft tree trunk and rests on three legs, which makes it stable even if the floor it stands on is not even. The back, where you sit, is supported by two legs; this side carries the most weight. For maximum stability, they point slightly back and outwards. The front has got one leg as this side carries less weight. This leg is more upright than the back legs.

The clamping mechanism consists of a frame, a board and a moveable block that goes under the board. The frame hinges around a long pin that goes through the seat. The frame has a block on top that clamps the wood and a footrest at the bottom. The board is fixed to the end of the horse with a rope. To prevent you from pushing yourself off the horse, there is a simple back support.

CLEAVING AND MAKING THE SEAT

Cleave the 1.25m (49in) log for the seat in half (see technique 1, page 54). Choose one of the two halves and decide if you want the convex side or the flatter side on top. Make sure the seat is at least 4-6cm ($1^1/_2$–$2^3/_8$in) thick after finishing. The back, where you sit, should be wide enough for you to attach two legs and to sit comfortably.

With a bit of luck, your log will cleave into two perfectly flat halves. More often though, you will find imperfections: hidden knots, a very fibrous and irregularly cleft surface, or twisted wood. If (hidden) knots appear in the wood, then try to work out how to avoid them. You can do this by choosing the half with the fewest knots. An irregular surface needs a lot of work with a (broad) axe and/or drawknife. This can be a hard job. To save yourself from having to do this, you can choose to have the convex side of the cleft log on top. If the stem is twisted, you can flatten both sides of the log to get rid of as much warped wood as possible. Sometimes the wood is just too twisted and you have to get a different log. If the log is too heavy and it is thick enough, you can try to cleave it again. Often, you will not be able to cleave the halved log exactly in the middle again and the log will slope to one side. In that case, remove some from both sides.

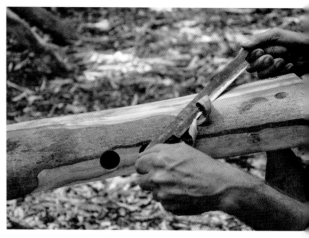

↑ *Flattening the front of the horse.*

FLATTENING THE FRONT OF THE SEAT

The front of the seat's top, where the wood will be secured, will have to be flattened. The block under the board will have to be able to slide well. This way, the opening of the clamp can change size. If the cleft surface is not flat, or if you chose the convex side as the top, you have to remove wood. The flat surface should roughly be as long as the length of the board. Flatten it with a drawknife or a (broad) axe. Sometimes you can cleave it too: make an indentation with a saw at the point where you want the flat bit to end and then cleave the wood from the end up to this point. Finish with an axe and/or drawknife.

MAKING THE LEGS AND TENONS

For the legs, saw the other half of the log off at 70cm (27^1/$_2$in). Cleave this piece twice so that you have four equal pieces (see technique 1, page 54).

Choose the best three pieces. Using three legs (instead of four) ensures that the horse will not wobble on an uneven surface. Make tenons of at least 30mm diameter at the ends of the legs (see technique 5, page 64). If there are knots in the wood, use the side of the wood with the fewest knots, saving yourself a lot of work.

Make the tenons as long as the thickness of the seat. They could be a bit tapered so that they will secure themselves when they are hammered into the seat. The tenon should enter the mortice to the depth of at least 4cm (1^1/$_2$in) to create a stable and strong joint.

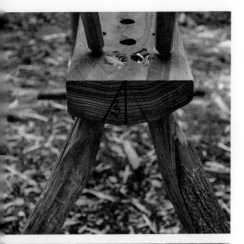

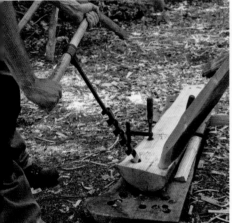

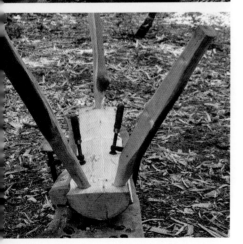

DRILLING MORTICES FOR THE LEGS

Make sure the back legs point slightly to the back and outwards; this makes the horse more stable. A distance of 50cm (about 19³/₄in) between the bottom of the legs is ideal.

The back carries most of the weight. If the back legs are too far apart, there is too much sideways pressure, and on a slippery surface the legs could break. If the leg ends are too close together, the horse will become unstable. Drill 30mm (1³/₁₆in) holes at 10cm (4in) from the end of the horse and screw on a clamp at the far end to avoid splitting.
Drill the holes from the bottom of the horse. Lay the seat down with the bottom facing up. You may secure it on an old board. With the bar-auger, you will put so much force on it that the seat could start turning around while drilling. The board will also prevent you from drilling into the ground or floor.

The front leg should be neatly in the middle of the seat, in line with the seat. Drill at an angle of 20 degrees. Carefully hammer the legs into the seat. Do not hit too hard because you could easily split the seat as long as the wood is green. If needed, make the tenons a bit thinner. Put the seat on its legs. The first part is done.

↖ The back legs point back and outwards to create stability.
← Drilling the mortices for the back legs.
↙ The front leg is centred in between the back legs.

MAKING THE FRAME

The frame that will hinge over a pin in the shaving horse consists of two arms, an upper block to clamp the wood under, two footrests (a low and a high footrest) and a pin that goes straight through the seat and where the frame hinges on.

MAKING THE ARMS OF THE FRAME

Cleave the arms out of the designated (bent, knot-free) branch (diameter 10cm/4in, length 70cm/27^1/$_2$in). Cleave the branch in two equal halves. You can do this by starting at one of the ends and then carefully following the centre along. It is safer to put the branch on a chopping block or something similar and place an axe (head) in the middle, parallel to the branch. Give it a firm blow. By cleaving from the middle, there is a bigger chance you will get two equal parts.

DRILLING HOLES IN THE ARMS

Secure the two arms back together again and drill five holes 25 or (preferably) 30mm (1 or 1^3/$_{16}$in) in diameter. Drill at 7cm (2^3/$_4$in) and 22cm (8^5/$_8$in) up from the bottom. Then drill at 6cm (2^3/$_8$in), 21cm (8^1/$_4$in) and 27cm (10^5/$_8$in) down from the top. It would be risky to drill first and then cleave the log, because the cleaving could go wrong and then you would have drilled the holes for nothing. Drill the holes parallel to each other. After drilling a hole, you can stick a straight stick in it so that you can clearly see how to drill the next holes parallel to it. If you drill holes close to the ends, put an extra clamp on the ends to prevent them from splitting (green wood!). With your axe or the drawknife, you could tidy up the arms.

↑ ↑ *All parts of the frame.*
↑ *Detail of the clamp block, with the pin.*

MAKING THE CLAMP, THE FOOTRESTS AND THE PIN FOR THE FRAME

From the remaining part of the log (that you used for the seat) you make the footrests, the clamp and the pin. The clamp and footrests are thicker in the middle. The ends of these stick through the arms.

Saw the leftover part of the 1.25m (49in) log to 50cm (19^3/$_4$in) and then cleave into four or six parts. Choose one of these parts as the footrest. Determine the middle of this piece of wood and mark the width of the horse (20cm/8in) from this point. There should be 15cm (6in) left on each side to make the 30mm tenons.

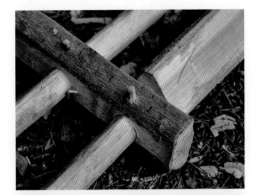

↑ ↑ *The footrests.*
↑ *Securing the footrests with pins straight through the arm and footrest.*

The middle part, which keeps the arms at the shaving horse's width, can stay rough. Carefully saw the wood slightly in all around, on the 20cm (8in) marks. Do not saw too deep because then the pin will break when pressure is put on it. Carefully cleave the rest and finish the tenons with a drawknife or axe. Make sure the tenons are neatly opposite each other (see technique 5, page 64).

Next, make the top clamp block. Saw one of the left-over pieces to 32cm (12⅝in) and follow the above instructions for the tenons.

Saw a V-shaped notch in the clamp block, which will make it easier to secure smaller wood or branches. You could choose to make a second footrest (or pin) for children or people with shorter legs.

Make the pin that works as a hinge for the frame in the shaving horse (see technique 5, page 64). The length is 30cm (12in), and the pin has a head on one side. To be able to hinge easily, the diameter has to be slightly smaller than 30mm (1³⁄₁₆in). The pin should be easy to take out of (and put into) the frame (and the seat). For transport and storage, it is useful if the frame can be taken off the seat completely.

Finally, assemble the frame. Fix the footrest(s) and the clamp. Fix the footrest by drilling a 6 or 8mm (¼ or ⁵⁄₁₆in) hole straight through the arms and the footrest. Connect them with a piece of square or octagonal wood, tapered, to just fit the 8mm (⁵⁄₁₆in) hole. The clamp block should be able to turn so secure it with a pin on the outside of and parallel to the arm.

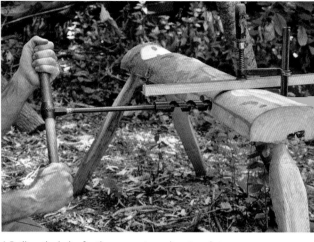

↑ Drilling the holes for the arms using a direction slat.

DRILLING HOLES THROUGH THE SEAT

To make the frame in the seat work as a hinge, two holes of 20cm (8in) long need to be drilled through the width of the seat. They are placed at 27cm (10⁵/₈in) and 33cm (13in) from the front. Make sure you drill in the middle of the thickness of the seat. If your seat is not very thick, you can drill a couple of millimetres above the middle, as the main force will be downwards.

Mark the holes at the correct distances. Drilling is easier when the seat is on its legs, but you could also secure it on a workbench. Put the horse against something so it does not fall over while drilling. Drill across the width of the seat and parallel to the top of the seat. It is useful to clamp a 'direction slat' on top of the drill marks, as a drilling guide. You can now hang the frame in the shaving horse.

DRILLING HOLES WITH AN ASSISTANT
Drilling the hinge holes through the seat is a job that is easier done with two people. You have to drill straight across the seat and straight through the middle. The first person keeps an eye on drilling across. The second person makes sure that the drill goes parallel to the top of the seat. This way, the frame will hang straight in the horse. Saying that, the frame does not have to hang perfectly straight to be able to work well.

THE BOARD AND THE WEDGE

Cleave a board 20cm (8in) wide by 55cm (21⁵/₈in) long (see technique 1, page 54). You can also take a sawn board for this, e.g. some softwood boards. With a rope, the board is attached to the far end (nose) of the shaving horse. Drill two holes next to each other: the distance between the middle of the holes should be 16cm (6⁵/₁₆in) and they should be 3cm (1³/₁₆in) from the end (see photograph on page 91); drill through the board and the end of the horse. Attach the board with the rope; it is handy if the rope goes just in front of the horse's front leg. Cleave another triangular piece of wood, 20cm (8in) wide, for the wedge that will support the board.

CONNECTING THE BOARD DIFFERENTLY

There are several ways to connect the hinged board to the horse. On our first horses, we used a blind wedged pin with a head in the seat. But because of the pressure that was put on the horse, these often came loose after a while. We also tried using two pins. After that, we had one or two pins with a head that would go across the board and the head of the horse. The pins were then fixed under the horse with a wooden pin or a piece of rope. We have often 'quickly fixed' a horse with a tie strap. For the last couple of years, joining the pieces with rope has been our favourite: simply drill two holes straight through the board and the horse and feed a rope through the holes. This works well and can easily be renewed if needed.

BACKRESTS IN ALL SHAPES AND SIZES

Backrests come in all shapes and sizes. The Rolls Royce of the backrests is a fixed rest, made of oak, in a kind of a chopper model. The minimalist version of a backrest is a sawn notch or an axed cut in the seat: this works great but you cannot move it. There have been several variations using pins in the seat, with or without an extra-wide backrest. These can easily be moved backwards or forwards by drilling extra holes in the seat. The variation with two sticks next to each other is most comfortable as your spine will sit between them.

MAKING THE SEAT ON THE HORSE

Finally, make something to sit on and to push yourself against. A comfortable option is to use two sticks, as your spine will fit in between them. Drill two holes with 8cm (3^1/$_8$in) in between, going at a slightly backward angle. You can determine where these should go by sitting on the horse and holding a piece of wood and a drawknife. You can also drill further holes for adults and children of different heights. Make two tapered sticks the same size as the holes so that they will not fall through.

Now the horse is ready for use!

↑ *Two possibilities for a backrest and a series of holes.*

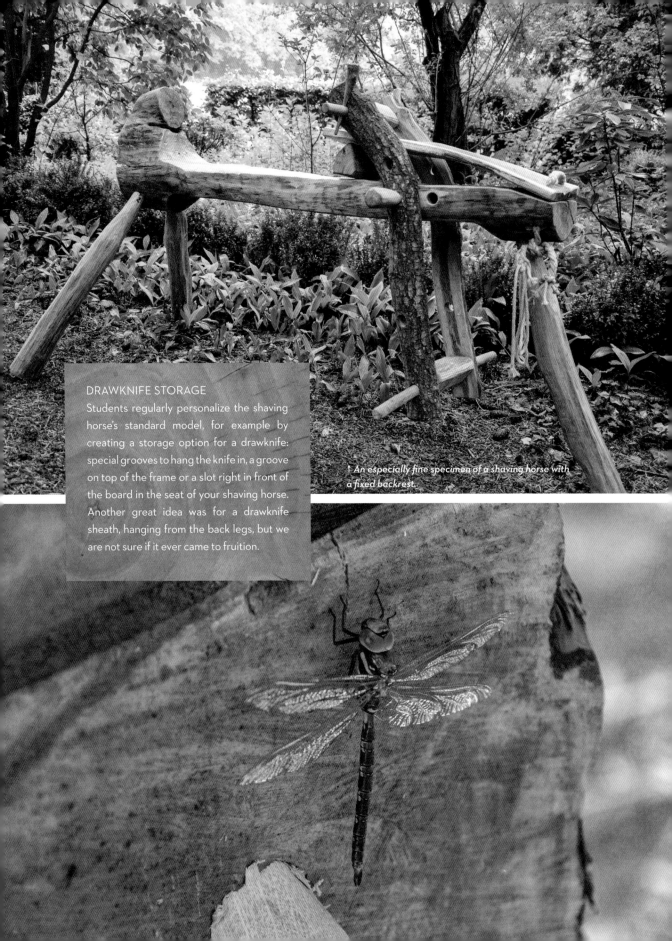

DRAWKNIFE STORAGE
Students regularly personalize the shaving horse's standard model, for example by creating a storage option for a drawknife: special grooves to hang the knife in, a groove on top of the frame or a slot right in front of the board in the seat of your shaving horse. Another great idea was for a drawknife sheath, hanging from the back legs, but we are not sure if it ever came to fruition.

↑ *An especially fine specimen of a shaving horse with a fixed backrest.*

PROJECT 2: WOODEN HAMMER/CLUB

The wooden hammer/club is essential in greenwood craft. It is used especially to hit the froe or wedges. With a wooden hammer you will not damage your froe, and no metal splinters will fly around. This makes the work safer, and your froe and wedges will last a lot longer. Wooden hammers take a lot of beating and therefore have a short life expectancy, so you will have to make a new one every now and then. And that is not at all a bad thing.

In greenwood craft, there are easy and heavy cleaving jobs. The heavier the job, the heavier the hammer. That is why you need a few hammers, with different weights and lengths. It is obvious that for a hammer you need strong and flexible wood. Ash is very good for this, but oak, sweet chestnut, beech and black locust are also good options.

In greenwood craft, we often make hammers from one single piece of wood. We choose a log with knots on one side – the hammerhead. The other part, without knots, will be the handle. Knots keep the hammerhead, which takes the biggest blows, together. The handle has to be without knots because it would be harder to make the handle from the wood otherwise.

MATERIALS
- **Wood:** ash, oak, black locust, beech or sweet chestnut.
- A log of 35cm (about 13³/₄in) long, with a 15cm (6in) diameter. The hammerhead, about 15cm (6in) long, must contain knots; the other end (20cm/8in) should not. The heart should be roughly in the middle.

From one piece of wood we can make a hammer you can use with one hand. The handle is made by partially cutting around the log, just behind the hammerhead, after which you can remove the excess wood by cleaving and chopping. You finish the hammer with a drawknife.

SAWING THE HAMMER WOOD

Saw (or chop) any branch leftovers from the head. Draw a 4cm (1^1/$_2$in) circle at the crosscut end of the log (without the knots). Measure the smallest distance from the edge of the circle to the bark. That is the maximum you can cut into the log.

Now draw a circle around the log where the head should start. You can also put an elastic band around the log, marking the saw line. With a saw, follow this line for as deep as you have just measured; make sure not to saw any deeper because that will weaken your hammer handle. To keep the depth correct, you can mark the depth on your saw with a piece of tape or a felt-tip pen.

First, saw just superficially around the log. Make sure the cut ends exactly where you began. Correct if necessary. Now you can saw deeper, along the cut you just made.

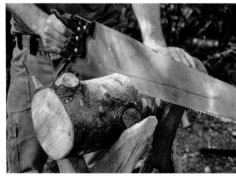

↑ *Saw around the log up to the line on the saw.*

CLEAVING THE HANDLE FROM THE WOOD

Put the log straight up with the hammerhead facing downwards. Put the froe or an old axe in between the circle and the edge of the wood, hit it and cleave off the first piece of wood. Do not try to cleave the wood directly on the circle as the wood could split at an inward angle; watch how the wood cleaves. Does it cleave straight down or to the outside? Then you can start cleaving on the circle. Repeat this process all around. You will end up with the first rough version of the handle.

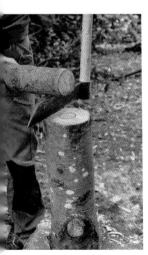
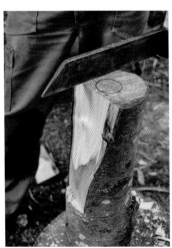

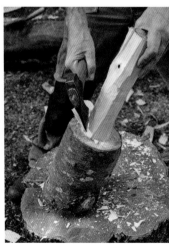

FINISHING THE HANDLE AND THE HEAD

Next, secure the hammerhead in a shaving horse and finish the handle with a drawknife or spokeshave (see pages 162–163). You could also use the drawknife while pushing it, in order to work on the hammerhead close to the handle. See if the handle is the right thickness. You have to be able to grasp it with one hand; if it is too thick for your hand, you have to use too much force to hold it. Finally, round off the sharp edges at the ends of the handle and head.

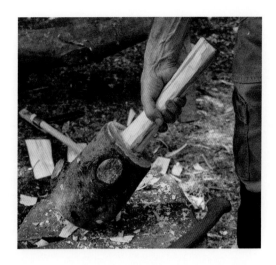

VARIATION: BEETLE OR MAUL

For big cleaving jobs, you need another type of hammer: the beetle or maul. Use a log with lots of knots for the head: 30cm (12in) long and with a diameter of 15–20cm (6–8in). Make a handle out of a piece of 1m (39in) knot-free ash or black locust.

The crosscut ends of the log will be used for hitting. To attach the handle, drill a hole of at least 30mm ($1^3/_{16}$in) diameter, straight through the log. Make a tenon that is slightly longer than the diameter of the head at the end of the handle. Make the tenon 1mm bigger than 30mm. Dry the handle and make the tenon exactly the right size. Put the handle in the hammerhead. Secure the handle by drilling an 8–10mm ($5/_{16}$–$3/_8$in) hole across the head and the handle. Hammer a 'square' (in diameter) dry wooden pin through the hole, which will secure itself when you hit it in. You can brace the ends with two metal straps, a couple of large hose clamps for instance, to considerably extend the life of the hammer.

← Beetle or maul for heavy jobs; note the securing pin.

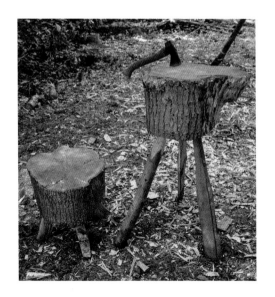

PROJECT 3: CHOPPING BLOCK ON LEGS

In greenwood craft we do a lot of chopping, so a good chopping block is indispensable. It is quite easy to make a block on legs. Working at the right height is safe, pleasant and efficient. You do not have to bend over or stretch too far. The ideal height depends on your body and the size of the wood you are working with. A block at hip height is perfect for regular chopping jobs. A low oak tree trunk with a couple of big knots is ideal for rough cleaving jobs; it can last for years. A trunk on higher legs is great for more precise jobs.

MATERIALS

- **Wood:** preferably heavier wood, like oak or beech, because of its stability and durability.
- **High chopping block:** trunk with knots for cleaving jobs, 30–40cm (12–15³/₄in) high, diameter 30–50cm (12–19³/₄in).
- **Chopping block for a small hand axe:** trunk 30cm (12in) long, diameter 30cm (12in). The heavier the trunk, the more stable the chopping block will be.
- **For the legs:** log, at least 10cm (4in) diameter by the height of your hip bone.

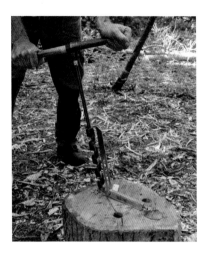

SAWING AT THE RIGHT LENGTH AND DRILLING HOLES

Saw the trunk to the right length. You will need to drill three holes in the bottom (see drills, page 150). Drill the holes at the corners of an equilateral triangle; mark the drill points at least 5cm (2in) inside the edge of the trunk. A drill angle of 60 degrees in relation to the surface is perfect. Drill holes with a diameter of at least 30mm (1³/₁₆in) and drill at least 3cm (1³/₁₆in) deeper than the diameter of the tenon.

TIP: to get the legs at the right angle and facing the right way, you can use a folding ruler. Simply shape this into an equilateral triangle and place it on the trunk. You want to drill on the corners or perhaps a bit to the outside or inside.

MAKING THE LEGS

Cleave the log for the legs into four equal parts (see technique 1, page 54). Choose the best three parts and make tenons of at least 30mm in diameter (see technique 5, page 64).

Make the tenons at least 6cm (2³/₈in) long and slightly tapered so that they grip the wood when you hammer them in. The tenons do not have to be round; in fact, if they are octagonal they will be stronger as the rough edges 'bite' into the wood.

ADJUSTING THE HEIGHT

Hit the legs into the block and stand it right side up. The block will still be too high. Make the block level (see technique 8, page 69). Next, measure the height from the floor. Then measure the distance from your waist – just above the hip bone – to the floor. Deduct this from the first height and you know how much to trim the legs. Saw the legs at the marked height.

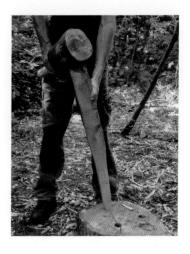

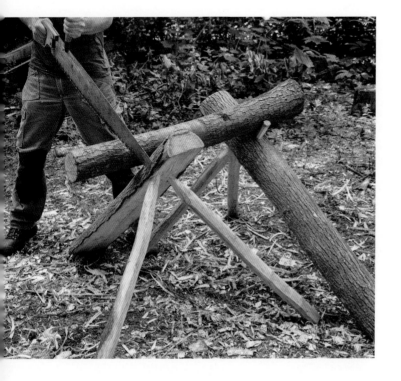

PROJECT 4: SAWHORSE (IN TWO PARTS)

Sawhorses are essential when working with trees and wood. Logs are stable and at the right height to saw when you use a sawhorse. If you work with green wood, a sawhorse in two parts is ideal. You can make it in a couple of hours. It consists of a long halved tree trunk, the girders, that both rest on two legs. Together they support the wood you want to saw, which rests on two supports that you insert into the girders.

MATERIALS

- **For the girders:** one log of 1.5m (59in). Oak, sweet chestnut or black locust will last longest, especially if you mean to store the sawhorse outside. The diameter depends on how heavy you want the sawhorse to be; 20cm (8in) is a good average.
- **For the legs:** one log, 1m (39in) long, 20cm (8in) diameter. The strongest legs are made of ash, oak or black locust but you can use other (softer) types of wood.
- **For the rests:** one log, 30cm (12in) long, diameter, 12cm ($4^3/_4$in).

MAKING THE GIRDERS

Saw the log for the sawhorse to the right length; 1.5m (59in) is good. Cleave the log in half.

MAKING THE LEGS

Saw the log for the legs off at 1m (39in). Cleave the log and make four legs. The tenons have to be at least 30mm ($1^3/_{16}$in) in diameter (see technique 5, page 64). You can make them octagonal and slightly tapered so that they get really stuck when you hammer them in, but perfectly round tenons are good too (dry them before use).

DRILLING HOLES IN THE GIRDERS

Secure the girders so that they are stable and horizontal. Drill holes 7–10cm ($2^3/_4$–4in) deep, 25cm (10in) from the end of each girder. Make sure the legs are spread correctly: the angle between the legs should be 90 degrees and the angle with the girder is also 90 degrees. Hammer the legs into the girders then turn the girders right side up.

MAKING THE SUPPORTS

The pins that stick out of the top of the girders will support the wood you are cutting. Cleave the 30cm (12in) log and make tenons with a 30mm ($1^3/_{16}$in) diameter. Make them slightly tapered as the part that sticks out of the girder can be left a bit thicker. Drill a few holes into which you can push the pins, e.g. 20, 40 and 60cm (8/16/24in) from the end of the girders. This way, you can vary the sawing height.

ALTERNATIVE

If you have two nice big 'forks' available, with legs that are wide enough, making the legs is a quick job.

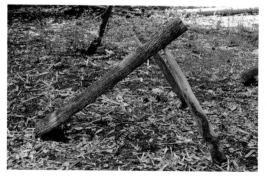
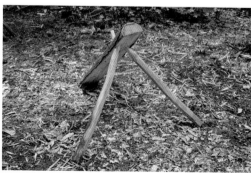

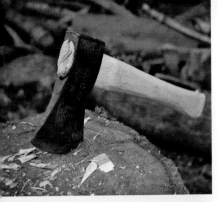

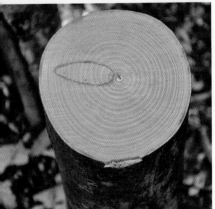

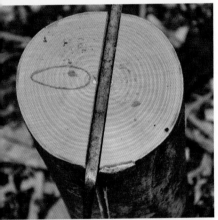

PROJECT 5: AXE HANDLE

Making a handle for an axe, hammer or other tool is a very satisfying job. Making a good handle is a real skill. The direction of the annual rings has got to be right, the curve has got to be correct and the handle should be well-balanced.

Traditionally, ash wood is best for handles: ash is strong and flexible and can therefore absorb the blows of the axe. Many modern tools have handles made of hickory, an extremely hard type of wood, which apparently is even better than ash.

MATERIALS
- A log of knot-free ash, 25cm (10in) long, 20cm (8in) diameter.
- An (old) axe head and perhaps the old handle, to copy the shape.

CLEAVING THE WOOD AND MAKING IT RECTANGULAR
Cleave a one-sixth or one-eighth part from the 20cm (8in) diameter log. The pictures show how the handle should be cut. Make one cleft part with these dimensions: 25cm (10in) long, 4cm (1¹/₂in) wide, 2cm (³/₄in) thick. When a lot of wood needs to be removed, first work with the axe (see technique 2, page 57) and then with the drawknife and/or the spokeshave on the shaving horse. First, flatten one of the longer sides and then make the rest of the corners 90 degrees so that you're left with a rectangle.

DRAWING THE SHAPE
Draw the shape of the handle on the long side of the wood. You can copy the shape of the old handle or another handle. Most handles are slightly curved but a straight one also works well. The end of the handle should be slightly wider, so that the axe will not slip from your hands. The cross section of the handle should be egg-shaped, or oval. A round handle will turn in your hand and will make chopping less precise. On the end of the wood, the top side of the handle, you draw the shape of the tenon that will fit through the axe. Draw the length of the tenon on the handle, plus 1cm (³/₈in) extra.

SHAPING THE HANDLE

Shape the handle with the drawknife and the spokeshave (see pages 162–163). Round off the corners so that the handle is pleasant to hold.

Shape the tenon that will fit into the axe head. Make sure the length runs parallel to the wide side of the handle. Dry the handle a couple of days before finishing the tenon for the axe head. You can use the hole in the axe as a template. Carefully hit the tenon into the axe head. Often the tenon gets stuck at certain points and it will not go in any further. Take it out, see where it got stuck, remove the wood and keep trying until the tenon fits the hole perfectly tight.

THE SHAPE OF AN AXE HANDLE

If you only have an (old) axe head, it can be hard to decide on the shape of the handle. Hand axes often have handles with nice curves but that was not always the case. According to axe specialist D. Cook from the USA, it was not until the 19th century that the curved handles appeared – before that, they were always straight. Apart from aesthetics, he maintains that curved axe handles do not contribute to the efficiency or strength of the axe. It is rather telling that the Japanese, outstanding tool makers, have straight handles on their axes. Having said that, a nicely shaped handle is charming and a nice challenge to make.

WEDGING THE HANDLE

The final step is wedging the handle to fix the tenon well in the axe head. Saw a wedge from dry hardwood – oak, for instance (see technique 6, page 66). The wedge should be 1cm (³/₈in) longer than the saw-cut. Saw a slot into the tenoned end of the handle, 1cm (³/₈in) less deep than the length of the hole in the axe. This will prevent the handle from splitting. Put the handle in the axe head, hit the bottom of the handle to get it where it should be (see the pictures). Then hit the wedge in place, possibly with a bit of glue. Next, saw off the wedge and handle, just above the metal of the axe head. You could also secure the wedge with a small steel wedge (from the hardware shop). Hit this diagonally over the wooden wedge and the top of the handle.

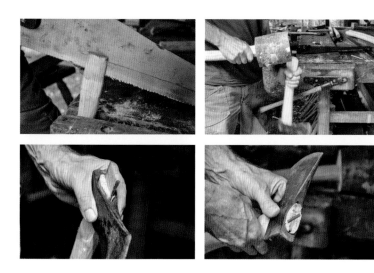

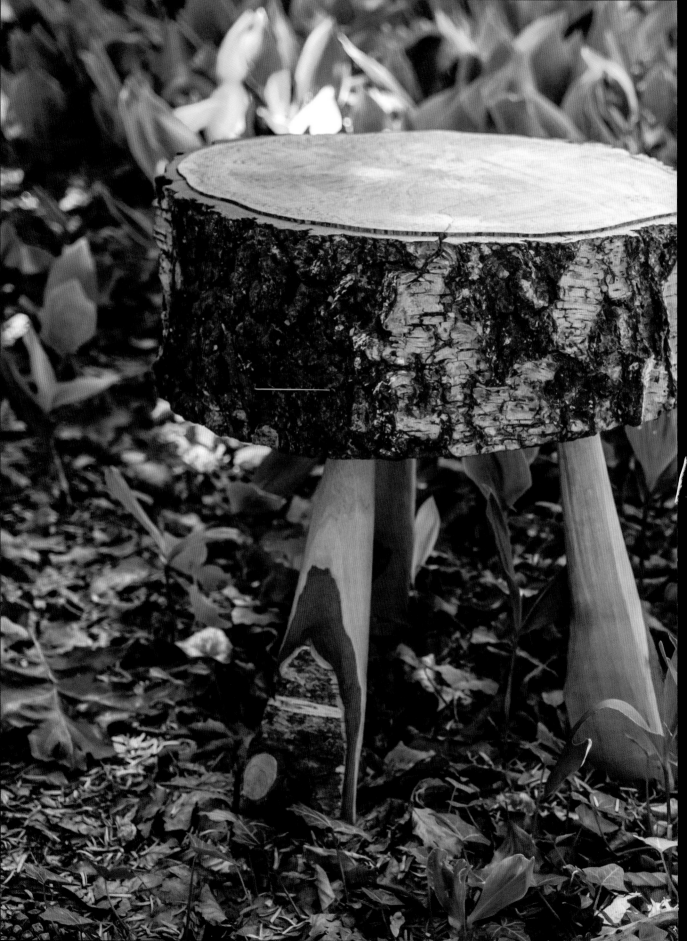

6. PROJECTS MADE WITH GREEN WOOD: OBJECTS

• STOOL • STOOL FROM CLEFT WOOD • SMALL TABLE/BENCH • TRIPOD • SHINGLES

In this chapter we make objects for the home. You look differently at things that you would normally buy and use daily if you have made them yourself, like that stool you can sit on or use as a coffee table – perhaps with the bark still in place.

PROJECT 1: STOOL

A stool is one of the simplest pieces of furniture to make. Stools have been around for millennia; keeping humans away from the cold, damp floor, without having to sit cross-legged or crouch. And they are multifunctional: you can use the stool as a table too, even for modern things like laptops. Making something to sit on can seem daunting at first, but a stool is an easy project to start with.

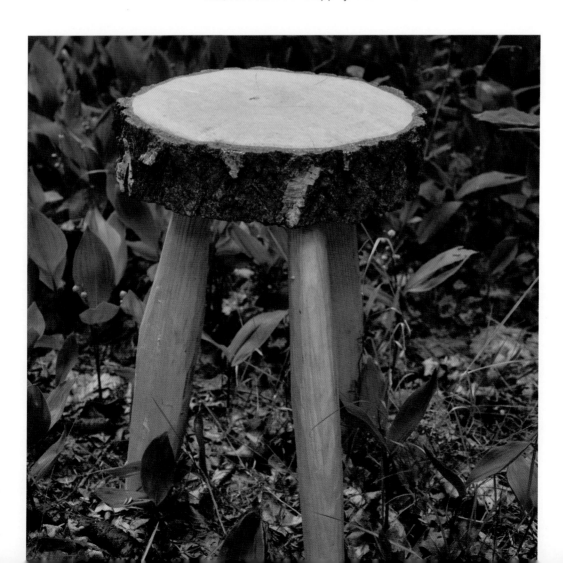

THREE LEGS, A DISC AND THREE HOLES

The legs are made from a log of green wood that is cleft into four; the disc comes from a big trunk. Simply put: you drill three holes in a disc and make some tenons on the legs (with the same diameter as the holes). Assemble, level and off you go!

MATERIALS

- **Wood:** ash, birch, oak (indigenous and northern red), sweet chestnut, black locust, maple, willow, nut and poplar are all suitable.
- **For the seat:** a trunk with a diameter of about 30cm (12in) – saw a disc of at least 8cm (3^1/$_8$in) thick.
- **For the legs:** log of 45cm (17^3/$_4$in) long, diameter 10cm (4in), preferably knot-free wood.

MAKING THE LEGS

Cleave the log for the legs in half using a froe (or an old axe) and a wooden hammer (see technique 1, page 54). Cleave the two halves again so that you have four potential legs. Judge the cleft pieces of wood: you should avoid knots at the end where you will make the tenon. A knot would make it much harder to make a tenon.

The tenons (and mortices) here are 30mm in diameter. Draw them with a template on the crosscut end. Cut the wood 1mm outside the line so that after drying the tenons will fit perfectly (see technique 5, page 64).

SAWING A DISC

Secure the 30cm (12in) trunk on a sawhorse or clamp it in a different way – you could tie it with a tie strap, if you want. Saw a thick disc, about 8cm (3^1/$_8$in) deep (see technique 3, page 59).

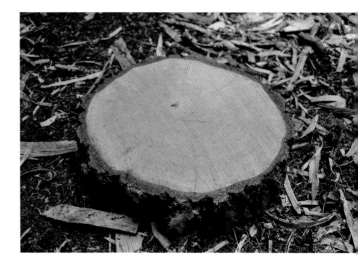

DRILLING HOLES IN THE DISC

Choose which side of the disc will be the top. Drill 5cm (2in) deep holes from the bottom up. You could also drill all the way through the disc, so that you can see the crosscut end of the legs.

- Mark the three holes at the corners of an equilateral triangle. Make sure the holes are not too close to the edge (about two-thirds from the middle is best).
- Drill three holes at an angle of about 17 degrees from the vertical. As well as the angle of the drill, the direction is also important. You can determine this by drawing an imaginary line from the drill to the point exactly in the middle of the two opposing holes. Drill exactly in the continuation of this line.
- Before drilling, clamp the disc to an old board with one or two clamps as there will be a lot of force from the drill. By clamping the disc on a flat board, the drilling hole will not splinter when the drill leaves the wood on the other side of the disc (should you choose to drill through).
- Position yourself exactly behind the drill. Use a bevel or a drill guide (see tools, page 167) for the right angle, or drill while judging by eye. Ask someone to keep an eye on the drill direction. Keep the drill as stable as possible so that the hole will not become unnecessarily wide.
- Let the legs dry and finish them at the right size.

FULL ATTENTION

During one of the first courses we organized someone made a very special stool indeed. After working hard all day making all the parts, he neatly drilled three holes in his disc. When he hammered the legs in the holes, it appeared that all three holes pointed in the same direction, which created a very unstable stool. Luckily, we could quickly saw off a new disc and after a little help with drilling, he went home with a lovely stool.

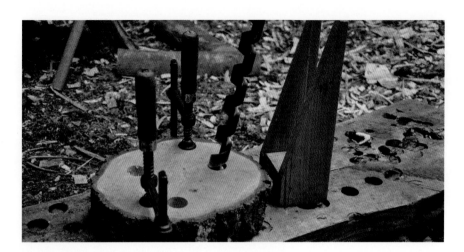

FIXING THE LEGS IN THE DISC, POSSIBLY WITH WEDGES

Hit the legs carefully into the disc. If the tenons are still too big, the disc could crack when you use too much force as the legs act as wedges (see technique 6, page 66).

MAKING THE STOOL LEVEL

To level the stool, the legs have to be sawn so that the seat of the stool is horizontal and the legs are straight on the floor (see technique 8, page 69). The stool is ready!

AFTERCARE OF THE STOOL

- Slowly dry the wood if the wood is still green (and contains a lot of moisture). Let it dry, but not in direct sunlight and not in a heated room. Quick drying causes cracks, although even slowly dried pieces can crack. A crack is not bad, as long as it does not run through one of the leg holes – then the leg would act as a wedge and the wood will surely split.
- The disc can be sanded down after drying.
- The stool's seat and legs can be treated with oil or wax.

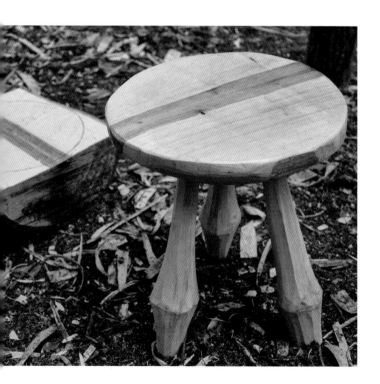

↑ *A simple stool from walnut.*

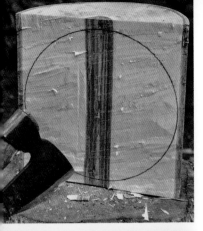

PROJECT 2: STOOL FROM CLEFT WOOD

This stool can be compared to the above stool but the seat has been made in a completely different manner. It is made of cleft green wood instead of crosscut wood, i.e. of a lengthways cleft part of a (thick) log. This way, the risk of splitting is minimized.

MAKING THE SEAT

Take a trunk of at least 35cm (13³/₄in) diameter, without knots. Saw off a piece that is the same length: in this case 35cm (13³/₄in).

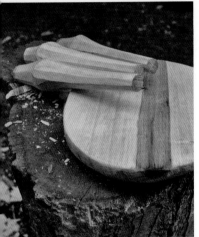

CLEAVING

Cleave this short wide log into two halves. Preferably with a froe, so that you get a nice straight result. You then have two thick, half cylinders. Choose which half you are going to use. You can remove some wood at the bark end so that the stool is less convex and heavy. Make the legs from the other half.

CHOPPING AND SHAVING

With a (broad) axe, remove the heart across the whole surface you have just cleft. Chop the surface nice and flat. Later, you can finish it with a spokeshave.

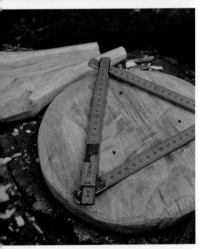

MARKING

Take a compass and draw a circle all the way to the edges of the surface.

CHOPPING SOME MORE

This is a nifty axe exercise: chop off all the wood outside the circle. Then make a slanting edge on the crosscut side. Work with slow but firm hits. Make sure you keep chopping in the direction of the grain, especially when you chop along the marked pencil line; pieces of wood can break off easily. Shape the seat into a nice, smooth fat disc with an even, slanted edge.

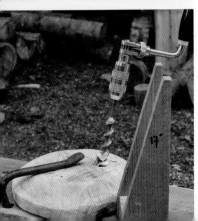

FINISHING

Make a smooth finish with an axe and spokeshave, which is quite a job. Dry the seat for a while before inserting the legs, to prevent splitting. Mark the drill points with a folding ruler. Follow the drilling and finishing processes given for the previous stool on pages 104–105.

PROJECT 3: SMALL TABLE/BENCH

One can never have enough tables! Low, high, big, small: they always come in handy. Usually, you can sit on them too and then we call them a bench or stool. In this project, we make a table with four legs and a top from an (old) board. You could, of course, also cleave a board, saw a disc or use waney-edged lumber. Waney-edged lumber often has the bark still attached on both long sides, and sometimes even on the convex side. Here, we make a knee-high table using a board.

MATERIALS

- **Wood:** almost all types are suitable.
- **For the legs:** a log, 50cm long (19³/₄in), diameter 15cm (6in).
- **For the top:** a board at least 3cm (1³/₁₆in) thick; length and width can be as you wish.
- **Wedges:** dry piece of oak.

MAKING THE LEGS

Cleave the log for the legs in four. Make a tenon 30mm in diameter and 4cm (1¹/₂in) long at one end of all the legs (see technique 5, page 64). Finish the legs as you like. Make sure that the legs – especially the tenons – are dry before assembling the table.

FINISHING THE TOP

Saw the board to the desired size. Tidy it up: you could sand it down and/or round the edges with a spokeshave.

BARK OR NO BARK?
One of the charms of working with green wood is that you can see that the wood comes from a tree. Leaving a piece of bark on a leg can look really nice. Some bark is especially beautiful, like birch, but that is, of course, personal taste. We often get asked if the bark will fall off after a while, and yes, it may happen. If the tree is cut down in spring, when the sap stream has started, the bark tends to come loose more easily. If a wood has been lying in the forest for a while, the bark may also come off.

↑ *Marking the legs.*

DRILLING HOLES

With clamps, secure the board upside down onto an old plank – this way, you prevent the drill from causing splinters when it comes through the wood. Drill four 30mm (1³/₁₆in) holes all the way through the table top. Make sure that the holes are at a slight angle, pointing outwards – this will make the table more stable; vertical legs make the table less stable. Do not drill too close to the edge as this could cause the top to split (see drills, page 150).

PREPARING TENONS AND WEDGES

Hit the legs into the holes so that they just stick through. Mark the legs so that you know which leg should go where and in which direction. Then, on the top end of each leg, mark in which direction the wedges and the saw-cut for the wedges should go (see technique 6, page 66). Remove the legs from the top and saw them at the marks you have just made. Do not saw too deep: the kerf must not show under the table top because then there is a risk of the leg splitting when you hit the wedge in. Saw four wedges from dry oak and make them 30mm (1³/₁₆in) wide – as wide as the hole is.

FIXING THE LEGS

Fit the marked legs into their holes in the stool seat. Use the marks to put them in the right position. Then hit the wedges into the saw-cuts, perhaps with a drop of wood glue on the wedges (see technique 6, page 66). Saw the ends of the tenons and wedges off to make an even table top.

Sjors: 'The other day, I went to a birthday party and brought a handmade table as a present. I had taken it from my own small stock and everyone liked it. Other guests immediately saw the business potential. After a tree is felled, it is always a good idea to see if there is a nice tripod hidden in there somewhere: a branch that you could use as legs for a little table. In between piles of prunings, you often find nice bits of wood that you can use for this. Also look for pieces that are right for things like spoons.

LEVELLING THE TABLE

To make the table perfectly level, saw the legs at the right height (see technique 8, page 69).

FINISHING THE TABLE TOP

Finish the table top. If necessary, plane it, sand it down and then oil it.

PROJECT 4: TRIPOD

SEARCH, LOOK AND FIND

Oak is the best kind of wood for nice tripods. Finding the right tripod seems easier than it is because most tree three-forks are not suitable. Look for three branches that are shaped in a nice equilateral triangle. The ash provides good quadpods, because of the symmetrical way it grows.

HARVESTING/SETTING FREE

When setting the tripod (or quadpod) free, it is important to cut the branches at a sufficient length. Imagine the tripod standing up and cut the legs at more or less the same length.

TABLE TOP

It is nice to saw an interesting disc with an irregular shape. You could also use an appealingly shaped old board or similar. If you live close to a lumberyard, have a look – there are often many pieces that will be thrown away.

↑ *Tripod table with built-in test-tube vase. Photograph: Dorien van der Meer.*

CONNECTING AND FINISHING

Connect the table top to the tripod. Make sure that the board or disc is fixed as horizontal as possible. It often looks better if the connection is not exactly central. Level the legs by following technique 8 (see page 69).

ADDING A VASE?

Look for a test tube with a diameter of, for example, 30mm ($1^3/_{16}$in). You can find them online or in specialist shops. Drill a hole in the table top and place the test tube in it. Treat your table with a good oil, pick some flowers and enjoy!

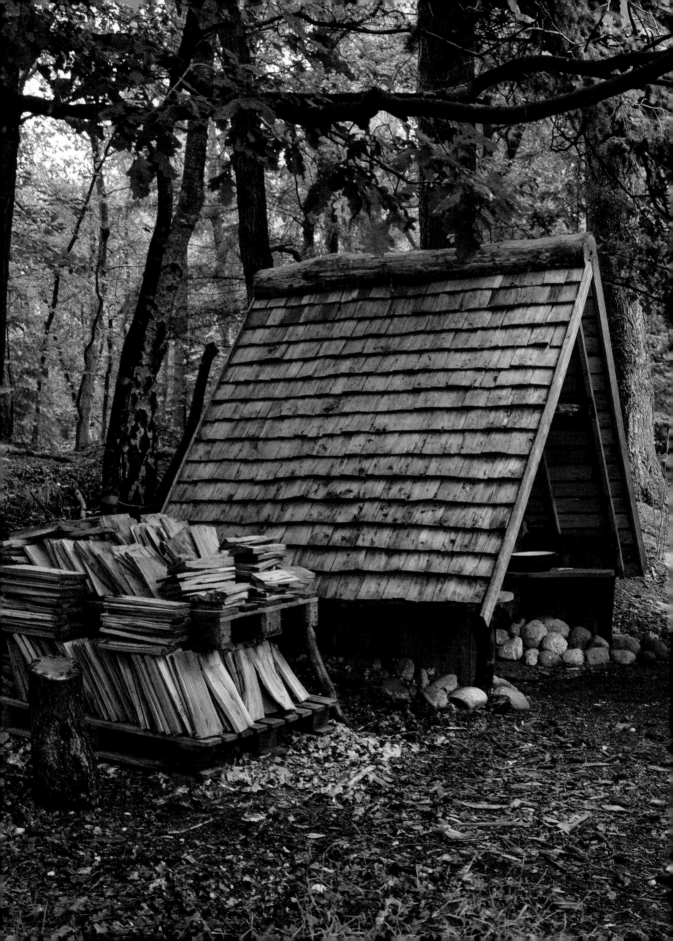

PROJECT 5: SHINGLES

Wooden roof tiles: surely that is not possible in western Europe? Well, you do not see them a lot and they are definitely not traditional. Plus our climate is too wet... But that does not stop us. A wooden roof tile actually works exactly like slate. Making shingles is a rewarding job and a roof covered in shingles looks beautiful and authentic. Start with a roof over your log pile, your chicken pen or tree hut before starting on your own home. The roof can lean against a wall or stand alone.

SHINGLES' LIFE SPAN

Some people say that wooden roof tiles last longer than conventional ones. It is important to use a durable type of wood. The slope of the roof is important too: it should be at least 30 degrees so that the water runs off quickly and the roof will not stay wet for too long. Moisture creates mould and rot. The surroundings of the roof are also something to take into consideration: does it dry quickly in the wind or is it in the woods, underneath the trees? If you need a roof for your firewood, potatoes or rabbits, wooden roof tiles are a great solution. Shingles are not sawn: they are cleft and the fibres stay intact. If the fibres get cut, the water is absorbed by the wood. This will shorten the lifespan of the shingles.

WHICH TYPE OF WOOD?

Indigenous oak, sweet chestnut and several types of conifer woods (larch and western red cedar) are suitable for making shingles. These types of wood can be used outside, do not have to be treated and are easy to cleave.

The wood needs to be green, without knots and even-grained. Note that you may come across some in-grown knots that you cannot spot from the outside.

WOOD WITH SHINGLE QUALITY

It is not always easy to find the right wood. Oak and sometimes sweet chestnut are not so hard to find but even-grained wood without knots is a different matter all together. We have come across more in-grown knots than we care to remember – you simply cannot always tell from the outside of the wood. In real 'shingle countries', people grow trees in a way that guarantees good shingle wood.

RING SHAKES

Sweet chestnut sometimes suffers from 'ring shake'. This means that the annual rings separate and the wood becomes useless. This was the case with a sweet chestnut tree at Midgaard. The tree was growing over a path and had to be cut down. It had the ideal diameter – 50cm (19⁵/₄in) – but to our great disappointment, ring shake meant that the wood was unsuitable for shingles.

← Gafur Wargerink's potato shed.

SHINGLE AND LOG DIMENSIONS

A shingle should be about 30-40cm (12-16in) long. If you make them smaller you will have to make more, but if you make them longer there is a bigger chance that they will twist, and then you will not end up with closely fitting tiles. 30-40cm (12-16in) is the length of the logs you need. Here, we make 35cm (13^3/$_4$in) shingles.

Saw the logs to the right lengths before you cleave them. If the crosscut end is dry, the cleaving will be a lot harder. The width of the shingles should be anywhere between 10-25cm (4-10in). Here, we make them 15cm (6in) wide. The logs need to be at least twice the width, so 30cm (12in), minus the bark and the sapwood.

CLEAVING THE SHINGLES

Cleave the logs in halves and then in quarters. Next, make 'boards' about 1cm (3/$_8$in) thick.

Important rule: wood cleaves straight if there is the same amount of wood on each side. If there is (a lot) less wood on one side of the froe, then the cleft will most likely slant. This means you have half a roof tile on one side and a thick roof tile that needs chopping or cutting on the other.

Cleave the shingles from quartered logs. Look at what you have got: how many shingles can you make? Mark this on the crosscut end. Then cleave a couple of 'thick roof tiles'. Cleave them in half and continue doing so; see right.

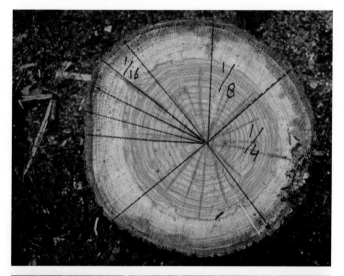

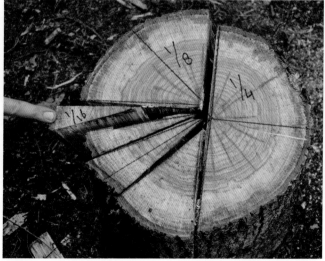

FINISHING CLEFT SHINGLES

If necessary, you can tidy up the shingles on one side using an axe or drawknife. Leave the other side as is, because otherwise you will damage the fibres. Remove the bark and sapwood. It is nice to make a facet on the side that you see, by breaking the sharp transition from cleft to crosscut wood, but you do not have to do this. The shingles have to be the same length but may vary in width.

APPLYING TILE BATTENS

For the roof, hammer horizontal tile battens measuring 2.5 x 2cm (1 x $^3/_4$in) onto vertical battens (4 x 2.5cm/$1^1/_2$ x 1in). Space them half the length of the shingles apart. Double the bottom tile batten so that the roof gets an even slant.

OVERLAPPING SHINGLES

To get a watertight roof, it is important to get the overlapping right. Will the roof tiles overlap twice or three times? It depends on where you use them. If the roof covers your log pile it is not a disaster if some rain comes through, so you could use less overlap. Should you cover the roof of your home, you will need a lot more overlap. In such case, insulation and foil will also be used.

TESTING THE SHINGLES

It can be useful to test the way you want to put the shingles on the roof. Lay out some of the shingles on the ground so that you see what surface area you can cover with the shingles that you have.

Start at the bottom. With the first row, the space in between the tiles only gets partly covered, unless you start with a row of half tiles underneath. Put the next row of whole shingles down. Each next row overlaps the previous row with just over half a length. Determine if you have enough shingles.

Hammer the shingles onto your roof with special nails (big flat heads) or use screws. Pre-drilling nail holes prevents the shingles from splitting when you nail them down. The final (top) row of shingles has to be covered with a board. All the different shingles together make a beautiful roof. The only thing you need to do now is sit under it while the rain is falling down; watch the drops and trickles of water fall off the roof.

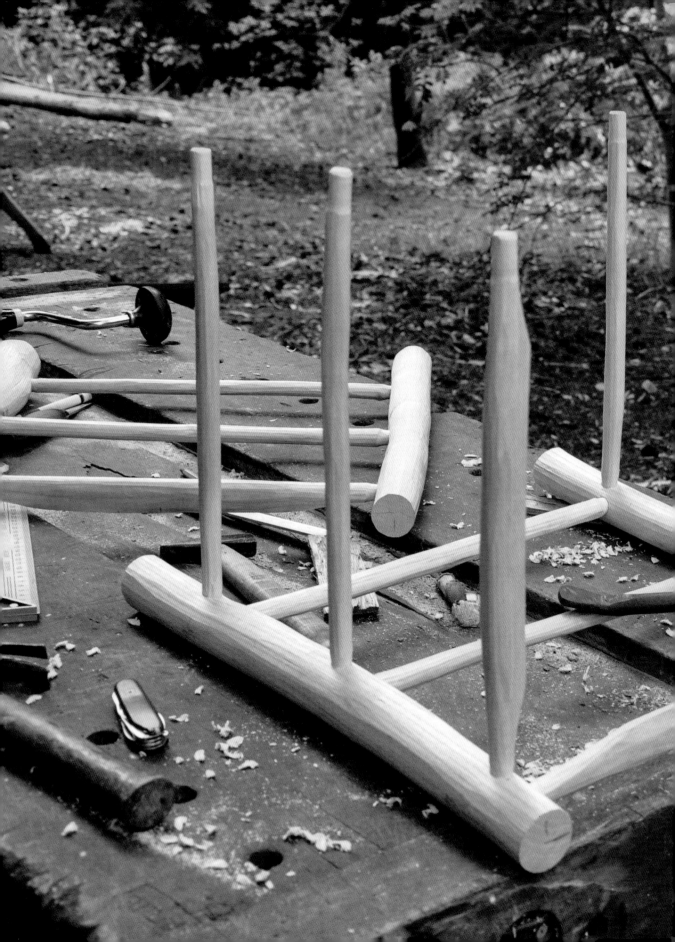

7. PROJECTS MADE WITH GREEN WOOD: DIVING DEEPER

• STOOL WITH RUNGS • CHAIR

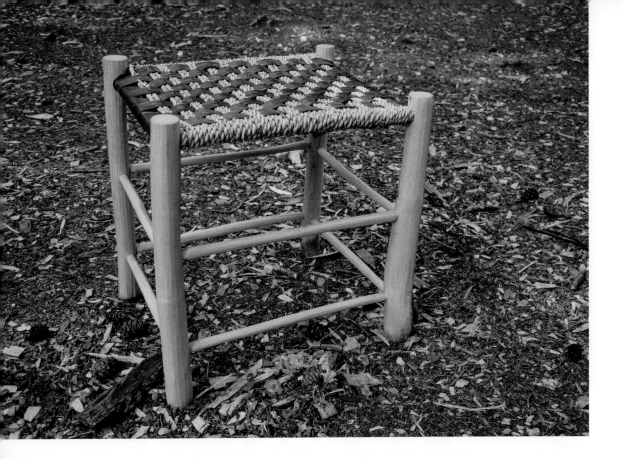

PROJECT 6: STOOL WITH RUNGS

We are now going to delve deeper and show you how to make a stool with four legs and lots of rungs. The mortice and tenon joints will be made very precisely, down to the millimetre. With this piece, you take advantage of the fact that round tenons shrink and become oval while drying. If you hit an oval tenon into a hole that is just a little bit smaller than the tenon, you get a super strong, glueless joint that could last 100 years.

You can add any seat you like to this sound, elegant stool. Experiment with different materials and patterns. Enjoy yourself and make a unique masterpiece that will stand the test of time.

The stool has four legs that are interconnected with rungs. We use a different type of mortice and tenon joint than with the tripod stool. With this project, you profit most from the strength of cleft wood. You could make the rungs really thin! Before you start, read the sections about cleaving and making tenon and mortice joints for a chair (pages 54–56 and 60–64). The tenons on the rungs are made with a 16mm (⁵/₈in) tenon cutter, but you can also make them on the shaving horse. You can finish them with a knife. Work with great precision! If the tenon is too large, it will split the leg; if it is too small, the joint will come loose.

MATERIALS

- **Wood:** oak, ash, birch, maple, fruit tree... whatever there is available! Adjust the sizes of the joints if you use a softer type of wood, so use a 19mm (³/₄in) tenon cutter for instance.
- **For the legs:** a log, 50cm (19³/₄in) long, 15–20cm (6–8in) diameter.
- **For the rungs:** a log, 45cm (17³/₄in) long, 20–25cm (8–10in) diameter.
- **For the seat:** rope, old inner tubes, tree ties, old tie-down straps, bark.

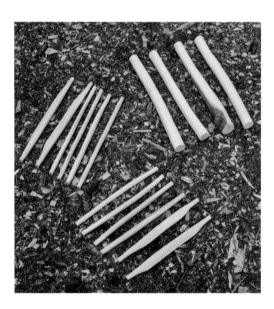

CLEAVING THE LEGS

Cleave the log for the legs into four equal parts. Tidy them up on the shaving horse. You could remove the bark and make the legs completely round; you could also choose to leave the legs quite rough, with the bark still attached. The legs should be at least 3cm (1³/₁₆in) wide, because of the depth of the drill holes.

Put the legs away to dry. It is good to leave them for a while before assembling the stool, to prevent the legs from splitting when you hit the tenons in.

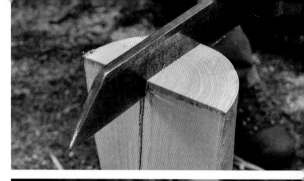

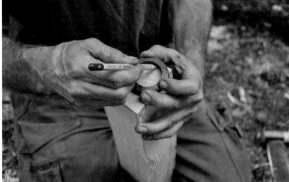

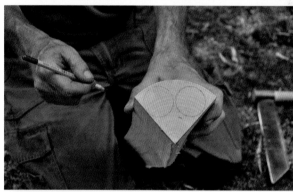

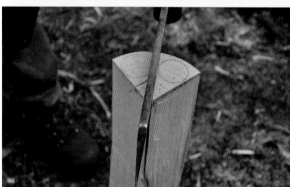

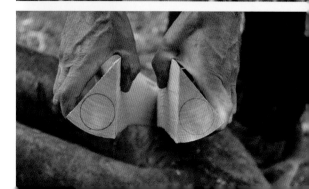

MAKING THE RUNGS

You can make the stool as big or small as you like; our chair will be 46cm (18in) high, with a short side of 35cm (13³/₄in) and a long side of 45cm (17³/₄in).

You need eight 'regular' round rungs for the stool, and four 'flat' ones, or seat-rails, to hold the seat.

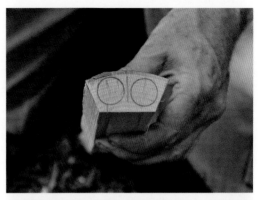

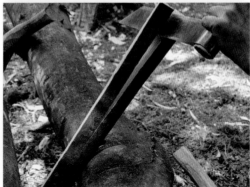

Cleave the log, following the rules of the art of cleaving. Cleave the log through the middle; then again and again, so that you have eight parts. Four of these will be the seat-rails. The other four will be used for the eight regular rungs. You can do this by cleaving the parts again radially. If this is too hard (because they get too thin), try to cleave them tangentially (see technique 1, page 56).

You should now have eight rather thin pieces of wood: at least 2cm ($^3/_4$in) thick. Saw them off at the desired length and tidy them up on the shaving horse. If the wood cleaved well and it is ash or oak, you could make them very thin. A rung made with good wood with a green diameter of 18mm ($^{11}/_{16}$in) will be very strong after drying.

Do not finish the rungs completely until you have made the tenons. Choose how to do this: either on the shaving horse or with a tenon cutter (see technique 4, pages 60–64). You need to make a tenon at both ends of the rung that will fit inside the holes. Here, we cut 16mm ($^5/_8$in) tenons on all rungs.

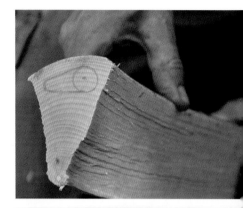

Once you have made the tenons the right size, you can finish the rungs with a drawknife or spokeshave. Be careful! Do not let the knife slip into the tenon you just made because that will ruin it. Please work in a very controlled manner, from the elbows and shoulders, by tightening the arm muscles while working with the drawknife. This way, you can stop the movement at any given moment. Try it! For safety reasons, you could also use the drawknife as a pushknife, if you put the knife in the wood just behind the tenon. Make eight nice round rungs for the stool.

MAKING THE SEAT-RAILS

To support the seat on the stool, you need to make broad, flat seat-rails. This is a somewhat different technique. Because we make use of the 'oval shrinkage' of the tenons with assembling (see technique 4, page 60), it is important to make the seat-rails more or less parallel to the annual rings, in the 'tangential surface'. If we were to just shave a cleft part with the drawknife and make a tenon at the end, we would create a tenon with the wrong shape for assembly, which will split the leg. The pictures show you how to make the seat-rail from the wood. First, make a nice flattened rung (think of the shape of a plane's wing). Next, make a neat transition from the width to the ends. Make neat tenons at the ends.

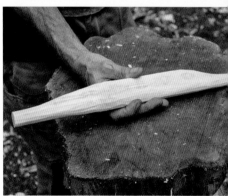

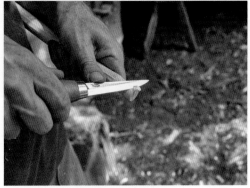

↑↑ *Two tenons: the right one has been flattened and has a 'seeker'.*
↑ *Chamfer, by rounding off the edges of the tenon.*

DRYING

Make sure the legs are dry but not too dry. The rungs and seat-rails have to be really very dry (see technique 7, page 68).

MEASURING AND PREPARING TENONS

For precision, we have removed the imperial conversions here. Start with a tenon of 16mm. This will shrink while drying, to become an oval tenon. The wide part of the tenon is roughly 15mm and the thin part about 14mm; it should never be over 14.5mm. If it is, then use your knife to carefully cut off a layer over the whole length. Take care to only do this at the thin side of the oval. The tenon's sharp edges should be rounded off so that it will sink into the hole more easily. You can do this with a wood-carving knife and the thumb push or the draw grip (technique 10, page 74). Check the rungs and seat-rails (so 24 tenons) and make them all the right size.

DRILLING HOLES

Now it is time to drill the holes. Take a good look at the legs. Is there one side that you think should point outwards or face forwards? After deciding, you can drill the holes. First, assemble two side frames and then connect the two. Take two legs that you want to connect. It does not matter whether this is the long or short side of the stool. Measure and mark both legs from the bottom up at 10, 27 and 45cm (4, 10⅝ and 17¾in).

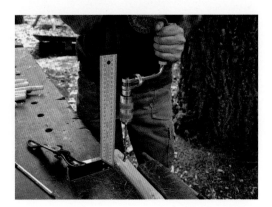

At these marks, with the brace and a 14mm ($^9/_{16}$in) drill bit, drill holes that are 2.5cm (1in) deep. We recommend drilling a trial hole in a piece of scrap wood. Count twenty turns and lift the drill. Measure the depth of the hole. Determine how many turns you need to make to get a hole of 2.5cm (1in) deep. Remember this number for the rest of your life.

You could also mark the drill with a pen or stick a piece of tape on the drill at the right height. If you do this more often, you could use an iron saw to make a 1mm ($^1/_{16}$in) deep cut around the drill, at the right height.

Drill the three holes straight into the first leg. This is most easily done by securing it firmly, in the vice of a workbench for instance, or by holding it tight with a holdfast. You could use a carpenter's square to make sure the hole is straight. Remove the drill dust from the holes and repeat with the second leg.

ASSEMBLING THE SIDE FRAMES

Assemble two side frames with the same dimensions. Firmly secure one of the legs you just drilled. Hammer in three same-size rungs; use force and control! A normal metal hammer works best. Keep a close eye on the tenon's positioning in the hole. The thick side of the oval should be perpendicular to the wood's grain (or the wood may split). Hit the tenon in the hole with firm hits. You will hear and feel when the tenon has reached the end of the hole. Make sure to hit the tenon straight on the top, or else you could easily break off a piece and you really do not want that to happen.

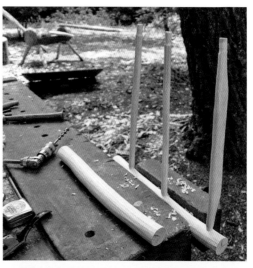

Put the second leg with the holes facing downwards in the right position on the rungs. Remember to place the seat-rail in the correct way! The 'wing' of the rung should point inwards. Sometimes you have to bend the rungs a little bit and that is fine. If they are well made, they will be strong enough. Hit the second leg so that the three tenons evenly slide into the receiving holes. Use a wooden hammer or use a wooden block to take the force of the blow. Sometimes it works better to hammer in one tenon first, so that the rest are easier to guide. To prevent damage, wrap a piece of leather around the wooden hammer or the wood.

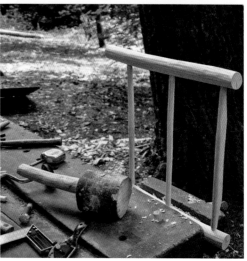

And there you go! You just made your first side frame! If you did this properly, it can take your weight. Look for a high place and hang your frame from it. Then (carefully) transfer your whole weight to the frame. You have just made a very strong wood joint! Repeat this for the other frame of the same size.

CONNECTING THE SIDE FRAMES

Now you have two equal halves that have to be made into one. The principle is the same as above. With the thinner legs, where there is less 'receiving' wood, it is important that the rungs are not at the same height so they do not meet inside the leg. This would make the joint weaker. Therefore, drill holes 1cm ($^3/_8$in) under the middle of the rungs that are already inserted. This way, you even strengthen the joints because the tenons will secure each other internally. Do this with the seat-rails, too. You can also avoid this problem with the other rungs by moving them a few centimetres.

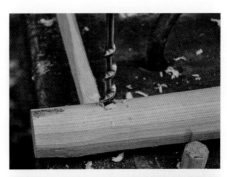

Drill six holes in the first half and then six in the other. It can be tricky to assemble everything but it will get easier after you have done it a couple of times. An extra pair of hands is welcome to easily manoeuvre the tenons in front of the holes.

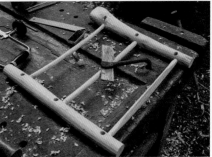

Make sure that all tenons disappear completely into the receiving holes. You could make a pencil mark on the tenon, at 2.5cm (1in), so that you can see how far the tenon has gone in.

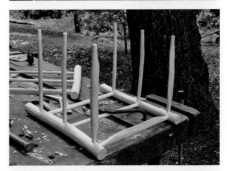

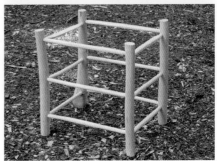

ALTERNATIVE ASSEMBLY

Instead of hitting with a hammer, you can also squeeze the frame together with a vice or heavy clamp. It gives more control but the disadvantage is that you have to keep tightening and loosening the clamp. Give it a try.

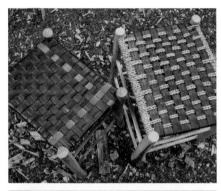

If you have made the stool correctly, you now have a rock-solid piece of furniture that can be enjoyed for the next 100 years. Reaching this point is great fun every time it happens! Using a natural material, you have made a unique and super-solid piece, with nothing but manual power and some good tools. Congratulations! All that is needed now is a seat and you can enjoy a well-deserved rest.

WEAVING THE SEAT

In our courses, we usually use rope for our seats. There are many possibilities. Do not use very thin material as that would make this a time-consuming job. Having said that, you could, of course, experiment. Old bicycle inner tubes look good and make a comfortable seat. Try your local bicycle-repair shop: you could walk out with bags full.

Traditionally, chair and stool seats were woven from bark. Elm bark is most suitable for this but because of Dutch elm disease, the number of elms has dropped dramatically over the last few decades and therefore there is not much elm bark available.

FINISHING

The legs still stick out over the seat. Saw them off at 2cm ($^3/_4$in) from the seat. If the stool is a bit wobbly, level it (see technique 8, page 69). If you want, you can tidy up the legs with a scraper or sandpaper. Oil the wood and enjoy.

PROJECT 7: CHAIR

You may be sitting on one right now. Chairs are often taken for granted. But if you take a good look at one, it usually is a fine piece of craftsmanship, especially if it is made of wood. In this chapter, we show you how much fun it is to make your own chair. A comfortable chair that can last a century.

HISTORY AND TRADITION

The chair, as an object, has been around for millennia. In ancient Egypt, the pharaohs sat on big chairs, thrones of wood or ivory, heavily decorated with carvings and gold leaf. But even before then, in the Stone Age, there were already chairs that were probably available to everyone. It took many thousands of years before that was the case again.

For centuries, chairs have been made the way you will learn in this chapter. Chairmakers in England, called bodgers, used to make the separate parts of the chair in the woods and assemble them later, after they had dried. The cities were supplied with chairs, straight from the woods. This way of working avoided having to carry heavy logs to the sawmills. In the UK, but also in the USA and Eastern Europe, there are still people that make traditional furniture this way.

A CHAIR FROM GREEN WOOD

If you are a greenwood novice, making a chair is quite an ambitious job; for the more experienced woodworker, a chair could be a true masterpiece. It is going to take you five days to make just the frame of a simple chair (here, we will make a frame without a fixed seat, which we will weave later). This basic chair can last 100 years. It is important to work neatly. One weak part and your whole chair is ruined. This chair and the method have been inspired by Mike Abbott's *Going with the Grain*.

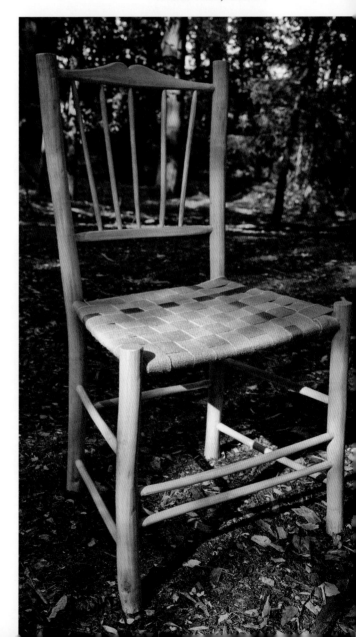

↓ *A chair made from ash.*

MATERIALS

- Two logs of green wood, 1m (39in) long, 30cm (12in) diameter. It is important that the wood is even-grained, without notable knots or deformities. Preferably ash, but oak and beech are suitable too.

The chair consists of legs and rungs. This table shows the size of the parts.

PART	AMOUNT	LENGTH	DIAMETER
front legs	2	50cm (19³/₄in)	40mm (1¹/₂in)
back legs	2	90cm (35¹/₂in)	40mm (1¹/₂in)
seat-rail, front	1	46cm (18in)	see text
seat-rails, back/side	3	35cm (13³/₄in)	see text
rungs front	2	46cm (18in)	18mm (¹¹/₁₆in)
rungs side middle	2	35cm (13³/₄in)	18mm (¹¹/₁₆in)
rungs side bottom	2	37cm (14¹/₂in)	18mm (¹¹/₁₆in)
rung back	1	35cm (13³/₄in)	18mm (¹¹/₁₆in)
spindles	5	30cm (12in)	10mm (³/₈in)
backrest bottom rung	1	36.5cm (14³/₈in)	see text
backrest top rung	1	41cm (16in)	see text

Another possible way to do this is to simply copy a chair you like. Adapt the dimensions and then follow the steps in this chapter.

CLEAVING

Make the parts of the chair by cleaving the wood and tidying it up with an axe, drawknife and spokeshave. If you have a good log, you should cleave it as efficiently as you can. Cleave it until you have all the parts. Finishing with an axe is often not even necessary, and you can start immediately shaping the parts on the shaving horse.

Make all the rungs and seat-rails the same way as for the stool (see technique 1 and 4, pages 54 and 60). In this case, we use a 16mm (⁵/₈in) tenon cutter and a 14mm (⁹/₁₆in) drill for the tenon and mortice joints.

MAKING THE BACKREST

The backrest is a frame that you make with two bent rungs, with five spindles in between. Make sure that the rungs are high enough to fix the spindles. These parts of the chair have to made of absolutely flawless wood because they will be steamed and bent.

The backrest's bottom rung is 36.5cm (14³/₈in) long, and 2 x 2cm (³/₄ x ³/₄in) square. The flat sides make it a lot easier to make the holes for the thin spindles or slats. Make 16mm (⁵/₈in) tenons with a tenon cutter.

The backrest's top rung is 41cm (16in) long and is made of a thin cleft part that, on the shaving horse, has been made into a plank of 2cm (³/₄in) thick and 3.5cm (1³/₈in) wide. Shape this in a way that the width gradually slopes towards the tenons. You can choose any shape you like but try to keep it simple. Make 16mm (⁵/₈in) tenons with a tenon cutter.

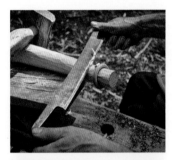

MAKING THE LEGS

Making the legs on the shaving horse is quite a job! You have to make long bars with an even diameter: no more than 4cm (1¹/₂in) thick – any thicker and they will be hard to bend. Cleave the wood until they are the right size; use a cleaving brake (see page 56) to cleave them evenly. Then draw a 4cm (1¹/₂in) circle on one of the ends. Old wooden curtain rings are handy, as you can use them to keep measuring your legs while working on them (available at haberdasheries or charity shops). Work on the whole leg and always in the same direction; never from both directions as that will cause problems in the middle. By working in one direction only, you maintain the grain and the legs will be stronger. First, make them roughly the right size and then finish them with a spokeshave and a scraper.

STEAM BENDING

To provide comfort, the back legs and backrest will have to be bent. This is done by steaming the legs for an hour and then bending them with a jig. For the back supports, thirty minutes in the steam is enough (see tools: setting jigs, page 153).

There are several ways to generate steam. A big pan of water on the fire with a bin bag over the top works well. Attach the bag with rubber bands, a tie strap or carrier straps. If you intend to do this more often, it could be useful to make a simple installation. We work with a wooden crate; the steam gets blown in by a hose pipe. The hose pipe is connected to an old gas canister full of boiling water, where the steam is generated.

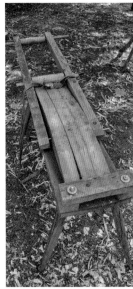

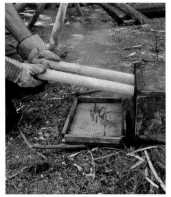

BENDING LEGS

After the legs have been steamed, remove them from the crate or other steamer (always wear gloves!). You now have a very short time (about two minutes) to place the legs on the setting jig, as they will cool down quickly.

Place the legs in the setting jig and push down the lever to bend the legs over the mould. Let your helper fix the lever with a tie strap or a clamp. Hit a couple of wooden wedges in between the legs and the mould to bend them even more. There you are!

Leave the legs on the mould for a couple of days so they will set properly. When you take them off the mould, they will bend back a little bit but they should keep a good curve.

BENDING THE BACKREST

This is best done in a vice. Put the mould in the vice and put the contra-mould on the workbench. Take the parts from the steamer and put them between the mould and contra-mould. Tighten everything and hit a couple of wooden wedges in between the mould and the rungs so that the wood follows the mould neatly. Leave to dry and set for a couple of days.

MAKING SPINDLES

Between the backrest's top and bottom rungs, some thin spindles will finish the backrest. Here, you can experiment to your heart's content. You could cleave twisted branches and fix them in between the rungs, but do not do this if it is your first time. Keep it as simple as possible. In the end, simplicity is not only the prettiest but also strongest and easiest. In the box on the left we describe a couple of options.

ASSEMBLING

Put all these parts together. It is quite a puzzle with all those tenon and mortice joints! Go about as follows.

MAKING THE BACKREST

If you make the version with spindles: in the upper and bottom rung, drill five 8mm ($^5/_{16}$in) holes of 2cm ($^3/_4$in) deep, at an equal distance. Drill the middle hole at a right angle, but the holes on the left and right should point slightly out (bottom rung) and slightly in (top rung). This is because the top rung is slightly longer than the bottom one and it is nice to have the spindles fan out. You do not have to measure this exactly, but you can if you want to. In practice, it suffices to just keep the brace at a slight angle while drilling.

If you make the version with slats: you do the same as above, but you make 20mm ($^3/_4$in) holes by drilling two 8mm ($^5/_{16}$in) holes with 4mm ($^3/_{16}$in) in between. Remove the 4mm ($^3/_{16}$in) with a sharp chisel. Make sure the rung is well secured while doing this.

Carefully hammer the spindles (or slats) in the bottom rung, one by one. Lay the top rung on top and hammer everything in place. The backrest is ready.

CHECKING THE TENONS AND FINISHING THEM

Before you continue by drilling holes in the legs, check all the tenons that you have made on the rungs. Have they shrunk as expected? Do they need tidying up? They must not be wider than 14.5mm on the thin side. Use a wood-carving knife to cut a facet at the end of the tenons: 2–3mm ($^1/_{16}$–$^1/_8$in) from the end, cut at a 45-degree angle so that you have a 'seeker' on the tenons that will help them find the holes. Also do this with the backrest.

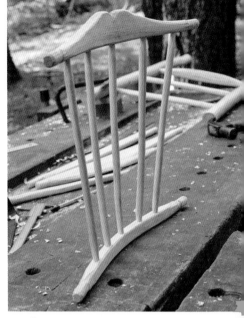

Put both the back legs back on the setting jig. You can also clamp them on a workbench; just use what you have. It is important to drill both legs at the same time because of the 'splay' that we will give them, to turn them slightly outwards. That looks nice and is also the reason why the top and bottom rungs of the backrest are different in size.

On the back legs, mark the point where you want to drill the holes for the seat-rail and the two side rungs. Because we 'twist' the legs outwards, it is important to drill the holes at an angle from the vertical; an angle of about 30 degrees from the vertical is fine. Use a bevel to help you with this angle.

It is very useful to make a 'centre finder' for this (see box below). This will help you to determine exactly where to drill.

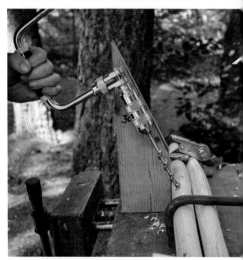

MAKING A CENTRE FINDER
Simply do this by drilling a 6mm ($^1/_4$in) hole in a 4 x 4cm (1$^1/_2$ x 1$^1/_2$in) piece of timber that is 12cm (4$^3/_4$in) long. Make a 'beak' on one end by sawing it off at a 45-degree angle, from two sides. Work very neatly and precisely. Now push a large 6mm ($^1/_4$in) nail through the hole (see the centre finder in use, see overleaf).

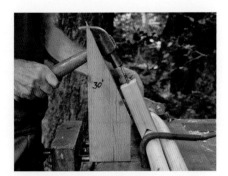

↑ Using the centre finder.

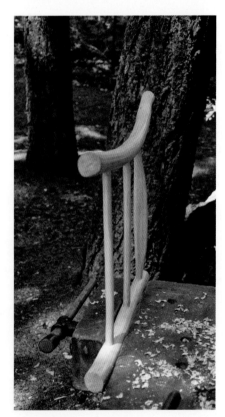

↑ The side frame as a whole.

Mark the three drill points at 11, 28 and 45cm ($4^5/_{16}$, 11 and $17^3/_4$in) from the bottom of the leg. Do this by placing the centre finder at the right height, parallel to your bevel. Hit it firmly with a hammer and you will know exactly where to drill because the nail marks the right spot. Nice trick. Repeat for the other leg and drill 2.5cm (1in) deep holes at the marks, holding the brace at the right angle.

Secure the front legs one at a time, and also drill holes at 11, 28 and 45cm ($4^5/_{16}$, 11 and $17^3/_4$in) from the bottom up. Drill the holes straight in (not at an angle!).

ASSEMBLING BOTH SIDE FRAMES

Hammer the rungs into the legs and make sure that the right rung ends up in the right place – and faces the right direction! Be really careful, as we regularly see a seat-rail end up in the wrong position:

- at 11cm ($4^5/_{16}$in): 37cm ($14^1/_2$in) rung
- at 28cm (11in): 35cm ($13^3/_4$in) rung
- at 45cm ($17^3/_4$in): 35cm ($13^3/_4$in) seat-rail.

Then take the other leg and see if the rungs connect nicely. Sometimes you have to shorten one of them to get a good connection.

Use the same method as for the stool (see page 121). Keep in mind though, that it is a lot harder to hammer them in properly because of the curved legs. The wooden hammer will not be as effective because of the curve of the wood. Always put a block of wood under the point where you hit it, so that the bent wood will not absorb the blows. Once you start, you will understand what has to be done.

After a short – or perhaps longer – struggle, you will have all rungs of the side frames in place. Now it is time to connect the two parts and make a chair.

PREPARING THE DRILLING OF THE SIDE FRAMES

Put one frame down on a workbench. Put 5.5cm (2³/₁₆in) blocks under the back leg so that it comes off the work surface. This is necessary to compensate for the difference in the front and the back of the chair: the front rungs are 46cm (18in) long, while the back rungs are 35cm (13³/₄in) long. By compensating for half of this difference, you can drill straight up, at a 90-degree angle from the work surface; see picture. Secure the frame well with one or more clamps, a holdfast or a tie strap.

↑ *How to secure the side frame in order to drill at a right angle.*

DRILLING THE HOLES FOR THE RUNGS

Drill holes on these marks:

- **Front rungs:** at 16 and 22cm (6⁵/₁₆in and 8⁵/₈in) from the bottom of the leg.
- **Back rung:** at 22cm (8⁵/₈in).
- **Seat-rails:** 1cm (³/₈in) away from the drill hole in the side panel (as with the stool).
- **Backrest's bottom rung:** 12cm (4³/₄in) above the seat.

Determine the top drill point for the backrest's top rung by measuring the backrest or by holding it against the back leg and marking it. With these last points, it is important to drill at an angle because the backrest is curved. Determine the angle by holding the backrest against a surface, at a right angle. Now copy the angle that the rungs and flat surface make with a sliding bevel. This is the angle that you have to use while drilling. Make sure you use this angle to the correct side!

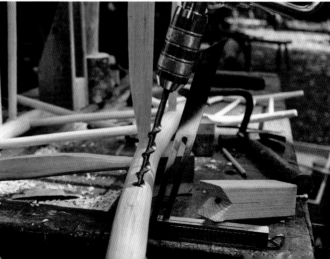

ASSEMBLING THE CHAIR

Once you have drilled all the necessary holes, hammer the rungs into the front and back leg of this side of the chair at a right angle. Also attach the backrest at the right angle. That is the easy part.

Next, the other half needs to be attached and that is a little bit harder. Arrange for at least one other person to help you – that will make the job a bit easier. First, shorten any rung that is longer than the rest. You can also use a large clamp or sash clamp. Just see what you like best. Because the backrest is curved, it will be harder to hammer it into the holes. While assembling, you can hit the back rungs firmly so that they are forced into the holes.

If it all goes well, after a 15-minute struggle you will be the proud owner of a CHAIR!

TIP: for easier assembly, you can make the backrest's tenons a bit smaller. You can secure these by applying a small pin, straight through the leg and tenon.

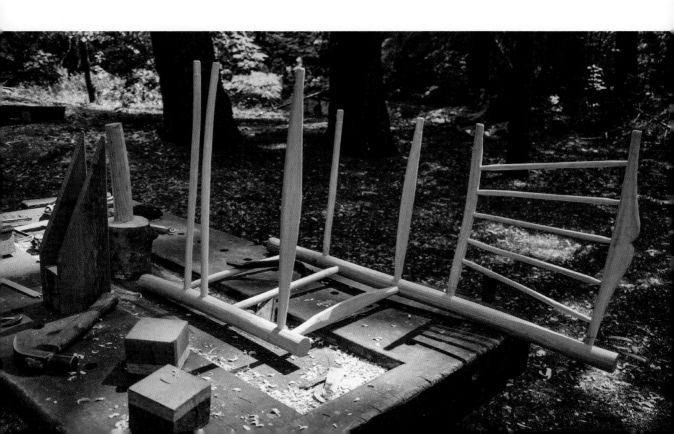

FINISHING

You can sand the chair lightly or finish it with a scraper. If you choose to do this, it may be wise to do so before assembling. Work on the whole wood surface and use long strokes. If everything is made smooth with a drawknife and spokeshave, it is not really necessary to sand it down.

To protect the chair, you can oil it. Choose a natural oil, preferably not a varnish or stain.

Let the chair dry and weave a comfy seat. There are all kinds of materials that will quickly give a nice result: tree ties (used to attach trees to a support pole), bicycle tubes, bark (elm or lime/linden, although these are hard to come by).

With rope you can weave beautiful patterns. The sky is the limit! You can find good patterns and techniques in Mike Abbott's book *Going with the Grain*. After weaving the seat, your chair is ready! A greenwood craft masterpiece is finished.

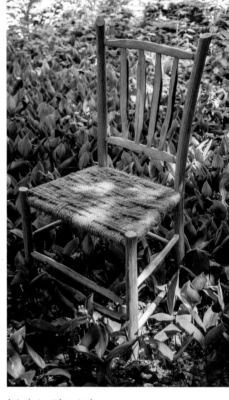

↑ *A chair with a sisal rope seat.*

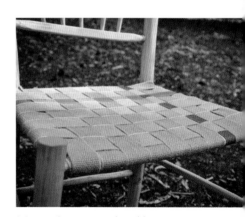

↑ *Seat with tree ties and an old tie strap.*

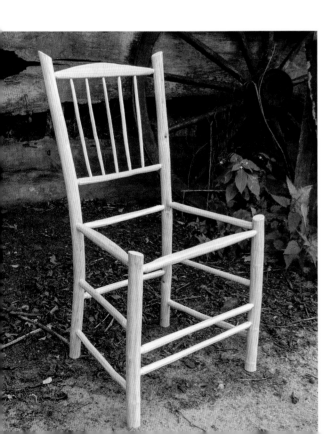

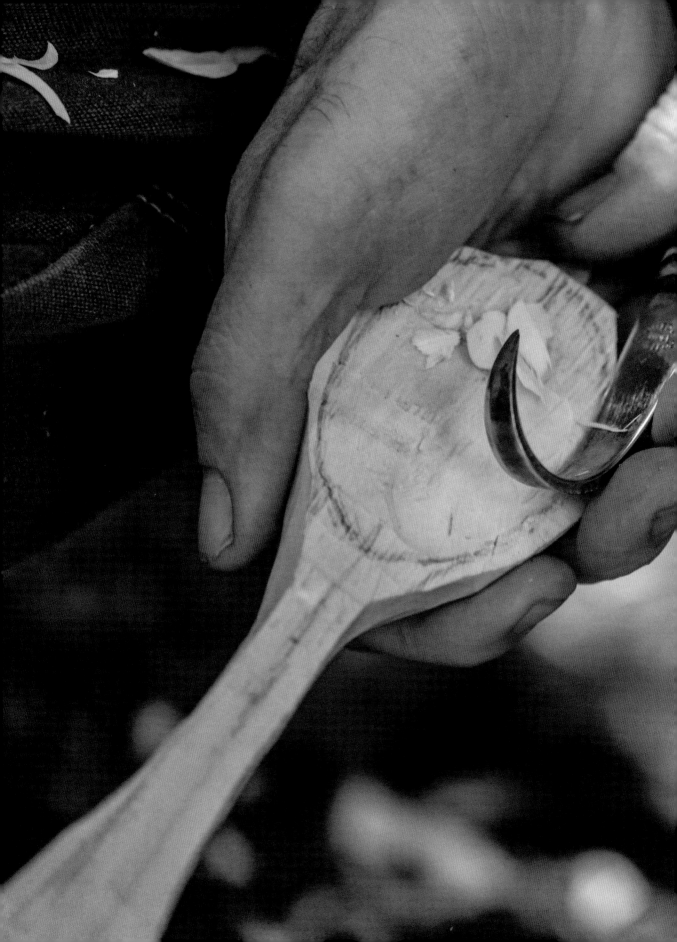

8.CARVING PROJECTS

• SPATULA • SPOON • SALT SCOOP

In this chapter, you will learn how to carve with a knife and spoon knife, and chop with an axe in the Swedish spoon-carving tradition. This is minimalistic woodwork: no workbenches, just your own body and hands to hold the objects. Perfect to do in winter, next to the wood burner, or in summer at a campfire.

PROJECT 8: SPATULA

The spatula is a great and simple object. A tool to help you stir onions and flip pancakes. You can make one in an hour. A spatula is, in fact, just a thin paddle with a flat handle. A round handle is for wooden spoons, but a flat handle will not turn in your hand, which is good when you are flipping pancakes. Maple is ideal because it does not absorb smells or give off a scent; birch is good too. Oak and other woods that contain tannic acid will affect the taste of the food. Wood with big pores (like oak) absorbs too much moisture and food, which can be unhygienic.

MATERIALS

- **Wood:** maple or birch; fruit wood is also good but is more solid (meaning harder work!).
- **Log:** 25cm (10in) long, 12cm (4³/₄in) diameter.

EVERY DAY
'Every day we use the spatula I made here!' This was said by an enthusiastic child from a Steiner school in the Netherlands. A year before, she had made her own spatula with us: cleaving, chopping and cutting wood. It is incredible how much fun it can be to make something that you can use every day. Now, there are hundreds of people who know what a lovely job it is. And we hope that many thousands of people, and especially children, will experience this too.

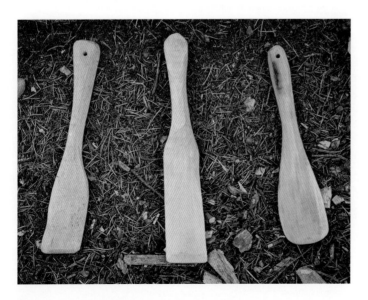

CLEAVING THE LOG

Cleave the log with the froe or an axe through the middle and then in fours; try to keep the froe as central as possible each time (see cleaving, page 55). Then cleave a slat as thin as you can, 3–4mm (about $^1/_8$in) would be great but that is not always possible.

You can cleave the wood radially (perpendicular to the annual rings) or tangentially (parallel to the rings). Make sure there is no pith in the wood to minimize the risk of splitting. Also remove the bark. Knots can be attractive, especially in the handle – preferably not in the spatula itself, as the wood is harder to cut.

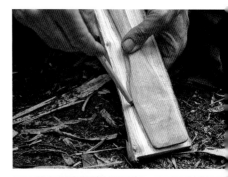

ROUGHLY SHAPING THE SLAT

Draw a spatula on the slat (or trace one) so that you have a shape to work with. Look at the wood: a nice knot in the handle or a discolouration gives the spatula extra character. Cleave the sides off the slat until it has the desired width. When the slat has the right width, you can narrow the part of the handle with an axe and/or a knife. You also can saw the wood up to the width of the handle, at the point where the handle changes into the spatula, and then cleave this bit off. If the slat is still quite thick, we would recommend you make it thinner with an axe (or with the drawknife, on the shaving horse). You now have the rough shape.

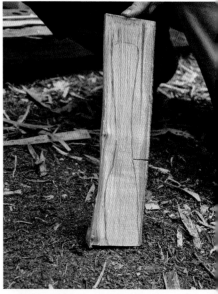

SHAPING THE ROUGH SPATULA

Carefully work towards the pencil marks. You can do this with an axe (see technique 2, page 57) or with a wood-carving knife. If you have a lot of experience with an axe and have a good sharp one, you could make the spatula using just that. Hold the axe close to the head for maximum control and chop off small pieces. You can also use the axe to cut along longer lines, like the handle. Thinning the wood of the spatula can also be done (carefully!), with an axe.

If you make the spatula with a wood-carving knife, use the different grips (see technique 9, page 70). First, work closer to the pencil line so that the shape is right. A thinner slat is easier to work with. Use the forehand grip and the pull stroke to shape the handle. Use the thumb push and draw grip to round off the corners. Remember: while shaping the transition from the spatula to the handle, it is important to work on both sides of the spatula, because this is where the grain of the wood could twist.

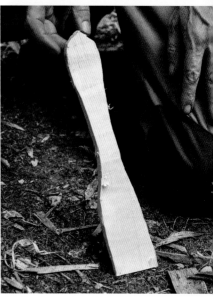

'But you can buy a spatula for next to nothing at the supermarket!' one of the participants of our workshop said. 'Why would you invest so much time in making one?' A fair question, maybe, but we find that most students get carried away making something that is as common as a spatula. They often end up telling us how much they enjoyed making it. The cleaving and cutting techniques may look easy, but they aren't always. Making something useful is a great experience in today's modern society. The spatula will become a part of you.

FINISHING THE SPATULA

To finish the spatula, you can carve the surface even smoother. You can do this when the wood is green but it will be even better if the spatula has dried for a couple of days. You can also round off the corners between the top and sides. At the end of the spatula you can cut a slanted edge so it is easier to wedge it under a pancake.

If you want to smooth the spatula even more, you could continue with a scraper or sandpaper (from rough to fine grit). Finish with vegetable oil, either olive or walnut oil.

You can, of course, decorate the handle in lots of ways, with carvings or a wood-burning tool. Experiment or just keep it simple.

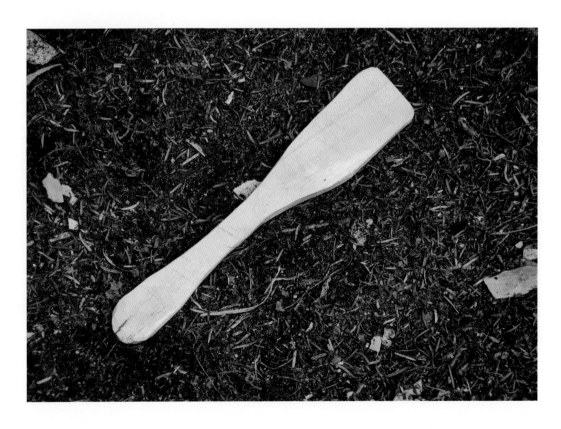

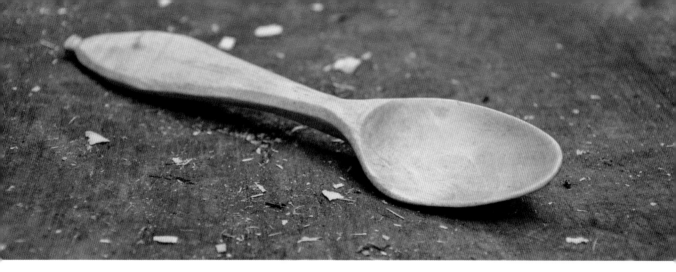

PROJECT 9: SPOON
'REST IN PROGRESS'

During the first years of our workshops, we hardly ever used a knife. We did everything with a froe, axe and drawknife. Until we were introduced to the great skill of spoon carving. Just like working on the shaving horse, it is very addictive, but different... smaller, more intimate. Something you do by the log burner in winter, although it is also fun to do in front of your tent in summer.

A big advantage of spoon carving is that you need considerably less wood than for a stool or chair. You will always find a piece of wood you can use. In this chapter we will explain how to do that. The art of spoon carving in the Netherlands is very much indebted to Jan Harm ter Brugge, possibly the best spoon carver of the country.

FINDING A SUITABLE PIECE OF WOOD

For spoons we use birch, maple, alder, apple, pear, cherry, plum, willow, or hazel. Willow and hazel do not dry very 'hard' but are easy to cut and so these types of wood are good for practice. Other types of wood are also suitable – just try them. Oak and ash are less suitable because of the long fibres and the open wood structure with big pores.

Apart from the type of wood, the state is also important. Knotty and bent wood is not advisable, especially with your first spoons. Start with a nice straight log of 20cm (8in) long, with a 7–8cm (about 3in) diameter. A young birch tree is ideal but other wood is good too. Just use whatever is available.

WORKING WITH AN AXE

The log contains two spoons! Start by cleaving it in two, straight through the middle. Put the axe on the crosscut wood, exactly in the middle. Hit it with a piece of wood or a wooden hammer. Usually the log will cleave completely. If not, you can lift the log with the axe and drop it down on the chopping block until it cleaves.

Take one half. The first phase of the work is chopping the rough shape – with an axe. This will make carving a whole lot easier. Working with an axe on such a small piece of wood requires some skill, attention and patience. With every hit, you should be aware of where you want the axe to land. Do not use much force! Let the axe do the work.

Cleave the log and judge both halves (picture 1). Are they both suitable? Or do you have to reject one because of flaws in the wood? Take the best part and remove the pith along the whole length.

Work with the axe on the bottom flat part (about a third; pictures 2 and 3). Lower this part – without making a slope – all the way to the end (see box, right). You do this by prising the wood fibres with the axe while chopping (see technique 2, page 57). It is best when the slope of the part where the bowl comes goes up a little at the end (picture 4).

Now turn the wood around and lower two thirds of the convex side. Only work on the part that will become the handle (picture 5). Now you have made a curve in the wood that will give your spoon a nice shape (picture 6).

Use the axe to make the handle part narrower. Make sure out that you do not make a pointy handle. Keep everything as straight and angular as possible at this stage. This will give you clarity and stability on the chopping block (picture 7).

Chop the part at the back of the bowl (picture 8). Do this by applying 45-degree corners. Towards the point, you lower the bottom side of the bowl. Make a 45-degree transition where the bowl is fixed to the handle. At this stage, you could also (roughly) design the shape of your spoon (picture 9).

Make two saw-cuts at the neck of the spoon. These cuts will help you remove this bit more safely. Work from both sides of the handle towards the saw-cuts. In the picture you see only one saw-cut; on the other side, the wood has been chopped off (picture 10). Do as much of the chopping with the axe as you feel comfortable with (picture 11). For the refinements, you will use the carving knife, see page 142.

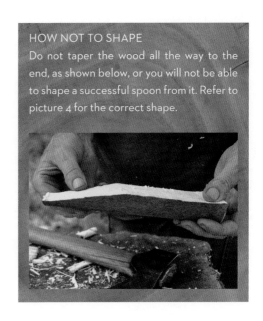

HOW NOT TO SHAPE
Do not taper the wood all the way to the end, as shown below, or you will not be able to shape a successful spoon from it. Refer to picture 4 for the correct shape.

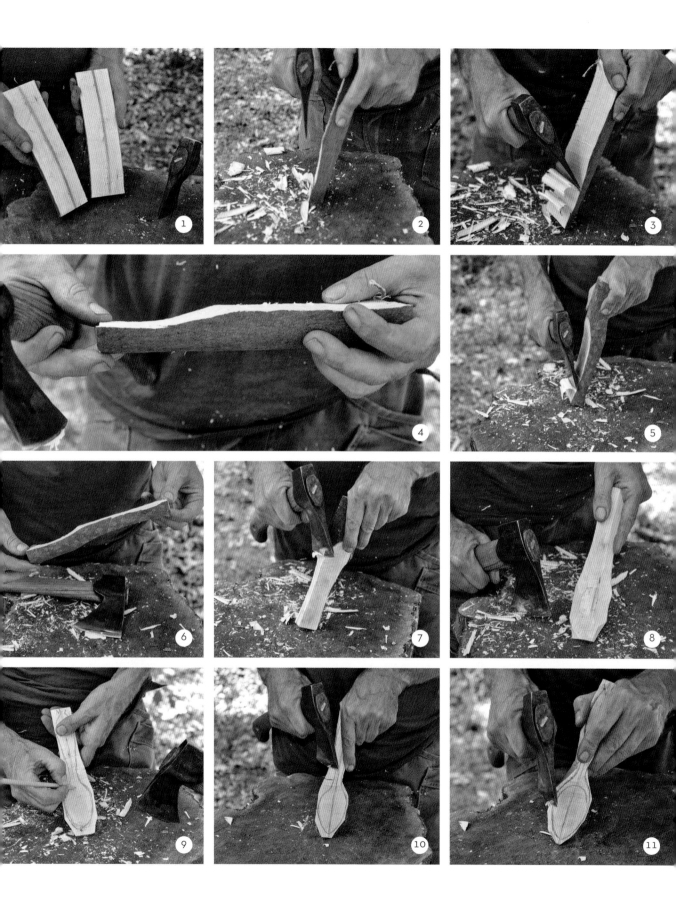

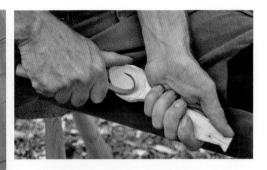

WORKING WITH A KNIFE

Start by hollowing the bowl (see technique 10, page 75). It does not have to be perfect at this stage. Carve with the spoon knife perpendicular to the grain (or fibres) of the spoon. Do not use too much force. Start carefully with short movements until the first irregularities have been cut away and the knife starts to cut smoothly. Work from the centre to the edge. Keep a couple of millimetres along the edges. Do not make the bowl too deep – the average spoon has a bowl of about 6mm ($^1/_4$in) deep.

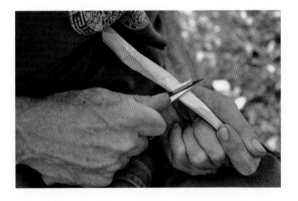

WORKING WITH A WOOD-CARVING KNIFE

First work roughly, with the forehand grip, shin grip and slicing grasp. The chest-lever grip is also good at this stage. With the reinforced pull stroke you can tidy up the handle. Where the bowl becomes a handle, use the pull stroke and the thumb push. Be careful! The grain changes direction here, so always work from both sides to the narrowest point and make sure the handle does not get too thin here. There is no fixed order in spoon carving. It is nice to alternate working on different parts of the spoon, using different carving techniques (see technique 9, page 70).

You will get a logical and elegant base shape by keeping the neck narrow and high and the rest of the handle wider and thin. You have now done a lot of carving, but the spoon is still rough and heavy. As one of our students once said: 'It is about taking everything off that is not a spoon.' It really is that simple.

Every now and then, look at the spoon from a distance, from every angle. Check whether the proportions and symmetry are right. Rounding off all sharp edges, with facets, gives a lovely finish. Make sure all the lines flow. Take your time and cut and carve it to the desired shape. The knifework is now done.

FINISHING

Dry the spoon. You can then sand it down if you want. Some people do not want to do this as it removes all the nice sharp cuts you have made with the knife. You can also finish the spoon by going around it with a very sharp knife. You will notice that the dry wood under the knife looks different than the green wood did. You are now 'closing' the wood, which gives a nice, shiny finish. Using a scraper is another option, but we will not discuss that here.

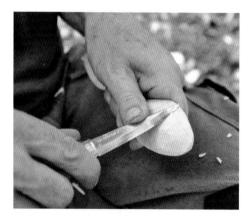
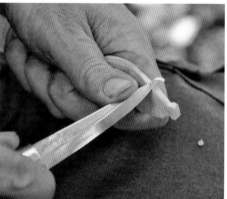

OILING

Several types of oil are suitable. Linseed oil can go rancid and dries very slowly. Olive oil is not ideal but does get used. Marsha van der Meer from 'Baptist' gave us a nice recipe: mix one part coconut oil with one part beeswax, then heat slightly. Apply with your hands onto the spoon. We have not tried it ourselves as we usually work with nut oil. Spread liberally over the spoon. You can heat the spoon beforehand, so that the spoon absorbs it better. Leave, then dry the spoon with a soft cloth. Enjoy your meal.

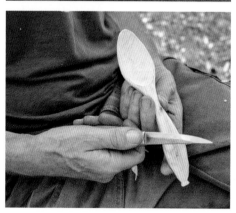

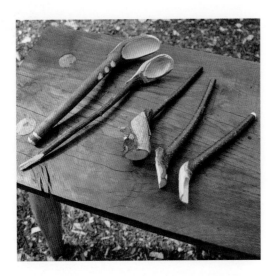

PROJECT 10: SALT SCOOP

A branch with a side branch: every tree has got lots of those. They are the wonderful start of a salt or sugar spoon. Saw a (young) birch or maple branch, and within an hour you will have made a unique spoon. The great thing is that it is made from the wood that you would normally throw away: a branch with a side branch.

MATERIALS

- **Wood:** birch or maple – make sure there are no knots in the bowl part of the spoon.
- **Branch with side branch:** e.g. diameter of the main branch 3cm ($1^3/_{16}$in), side branch 1cm ($^3/_8$in).

SAWING AND CLEAVING THE BRANCH ROUGHLY

Saw the main branch at the same angle as the side branch, right behind the side branch – this is the back of the bowl. Next, saw the front straight, about 3cm ($1^3/_{16}$in) from the handle – this also depends on your chosen diameter. Also saw off the side branch at the right length. The side branch will become the handle of the spoon.

Now cleave the short stump in two, right through the heart. The heart has to be removed completely as it might cause the wood to split.

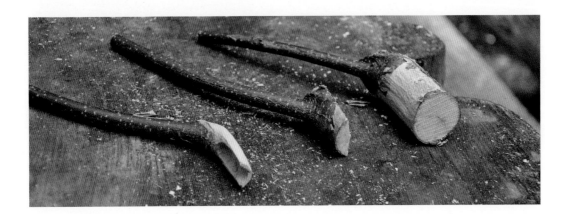

Now flatten the top of the scoop with the chest-lever grip or the thumb push. Draw the shape of the scoop, both at the top and at the front. (You can, of course, make a spoon instead of a scoop.) Hollow out the scoop with a spoon knife or a small gouge, until you reach the lines. Start by working perpendicular to the grain so that you will not pull out the fibres.

Finally, remove the wood on the outside. You can do this roughly with an axe, or with a carving knife. Finish as you like (see page 138).

MORE POSSIBILITIES WITH GREEN WOOD

GARDENING TOOLS

We also organize workshops on making pitchforks and rakes; they are mentioned and shown here for inspiration.

A **pitchfork** (right) is one single piece of (ash) wood that is bent by means of steam and the right jig. Easy to do.

A **rake** (below) has many parts: a long stick, a crossbeam, and a row of teeth (called tines). The teeth are made by hitting small cleft parts through holes in a small iron sheet.

↑ *Making a rake is a challenge!*

9.GREENWOOD CRAFT TOOLS

AXES • DRILLS: BRACE AND BAR-AUGER • SETTING JIGS • FROE • SAWS • SHAVING HORSE • SCRAPER • HOLDFAST • TENON CUTTER • SPOKESHAVE • DRAWKNIFE • ADZE • HAMMER/CLUB AND MALLET • CHOPPING BLOCK • WOOD-CARVING KNIFE • SPOON KNIFE • CLAMPING TOOLS • MEASURING TOOLS

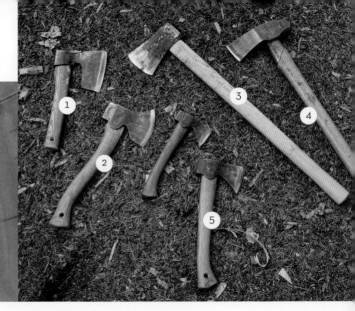

↑ *1 Broad axe. 2 Carving axe. 3 Felling axe.*
4 Cleaving axe. 5 Hand axe.

AXES

The axe is one of mankind's oldest tools. A very effective tool that evolved from a stone axe. In greenwood crafts, the axe is quite important. There are different axes for different jobs. The biggest distinction is between axes that are used for cleaving and axes that are used for chopping and/or carving. The cleaving axe, hand axe, carving axe and broad axe are the most important ones.

AXES FOR CLEAVING

To be able to cleave well, an axe needs a cutting angle of at least 40 degrees. Cleaving can only be done in the direction of the grain. An axe pushes the wood fibres away from each other instead of cutting through them. The power of the axe is in the weight of the head, combined with the speed that you give it when swinging. A typical axe for cleaving is, of course, the cleaving axe, used for cleaving firewood.

With green wood, cleaving axes are used for cleaving logs with a large diameter. The axe is driven into the wood with a big wooden mallet. This way, you fully control where the log cleaves. The axe head is used as a wedge. We strongly advise against hitting the axe with a metal sledgehammer as metal splinters could come off. There are cleaving axes with a hammerhead on the other side of the axe; these are most suitable for being hit. Smaller axes are also used in combination with a wooden hammer but they are not made for this purpose; the cheeks – the sides of the axe blade – are not strong enough to take the blows and could tear.

When choosing a cleaving axe, also pay attention to the weight. They weigh 1.5-3.5kg (3^1/$_4$-7^3/$_4$lb). An axe has to suit you. Sometimes the handle just beneath the axe head is protected with a piece of metal, so that the handle will not damage easily while hitting it. Personally, we prefer axes with a wooden handle.

AXES FOR CHOPPING OR CUTTING

Greenwood crafters are very proud of their sharp hand axes. An axe can do more than just cleave wood. When chopping wood, you can guide the axe exactly to get the shape you want. You can even use it to carve! Read about the various techniques for efficient and safe use of the axe: see technique 2, page 57.

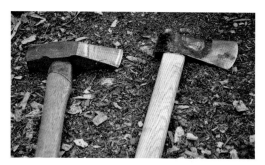

↑ *Cleaving axe (left) and felling axe (right).*

WHAT KIND OF AXE?

Choose an axe that fits you. If it is too heavy, your arms will hurt and you will use too much energy lifting it. An axe that is too light will also give you an aching arm because you will have to hit more often to get the desired result. A 700g (1¹/₂lb) axe is most common. We often use axes made by Gränsfors Bruk. These come in various shapes and sizes. They are not cheap but if you use them correctly, even your great-grandchildren will be able to enjoy them.

Apart from the normal, symmetrical axes there are also the broad axes. These look a bit like a very broad chisel, but are square to the handle. The axe head is flat on one side and bevelled on the other side. Broad axes are not commonly used in the Netherlands and they are difficult to find. Clog makers (another craft that is becoming extinct) use the broad axe for shaping clogs. After this, they tidy up the outside of the log with a stock knife or clogging knife (an enormous knife with a hook on one side that attaches to the work bench and a handle at the other end; see page 163).

In the UK, the broad axe is a lot more common. So common even that the Brits can hardly imagine how we in the Netherlands get by without one.

↑ *Broad axe (left) and normal axe (right).*

AXES FOR FELLING

Felling axes are obviously used to fell trees. The handle is a lot longer than that of the hand axe and the head is heavier. The length of the handle, in combination with the weight of the head, determines the force of the axe. The cutting edge of the axe is only slightly curved (the people in the know cannot agree on whether the handle should be curved or straight). Choose a weight and length that fit you. Felling with a felling axe is a job where safety comes first.

DRILLS: BRACE AND BAR-AUGER

When it comes to drills we usually think of strong machines that make holes in wood, stone or metal while producing a lot of noise. For stone and metal you will need a machine, but for wood there are great alternatives, like the brace and the bar-auger.

For many people, drilling holes with a good hand drill is a true revelation. A good, sharp drill makes neat holes in no time. The big advantage over an electric drill is the control you have during the drilling. Drilling large, deep holes with a bar-auger is a quiet and controlled task. With an electric drill that is no fun at all (we have tried)! Because of the force of the drill, it gets pulled from your hands and because of the speed, power and noise it is hard to 'aim' properly. The bar-auger gives you all the time you need to drill the perfect hole without a lot of effort.

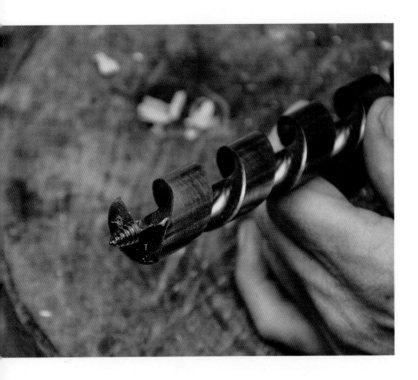

HOW DOES A DRILL WORK?

The principle of the drill is based on the 'Archimedes' screw'. The drill's point, the so-called screw, pulls the drill through the wood. Then the circumference of the drill hole gets cut out by a small vertical chisel. A horizontal 'scooping' chisel transports the loose wood chips from the hole. If you have to drill many holes, it is handy to count the number of turns you make on the first hole; for the next holes you repeat the number of turns. You can also make a mark on the drill, or even use an iron saw to make a light indentation, if you use the drill a lot for similar jobs.

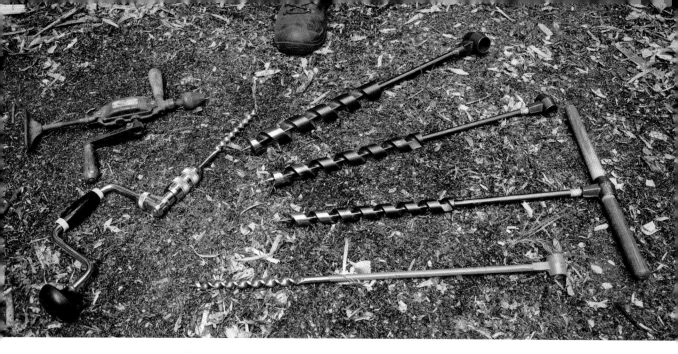

Working with your hands makes you smarter! Schools usually ignore crafts. That is not at all that strange, because who still makes a living by weaving baskets, forging axes or making chairs? It is troubling to see how impractical people are nowadays. The child's brain is stimulated but the hands seem to be forgotten.

We believe that the development of a healthy brain and power to assess are directly connected to so-called hand development. There still are schools that support this vision, and indeed there is a surge in the number of 'Forest Schools' in the UK, but they still form a minority. It is obvious to us that there is a chronic need to not think but do: to create something physical instead of delivering a virtual performance.

USING THE BAR-AUGER

With a bar-auger you can easily drill holes with a diameter of up to 50mm (2in), and as deep as you like. The bar-auger has a loop at the end, through which you can insert a handle. That handle forms an enormous 'arm' for you to drill with – even children can use it. Because of its size, 60cm (24in), you can aim really well, for instance along a bevel or a square.

During the first couple of turns, you must put quite a lot of pressure on the drill; the aim is not that important. Once the screwhead grips the wood, you only have to line up and turn. Correcting is done while you turn, otherwise the drill will not get the space it needs to adjust and it could break! Drill to the desired depth. Always remember the length of the drill, as it could ruin your work if it goes straight through the wood.

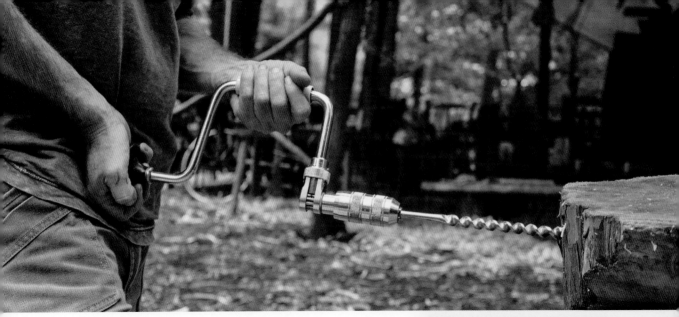

USING THE BRACE

We love drilling a hole with a brace and bit! Up to 20mm (³/₄in) is easy; anything over this requires too much strength. The brace's 'arm' is much shorter than the bar-auger's and therefore you cannot apply as much force. A lot depends on the quality of the drill, which you fix firmly in the drill head. If at all possible, do not use normal, straight drills but drills with a square shank. While square shanks are certainly preferable, you can get auger bits with hexagonal shanks that grip well and usually have much better cutting edges.

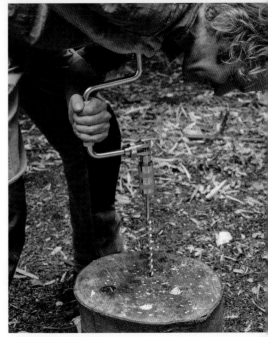

Put the drill bit firmly on the wood, at the right angle, and then start turning. Do not wobble because thinner drill bits could bend or even break. Children can help here: if you hold the drill at the right angle, they can turn the brace. Soon, the miracle happens and you end up with a beautiful small hole. Braces usually have a ratchet so you do not have to do a whole (hard) turn. You can use short, half turns (the ratchet is actually meant for small spaces, where you cannot turn the brace fully, although that seldom occurs).

Secure the wood firmly if you want to drill precisely. With the hand brace, you have to lean against the drill with your chest, which can be done horizontally and vertically. The brace drill is a great substitute for the electric cordless drill, also when you have to tighten screws. If you attach the bit-holder and the bit to the brace, you will be surprised at how easy this is.

At flea markets and charity shops you can often find drill braces. Look for one with four jaws to grip the drill, as these are much better than those with only two.

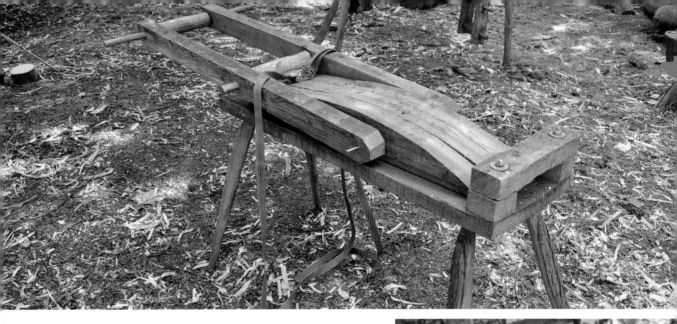

SETTING JIGS

You can bend chair parts (legs and backrests) using setting jigs. These are simple wooden frames with moulds that you bend the wood around. This takes power! By using a vice, you can generate the power that is needed. The mould for legs is about 90cm (35^1/$_2$in) long. In the middle it is 10cm (4in) high. In the picture, above, you see a possible construction to bend the legs around the moulds. You put the (warm) legs in the mould that is connected to the 'bending table'. Next, you use the lever to bend the other end of the legs across the mould. Use your full body weight and let someone else fix the lever with a tie strap or clamp.

The lever consists of two arms that turn around an iron pin, which goes straight through the mould. The chock between the arms pushes the legs on to the mould. After clamping the legs, immediately hit some wedges in

between the holder and the legs and in between the chock and the legs to make an even bigger curve. When you remove the legs from the mould, the legs will bend back somewhat; this is only normal.

Bending the backrest follows the same principle. In this case, the rungs are bent around a 40cm (15^3/$_4$in) mould. At the widest point – the middle – the mould is 6cm (2^3/$_8$in). A vice provides the bending force. The short beam with the two chocks pushes the rungs nicely against the mould. Immediately after clamping, hit a couple of wedges behind the rungs to get a good curve.

The only tool that does not have to be razor-sharp – 'as dull as a froe'.

FROE

CONTROLLED CLEAVING

Green wood is very suitable for cleaving, and the froe is the most efficient tool here. A froe is a straight piece of steel with an eye at one end, through which a handle is fitted. This can be a loose or a fixed handle. The bottom of the steel is sharpened at an angle but must not be too sharp. An angle of about 35 degrees is right. A froe has to cleave the fibres in a controlled way and not cut through them.

With a froe, you can control the cleaving, unlike a cleaving axe. You put the froe on the end of a log. You get maximum control if the froe covers the whole diameter of the log. Next, with a heavy wooden hammer, bang the top of the iron as deep into the log as you can. Green wood, without knots, may cleave from end to end after one blow, depending on the length and thickness (see technique 1, page 54).

If the log does not cleave completely, put it on the floor. Now put one hand where handle and iron meet and your other hand at the far end of the handle. Put the froe straight up in the cleft, as it were. Pull the top part of the handle towards you while pushing down the wood and froe with your other hand. This way, you prise the log open (see page 55).

For precision cleaving you can make use of a cleaving-brake (see page 56).

BUYING A FROE

Not many DIY stores stock froes although a few tool-makers now make them, thanks to the revival of interest in green woodworking crafts. It is relatively simple to make one yourself though. Pay attention to the right quality steel and the right angle (about 35 degrees). Perhaps you can find a blacksmith who can make you one. Froes exist in many shapes and sizes.

SAWS

The birch, ash, beech or oak has been felled. The tree is no longer a tree. It has become wood. You honour the tree by making useful and beautiful things with the wood it supplies. And to do that, it will have to be divided into pieces. We do this using a saw.

Sawing is hard work but can be fun. But not when your saw is not straight or you are using the wrong technique. Both can be improved. Good saws are precious! It takes a lot of work to make a saw, sharpen it and maintain it – that is why a saw deserves to be handled with respect. Take care and it will last you for the rest of your life. Wikipedia tells us that saws have been around for 60,000 years. We are not talking about those super-fast Japanese pull saws, but about pieces of wood with flint, shell or sharks' teeth attached to them, which can act like a saw. Later, the Egyptians made copper and bronze saws. The Romans discovered the 'setting' of a saw, meaning that the teeth bend outwards slightly so that the blade does not get stuck.

↓ Most commonly used models, from top to bottom: two handed saw, American D-Day saw, Japanese pull saw, pruning saw and a regular hand saw.

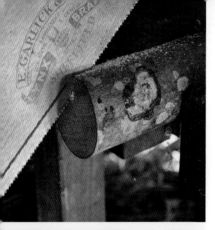

HOW DOES A SAW WORK?

Knives and chisels! You push or pull many of them through the wood and a wood groove appears. That is sawing. Wood consists of many fibres that are tightly packed together lengthways. If you want to cut straight across them – cross-cutting – then you use a cross-cut saw. If you want to cut lengthways, i.e. in the direction of the fibres, you call that 'ripping' and you use a ripsaw.

The teeth for cross-cutting or ripping look different. Teeth for cross-cutting are shaped like knives, while teeth for ripping are shaped like and work like a chisel. The cross-cut saw has two rows of teeth that are slightly bent outwards. The teeth have been sharpened like small knives. In fact, you cut two parallel grooves in the wood, at a small distance from each other; during sawing you remove the wood in between.

You can rip with a razor-sharp cross-cut saw but you will probably give up fairly quickly as the 'knives' will get stuck in the fibres. What you need are chisels that will shorten the fibres. The other way around does not work either: ripsaws 'bounce' off the wood. You need knives to cut through the fibres. Try it.

In the DIY store you can buy universal saws that you can use for cross-cutting and ripping. They will work but do wear. You cannot keep sharpening them like the massive, unhardened old-fashioned saws, so you will have to throw them away one day.

TECHNIQUE

Sawing needs a steady hand, and you can work on that. Make sure the wood is well-secured in a workbench or a sawhorse. Place the saw on the wood and stand behind the saw with your eyes, and your whole posture, aimed towards the top (back) of the saw blade. With a normal cross-cut saw, you put the top of your free thumb against the side of the saw. The rest of the hand rests on the wood. Now carefully move the saw back and forth until the saw has got a good grip. Let it slide along your thumb and use your thumb as a guide. As soon as the saw knows the way, you take your free hand away and start sawing with firm strokes. Work efficiently and use the whole length of the saw and not just a small part.

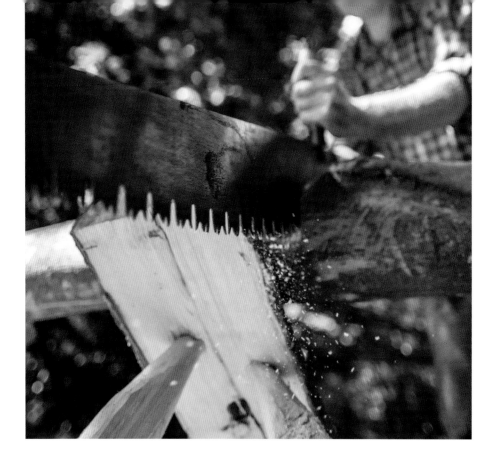

DIFFERENT TYPES OF SAWS

Green wood needs different saws than the usual cross-cut saws for dry wood. A saw will get stuck in green wood more easily, which is why the teeth are set further outwards than on a dry-wood saw. We use a number of different saws for green wood: pruning saws in different sizes (Japanese, pruning saws), bow saws, universal and greenwood cross-cut saws, and tree saws for one or two people.

JAPANESE PRUNING SAWS

Japanese pruning saws are very sharp, fine-toothed saws that leave a very smooth saw cut. We often use them to saw discs for stools; the surface does not need tidying up after. They were originally meant to prune trees and make very flat 'wounds' to minimize the chance of infection.

The teeth of these saws are not set. The blade is thin and hollow so that the saw does not get stuck. Japanese saws are pull saws, which means they only saw when you pull. This way, you can control the direction and you will get a smoother cut than with European push-and-pull saws. The teeth are hardened and stay sharper for a longer time. These saws are available from pocket size to saws with a 60cm (24in) blade.

We would advise you not to use these saws for sawing dried wood as that will make them go blunt and it is hard to sharpen them yourself. The hardened teeth and the special shape of the teeth make that a tough job. You cannot rip (saw in the direction of the fibres) with these saws.

PRUNING SAWS

Pruning saws are for pollarding and pruning. They are curved pulling saws with special teeth. They are ideal for pollarding because they follow the curve of the branch. The pruning saw was developed for Soviet women in the 1940s. It takes less energy to saw with a pruning saw. They are nice saws for smaller cross-cutting jobs. Pruning saws or branch saws are usually quite small but sometimes you can find bigger ones second hand.

EFFICIENT SAWS

For bigger greenwood saws, many different teeth patterns have been developed. The simplest teeth setting is the old European style, with simple triangular teeth. These teeth have been bent outwards in turns, without extra space for sawdust disposal. An improved version of this pattern is the crown-tooth setting, with space for sawdust disposal. In the US, a lot of wood was sawn in the 19th and 20th century (and chopped as well, because saws were expensive). At that time, the teeth were further developed. It became economically interesting to search for more efficient teeth patterns. The peak of this is the lance-tooth setting, with rakes set in between the teeth. These extra teeth are in fact small chisels that shave off the wood. These saws, if set properly, will produce wood shavings and not sawdust, but they are hard to find in Europe.

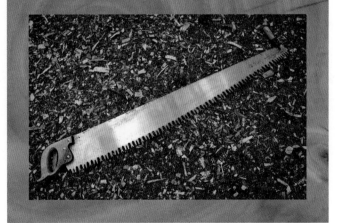

CROSS-CUT OR HAND SAW

The cross-cut saw, or common hand saw, is the most commonly used saw. Depending on the roughness and teeth setting, they are usually suitable for green wood. The roughness of the teeth is expressed in the number of teeth per inch. For green wood, seven teeth per inch is ideal. The universal saw is also quite good for ripping. Modern saws' teeth have been hardened and therefore they stay sharp for longer, but they cannot be sharpened well. They will get blunt and then they are useless, unless you use them to make scrapers (see scrapers, page 160).

Unhardened saws, which you can sharpen yourself, are available at DIY stores. With a bit of luck, you can also find them second hand. Old saws are easily restored. It is a rewarding and valuable job.

ONE-MAN AND TWO-MAN CROSS-CUT SAWS

For bigger jobs (sawing tree trunks with a diameter of 20cm/8in or more, or felling trees) there are special saws. Nowadays, the chainsaw is usually used – but not in this book. A sharp, well-set tree saw is hardly any slower than a chainsaw.

Tree saws are in every way bigger than normal saws. The length of the saw determines the diameter that you can saw with it. It is best to have a saw length of at least twice the diameter of the tree, as the saw can then dispose of the sawdust properly. Shorter tree saws are one-man saws that can be turned into a two-man saw by moving the handle. It is fun to saw together. Finding a rhythm is a challenge and an art. In the greenwood craft, we like to use tree saws because we can sharpen them ourselves.

Tree saws are still for sale in some specialist shops but there is a bigger chance that you will find them second hand, in varying stages of maintenance. Sometimes we get offered them because people do not know what to do with them. Repairing these saws is quite a task as there are many teeth. Every tooth has to be filed on both sides and then has to be set. It is a very satisfying job, though.

MANUAL TREE-SAW MAINTENANCE

To our great surprise, we found out that there is a manual about the maintenance of tree saws. It is an edited version of manuals from the 1930s and 1950s. Look online for 'Saws that Sing', by the USFS.

D-DAY SAW

We were looking for a tree saw with the super-efficient American lancet teeth setting. In 2016, our 'saw man' Henk showed us a very special saw. A one-man saw with lancet-teeth setting that had never been used. The saw was brought along by the Americans on D-Day, in 1944. Somewhere in a forgotten shed, a whole bunch of them were found. A bit of rust here and there but other than that, as good as new. It is a joy to use: a saw that saws and 'chisels' at the same time and that cuts through green wood like a warm knife through butter.

SHAVING HORSE

See chapter 5 (page 82) and page 166.

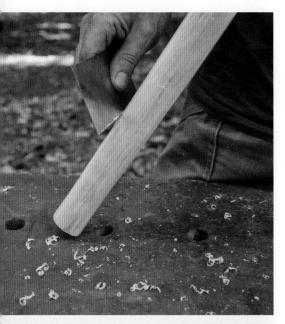

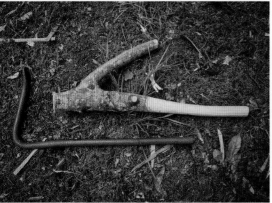

SCRAPER

With green wood, we prefer to not use sandpaper to get a smooth finish. We prefer to use the smooth finish of a drawknife. If we do use sandpaper, we only do so after the wood has dried. If you sand green wood, you loosen the fibres. The sandpaper also fills up quickly and it will not last long. A great alternative is the scraper: a super-simple and efficient tool that is also used by (dry wood) furniture makers. A scraper is in fact a thin piece of steel, on which you make a wire edge. This wire edge is then used for cutting or removing wood. If done correctly, you do not produce dust as with sandpaper but very fine, curly wood shavings. You can buy a scraper or make one yourself, e.g. from a blunt modern/hardpoint hand saw.

HOLDFAST

You can secure wood with your hands, between your knees, with your feet, or with a vice or clamp. If the wood is properly secured, it is easier to use the tools more efficiently. The holdfast is a simple but ingenious, forgotten clamping tool. In the past it was used a lot, but today you will hardly find it. The wooden holdfast is simply a branch with a side branch that gets hit into a hole in a workbench. You can clamp the wood under the side branch. In many cases, the holdfast is a good substitute for a clamp or vice. Hit the holdfast on the head and the wood you are working on is steady as a rock; hit the side of the head and the holdfast immediately jumps loose.

It is easy to make a holdfast yourself from wood, or you can forge one – a good job for an apprentice blacksmith. A wooden version is preferably made of ash wood, as it is bendy and strong. Look for a 40cm (15³/₄in) long branch with a diameter of 2.5–3.5cm (1–1³/₈in). At about 5cm (2in) from the head, the branch needs to have a 20cm (8in) long side branch with a diameter of 2cm (³/₄in). The side branch's angle should be at about 60 to 40 degrees from the main branch.

Round off the end of the main branch and make it about 1–3mm (¹/₁₆–¹/₈in) thinner than the diameter of the hole you are going to drill. The hole should be about 4cm (1¹/₂in) long. Make the end of the small branch horizontal so that you have more of a surface for securing. You can use the holdfast everywhere, as long as you have a fitting hole to clamp it in.

TENON CUTTER

When making a chair or a stool you need many tenon and mortice joints – up to thirty for a chair. Traditionally, all tenons were turned on a turner's pole lathe. A fun job, but a huge job. A great tool to make this a bit easier is the tenon cutter. There are several models available: a model that fits the brace and a model to turn by hand. They are, in fact, giant pencil sharpeners that will quickly cut a perfect tenon on your rung.

The Veritas company from Canada makes very functional tenon cutters, in all sizes. We usually use a 16mm (⁵/₈in) cutter. With it you can make tenons about 8cm

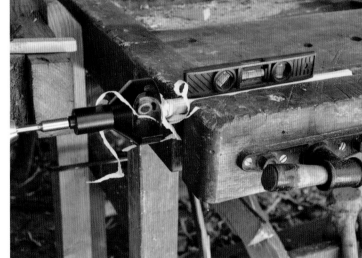

(3¹/₈in) long, but for a chair or stool a tenon of 2.5cm (1in) is long enough. To make life easy for yourself, simply put a 'stop' in the tenon cutter's neck so that the tenons are automatically made to the right length. With an adapter you can attach the tenon cutter to the brace.

Another type of tenon cutter is the English rounding plane. It uses the same principle as the tenon cutter but the drive is different. This cutter has two handles. You put the plane on the rung and you turn it smoothly, nice and square on the rung so that the tenon ends up straight. They are harder to work with but they look good and they do what they are supposed to.

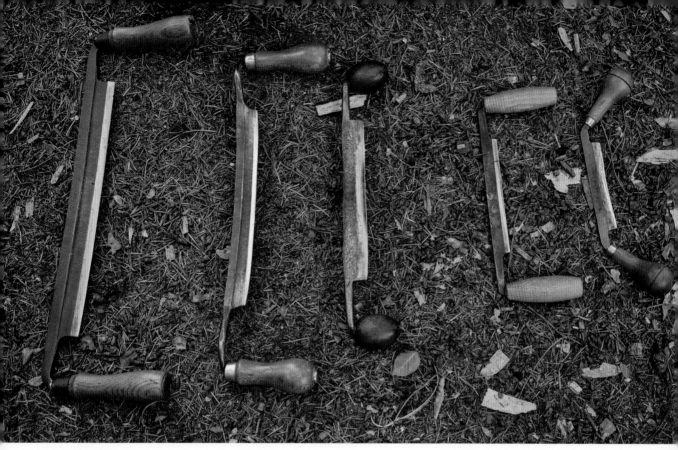

↑ *Drawknives.*

SPOKESHAVE

A spokeshave is a cross between a drawknife and a normal plane. The plane has an adjuster so that you will always take off an equal amount. A spokeshave has two handles and is therefore great to use on the shaving horse. You can then use two hands to give the wood a smooth finish. There are wooden and cast-iron spokeshaves, with or without adjusters.

Use the spokeshave diagonally, so that the shavings are most effective as you use the whole knife. With the adjusters, you can select the amount of wood that comes off. Some people put the blade in at an angle so that they can shave off more or less without having to change the setting. You can also buy hollow and convex planes. When you buy a new spokeshave, you will have to check whether the chisel has been sharpened; you often have to do this yourself.

DRAWKNIFE

The drawknife is an important tool if you work with green wood. The knife has a handle at both ends and therefore can be used with a lot of force and precision. A drawknife lives in symbiosis with the shaving horse; it is almost as if they were made for each other.

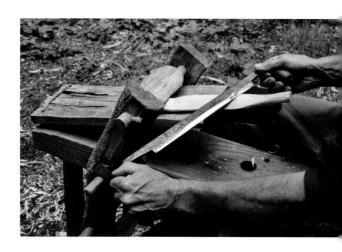

Drawknives come in many shapes and sizes. The most common drawknife is the somewhat bent knife with handles at a 90-degree angle from the blade, and level with it. The bottom (back) of it is flat, like a chisel. The top is bevelled, also just like a chisel. If you work with the flat side facing down, the knife will quickly sink deep into the wood. That can be handy if you want to remove a lot of wood. If you work with the bevel facing down, you have more control over the depth, which is good for the finer jobs. Cutting with a drawknife is best if you use the entire blade. When cutting, move diagonally from left to right, or from right to left and forward. If you do it well, you will produce nice curly wood shavings.

Good old drawknives can be found online. You might have inherited one from your grandfather and you never knew how to use it. The large, straight and rigid drawknives were mainly used for peeling – taking bark off a tree trunk. If you use these drawknives with more power, the cutting will turn into cleaving.

STOCK KNIFE OR CLOGGING KNIFE

A stock knife is a tool that was, and still is, used by clog makers. The knife is long, has a hook on one end and a handle on the other. The hook goes through a screw eye on a special workbench.

Because the knife is attached on one side, you can use the leverage effect. This way, you can cut the wood. The clog makers use the knife to shape the outside of the clog. If you are lucky, you can find them second hand.

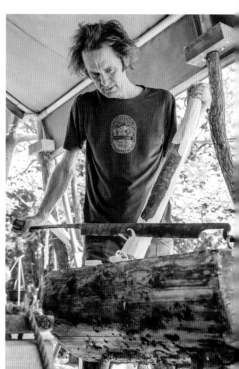

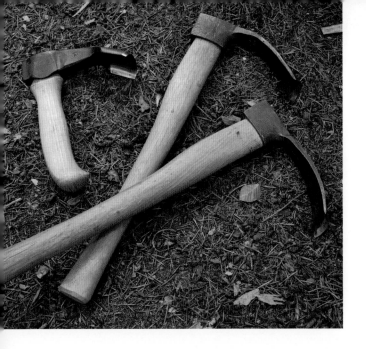

ADZE

The adze is a great tool that gets used almost across the entire world – although it is becoming less popular in the Western world. An adze is an axe with a head that is turned 90 degrees. The cutting and/or chopping surface is often hollow. There are long adzes that you can use to hack away while standing up. This type of adze is good for flattening rough surfaces. On beams in old houses and farms you can sometimes see traces of the adze. With short adzes you can hollow out the wood, for instance, if you want to chop out bowls. The adze is a very efficient tool if you know how to use it and if it is sharp. Working with the adze is not without risks, as you swing the sharp end towards you. That is where the saying on the right comes from.

With an adze, you have to make sure you cut the grain of the wood at an angle, as you do when you plane the wood. If you chop along with the grain, there is a chance that you pull along the fibres over a longer length. You have to position yourself in a way that the adze scoops off bits of wood and does not enter the wood too deep.

'The only tool the devil is afraid of.'

HAMMER/CLUB AND MALLET

See chapter 5: wooden hammer/club project (page 92).

CHOPPING BLOCK

See chapter 5: chopping block on legs project (page 95).

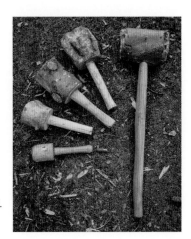

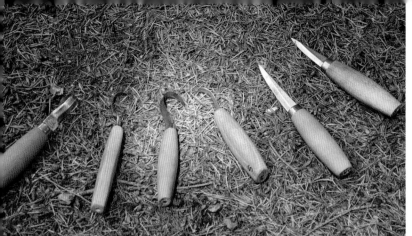
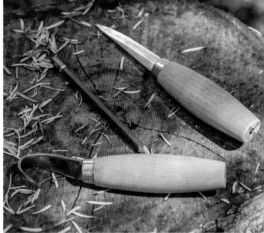

↑ Above, a wood-carving knife. Below, a spoon knife.

WOOD-CARVING KNIFE

The knife that we use most is a special wood-carving knife. Because of the relatively long blade, you can make long strokes, and with the long thin point you can make lovely curves. Mora, from Sweden, has some good and not too expensive wood-carving knives. There is a long tradition of forging knives. Frost's Mora 106 is our favourite.

Spoon carving requires a very sharp knife. The Mora knife is a laminated knife: a layer of hard steel, surrounded by two softer types of steel. The stronger steel stays sharp for longer but is a bit more fragile, and that is why it is protected by the softer steel. The Mora knife has a 6mm ($^1/_4$in) bevel on both sides. You can use this bevel as a guide with the chest lever grip (see page 72). In addition, the wide bevel makes it easier to keep the knife sharp (see chapter 10). The wider the bevel, the easier it gets to follow it while stropping or sharpening (see page 170). The handle of the knife is symmetrical so that you can use it for all possible wood-carving grips.

SPOON KNIFE

Spoon knives are knives that are used to hollow out the bowl of a spoon. Spoon knives are curved and are available with a few types of curves. They are two-beveled or single-beveled. Single knives are made for left-handed or right-handed people. Knives that have two sharp sides can be used by everyone. A disadvantage is that you cannot apply force to the back of the knife, which you can do with single-sided knives. With spoon knives it is handy to have a wide bevel, so that it is easy to keep them sharp. Mora's spoon knives are great and do not break the bank. Hans Karlsson, Svante Djarv and Ben Orford all deliver good-quality spoon knives, but they are more expensive.

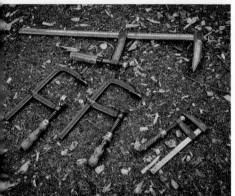

CLAMPING TOOLS

You have to be able to secure a piece of wood in order to work efficiently and safely. There are many different tools to help you do this. A number of them we use frequently in greenwood craft.

The **shaving horse** is used for clamping greenwood. Depending on the shaving horse, you can use it on wood with a diameter up to 20cm (8in). Ideal for securing legs, tenons, tool handles, longbows and more. See page 82 for how to make one.

The **sawhorse** is mainly used to help you saw logs. You secure logs in the 'fork' of the horse and they sit at the right height. To clamp the wood, we often use a tie strap (see below). There are various types of sawhorses: we use one that is made in one piece and one that is made of two pieces. On page 96, learn how to make the latter.

The **clamp** is ideal for securing a piece of wood on a loose workbench, table or board. Note that clamps differ in quality. The best (and most expensive) are those that consist of one single piece of metal (see picture). You can buy them in all sizes. It is always handy to have a couple of big ones and a couple of small ones.

A **tie strap** is a strap with a mechanism (a ratchet or clamp) so that you can apply force. Handy when you want to secure big pieces of wood to a sawhorse. The straps with a ratchet can take great tension.

The **holdfast** is a bent iron pin (or a wooden pin with a side branch) that you can use as a clamping device by hitting it into a hole in the workbench (see page 160).

You can use a **cleaving brake** to help you cleave a long piece of wood lengthways. You put the log in the cleaving brake and by turning the wood, you can keep correcting the cleft towards the middle (see page 56).

A **workbench with a wooden vice** is very useful.

A **workmate** can also be handy, but only for the lighter jobs. You can weigh it down with some wood or a rock, making it more stable.

The **bench hook** can help you saw (smaller) pieces of wood. You use it on a workbench. It is a board with two battens across it: one (on the underside) to hook behind the workbench and the other one (on top) to push against with your hand.

A **stop** can be any piece of round timber that you push into a hole in the workbench. You push your wood against it so that it will not slip.

MEASURING TOOLS

A **folding ruler** and **tape measure** are indispensable. A folding ruler goes up to 1.5m (59in) but a tape measure can go up to 15m (49ft). The **calliper** is what you need for really fine measuring. You can go as precise as a tenth of a millimetre. We use it mainly to measure diameters of tenons and rungs (for chairs and stools). You can also use callipers to measure the inside and depth of holes.

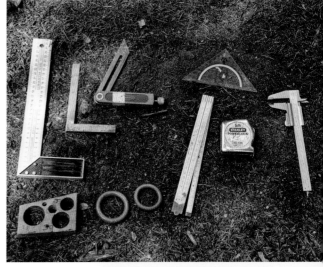

We use a **protractor** to determine an angle and often copy that angle with a **sliding bevel**. A sliding bevel is a tool that helps you with angles, for instance the angle at which a stool's legs should point outwards. You can drill parallel to the bevel. If you use the same angle a lot, you can make a **drill guide** for that.

With a **square** you can draw and check right angles (90 degrees).

Then there is the **drill template**: a piece of wood in which you have drilled holes with the diameters that you use the most, in our case that is 25, 30 and 38mm (1, $1^3/_{16}$ and $1^1/_2$in), with the bar-auger. With a drill template, you can quickly check if the tenon you have made for a leg is the right size. You just slide it on and see if it fits. With legs for chairs we often use a 40mm ($1^9/_{16}$in) (wooden) curtain ring, which slides on easier. The legs are the right size when you can slide the ring across the whole leg.

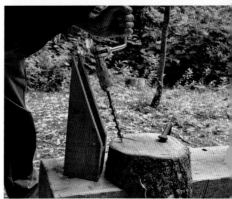

10.MAINTENANCE AND SHARPENING

KEEPING YOUR TOOLS SHARP

Carving with a sharp knife or sawing with a super-sharp saw is a real pleasure. Almost without effort, the tools do the job for you. Tools have to be sharp otherwise using them is a tough job. Besides, working with blunt tools can be dangerous because you have to use more force, and then there is greater chance that a knife or axe will slip. But how do we keep our tools sharp? In this chapter, we present a couple of tips for tool stropping and sharpening. We take the wood-carving knife as an example and will conclude with some tips for other tools. We will focus on the easiest way to sharpen and strop. You mainly learn by doing.

'Blunt tools are no tools.'

Felo Hettich, Midgaard

STROPPING, SHARPENING OR MAJOR REPAIRS?

A sharp knife will become less sharp as you use it. At first, you can keep it sharp by stropping it. With a very fine paste on a piece of leather (razor strop) you polish the knife and you can use it again. After a while and after stropping many times, the bevel of the knife will get blunt. A knife can also get blunt when it is damaged. You can use waterproof sandpaper, diamond files and hand grindstones to sharpen it again. In our workshops we use all three of these. If a blade has been severely damaged, the knife will need major repairs. It could be that the blade is chipped, so that you can no longer cut or chop properly. Often axes are damaged this way, but a knife dropped on a stone floor will also get chipped. To get the cutting edge straight again, you have to take off a lot of metal. You can do this by hand but that is sheer drudgery. It is better to use a grinding machine. A big advantage of working with green wood is that the blades of your tools will not blunt very quickly. The wood is soft and does not cause too much wear and tear.

FINDING THE RIGHT SHARPENING ANGLE

When stropping and sharpening your tools, it is crucial to follow the existing angle of the edge of the blade. How can you find the right angle? That is relatively easy if your tool has got a clear bevel of a couple of millimetres. The bevel of the blade is the piece right before the beveled edge ends in a point; the slanted part of the blade that runs along the whole length. It is easy to find the existing surface of the edge and follow it while pushing the knife onto the grinding stone or something similar.

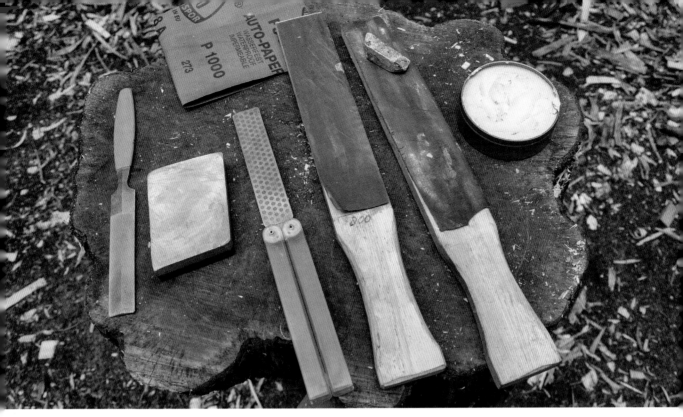

↑ *Diamond file, Belgian sharpening stone, another diamond file, waterproof sandpaper on wood, leather on wood, honing compound, stropping compound.*

SHARPENING TOOLS

- Narrow strips of waterproof sandpaper in different grit sizes (600, 800, 1200), glued to narrow slats of 3 x 20cm ($1^3/_{16}$ x 8in), e.g. large paint stir sticks.
- Diamond files in different grit sizes (rough, medium, fine).
- Water or oil sharpening stones in different grit sizes (600, 800, 1000, 1200).

STROPPING TOOLS

- A piece of leather (old belt), glued to a slat, also called a strop, with the rough side facing up.
- Honing compound or stropping compound.

STROPPING

Stropping is best done with a piece of leather, glued to a long slat or paddle. Apply the honing compound or grinding paste to the leather. Put the paddle with the leather on a flat surface. Pull the blade of the knife with the cutting edge flat over the leather. Make sure to follow the angle of the edge. Put some pressure on the blade using the fingers of the other hand. Pull the knife towards you so that you do not cut into the leather. Repeat this a couple of times, on both sides.

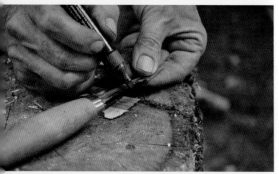

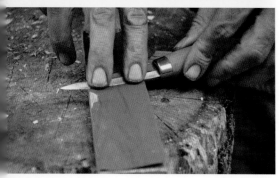

SHARPENING

If you have used a knife for a long time, you will need to sharpen it. It is easy to see when a knife is blunt. If you hold the cutting edge up in the light and move the knife, you can see a thin silver line on the edge. That is where the edge is flat (at a 90-degree angle) and where it reflects the light. No light will be reflected when the cutting edge is still sharp.

The biggest challenge of sharpening is following the existing angles of the bevel of your knife. You need instinct and you have to keep looking at the effect of what you do. Make sure there is enough light so that you can see what you do. In this example, we sharpen with waterproof sandpaper in different grit sizes. Secure your knife or the sharpening tool or put it down so that it cannot move. To help you, you could use a felt-tip pen on the bevel of the knife. During sharpening, you will be able to see if the coloured part is coming off, and then you know if you have the right angle.

First take the roughest sandpaper. Put the knife down at elbow height, on your workbench for instance, for the best grinding position. The cutting edge points away from you. Take the paddle with sandpaper in your hand, with your index finger behind the grinding part. Follow the bevel with your finger on the paddle in one fluent motion. Grind until there is a wire edge along the whole cutting edge: a thin piece of metal that curls over to the other side. Then grind the other side in the same way. Grind both sides of the knife the same amount of times so that the cutting edge stays central. Change to a finer sandpaper when the silver lines on the cutting edge have disappeared and continue until there is a wire edge again. Repeat with the finest sandpaper. Strop the knife until the bevel is shiny and polished.

TIPS FOR SHARPENING OTHER TOOLS

DRAWKNIFE

Drawknives have very long blades and usually only a bevel on one side, while the other side is flat. They are often somewhat curved. To sharpen a drawknife, put one end of it on a surface or vice so that it will not slip. Hold the other handle. Hold it so the bevel points away from you. With your other hand, move the sandpaper exactly along the line of the bevel, at the right angle. Then polish the flat side of the drawknife.

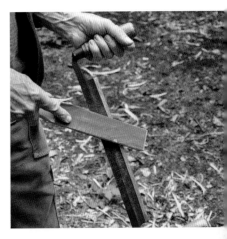

SPOON KNIFE, GOUGE AND ADZE

Tools with a (sharply) curved blade need to be treated differently. The normal, single-sided sharpened Mora spoon knives are almost circular. It is advisable to colour the edge of the blade with a felt-tip pen. A spoon knife with a very clear bevel of a couple of millimetres makes it easier to follow the edge. Secure your spoon knife and pull your sandpaper paddle (in decreasing grit sizes) in a circular motion along the cutting edge until you can see a wire edge. For the rest, follow the description of how to sharpen a wood-carving knife. A spoon knife usually only has one cutting edge. The inside is flat but curved. Get some sandpaper (of every grit size) and glue it to a matching rod so that you can file the wire edge away from the inside of the knife. For stropping it, glue some leather around a rod.

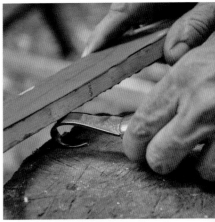

AXES

Sharpening axes is very similar to sharpening knives. With a felt-tip pen, draw across the cutting edge and then follow the edge with your preferred sharpening tool. You can secure an axe while sharpening it, by putting it on your leg or on top of a workbench. Then use a circular motion across the edge until there is a wire edge. Repeat on the other side, as many times as you did on the first side. Then repeat with the sandpaper in increasing grit sizes.

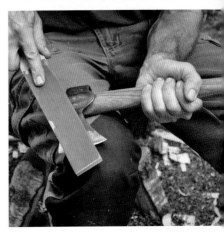

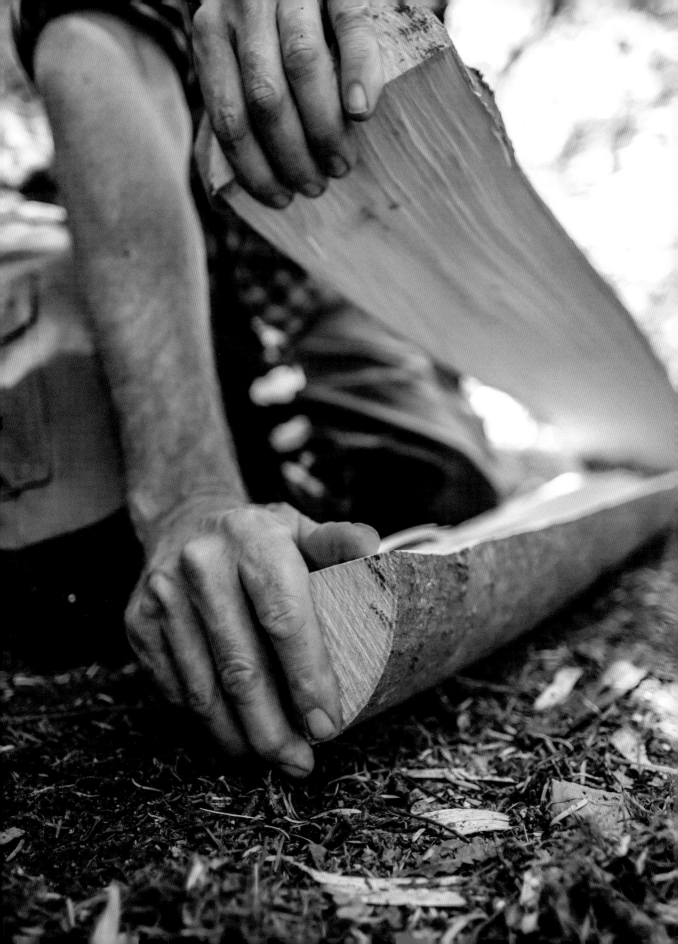

BOOKS AND MORE

On green wood

- *Encyclopedia of Green Woodworking*, Ray Tabor, published by Eco-Logic Books, 2000
- *Living Wood: from buying a woodland to making a chair,* Mike Abbott, published by Living Wood Books, 2002
- *Going with the Grain: making chairs in the 21st century,* Mike Abbott, published by Living Wood Books, 2011
- *Green Wood Chairs: chairs and chairmakers of Ireland,* Alison Ospina, published by Stobart Davies, 2009
- *Roundwood Timberframing,* Ben Law, published by Permanent Publications, 2010
- *Woodland Craft,* Ben Law, published by Guild of Master Craftsman Publications, 2016
- *The Woodwright's Companion: exploring traditional woodcraft,* Roy Underhill, published by University of North Carolina Press, 1983
- *Essential Woodworking Handtools,* Paul Sellers, published by Rokesmith Limited, 2016
- *Timberframe Construction,* J. Sobon and R. Schroeder, published by Storey Publishing, 1984
- *The Ax Book,* D.Cook, published by Alan C. Hood, 1999

On carving spoons

- *Swedish Carving Techniques,* Wille Sundqvist, published by Taunton, 2013
- *Spōn: a guide to spoon carving and the new wood culture,* Barn the Spoon, published by Virgin Books, 2017
- *The Urban Woodsman,* Max Bainbridge, published by Kyle Books, 2017
- *How to Whittle,* Josh Nava, published by Search Press, 2018

Others

- *Know Your Broadleaves,* Herbert L. Edlin, published by Stationery Office Books, 1968
- *Wood,* Andy Goldsworthy, published by Harry N. Abrams, 1996
- *Grandfather,* Tom Brown, published by Berkeley, 2001
- *Educating through Arts and Craft: an integrated approach to craft work in Steiner Waldorf schools,* Michael Martin, published by Steiner Schools Fellowship, 2008
- *The Invention of Nature: Alexander Humboldt's New World,* Andrea Wulf, published by Vintage, 2016
- *The Forest Unseen,* David George Haskell, published by Penguin Random House, 2013
- *The Song of Trees,* David George Haskell, published by Viking Press USA, 2017

Novels

- *The Sixteen Trees of the Somme,* Lars Mytting, published by MacLehose Press, 2017
- *Barkskins,* Annie Proulx, published by Fourth Estate, 2017
- *The Man who Made Things out of Trees,* Robert Penn, published by Penguin Random House, 2016
- *The Lost Words,* Robert Macfarlane and Jackie Morris, published by Penguin Random House, 2017

Websites

- www.vers-hout.nl
- Mike Abbott: www.living-wood.co.uk
- Roy Underhill, instructive and entertaining lessons: www.pbs.org/woodwrightsshop/home/
- Jan Harm ter Brugge – master spoon carver: www.houtvanbomen.com

YouTube

- Subscribe to our channel 'VersHout', and you will receive notifications about our films about green wood
- Timber framebuilding, Ben Law
- Alone in the wilderness, Dick Proenneke
- Instructional films on the turning of wooden bowls, among other things, Ben Orford.

SAFETY AND TAKING CARE OF YOUR TOOLS

Don't 'halloo' till you are out of the woods

Working with green wood is not without risk. Tools are sharp and green wood can be heavy. Luckily, only dry wood has splinters, so these will not bother you.

Pause or stop in time

Tiredness is the number one danger. Working with sharp tools requires your full concentration. Stopping is not easy as you are doing a nice job and you may just forget about the time. Drugs (like alcohol and some medicines) decrease your concentration and should be avoided.

Mind your posture and position

Before you start, ask yourself where the knife or axe would end up if it slipped. In the air, in the wood or in you? Securing the wood properly prevents accidents. Keep your sharp tools away from your hands. In the relevant sections on the various tools and techniques, you can read more about working safely.

Keep a distance

Make sure you keep your distance from other people, especially with spoon carving, which is often done in a circle. You do not want your knife to end up in your neighbour's leg.

Learn different techniques

Practise the different techniques. With wood carving, you can work safely if you know all the grips.

Protect your tools

Keep your tools in sheaths so that the cutting edges are well protected. Or hang your tools up so they will not get damaged.

Looking after sharp tools

More accidents happen with blunt tools than sharp tools. A blunt knife makes carving dangerous as you need to use more force, increasing the chance of the knife slipping. A blunt axe bounces off.

Looking after your tools

Working with green wood means that you work with soft wood, much softer than the normal dried wood. This keeps your tools sharp for a longer period of time and makes it easier to sharpen them. Follow these rules and your tools will stay sharp for even longer.

Blunt tools take away the joy of working with green wood!

Keep your work surface and wood free from sand and dirt

Prevent sand and dirt touching your tools, and make sure the chopping block and other surfaces are clean. Brush away grit and dirt. The wood that you work with should also be free of soil and sand.

Tidy up your tools and workstation

After working, always tidy up your tools. Put everything back where it belongs so that your workbench will not get cluttered. It is even more important to make sure you never have to look for any tools. Whether you work inside or outside in the woods, a tidy floor contributes to safety. Put loose logs or pieces of wood where you will not trip over them. Tidying up at the end of the day is a satisfying task that gives you the opportunity to quietly complete the job.

Addiction to green wood

Working with your hands and green wood can be addictive. We do not know of any rehabilitation centres yet.

THANKS

Running VersHout is great fun but it is also hard work that requires a lot of support; luckily for us there are plenty of people who have supported us on our journey.

First of all, thanks go to Titus Baptist; without him this book would not exist. It was his idea to work with our publisher, Els Neele. We are extremely grateful to Els for her enthusiasm and inspiration. Otto Koedijk has been an incredible support. He keeps us in our place and offers guidance where necessary. He was one of our highly esteemed co-readers, along with Jan, Rob and Thomas. Thanks also to Wouter, who so generously loaned us his professional camera for months on end.

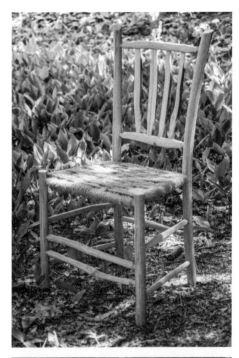

We build on the shoulders of giants. We found inspiration in books by Mike Abbott - who checked through this English language edition - and Ray Taybor and our American hero Roy Underhill. Wille Sundqvist's book must also be mentioned. We take our hat off to our fellow countryman Jan Harm ter Brugge: he has given us, and spoon cutting, a huge boost. Our thanks also to Menno Swaak (Edible Park, The Hague) who initiated our very first workshop in 2011, which turned out to be such a success. With this, a possible greenwood revival in the Netherlands came into view for us.

We are extremely grateful to our students. We teach them a lot, but through that teaching process they teach us a lot too! Thank you!

Finally, our partners: Annelies and Inge.

Inge, last year your husband was often absent as a partner and as a father; you have made it possible that Sjors has been able to free up a lot of time for this book. Many, many thanks.

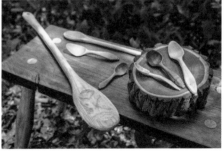

Thank you Annelies for your support, patience (and love) when writing this book... all this as well as breaking your leg at the same time.

And you, honoured reader, thank you for delving into this great craft with us!